Praise for *American on Purpose*

"Craig Ferguson is so much more than a talk show host. Craig Ferguson is so much more than an author. Craig Ferguson is so much more than a godlike creature. Craig Ferguson is so much more than a mysterious force controlling tides and seasons. Craig Ferguson is so much more than an all-powerful, all-knowing, cosmic, intergalactic time traveler for the ages. Craig Ferguson is so much more than a harmonic vibration of the stars, the universe, the heavens and eternity. Craig Ferguson is full of shit. Enjoy the book."

—DAVID LETTERMAN

"Funny and poignant and inspirational and brilliant. Nowhere in his story of emigration and redemption does Craig Ferguson realize that as lucky as he thinks he is to be 'American on Purpose,' we are luckier still to have him."

—KEITH OLBERMANN

"With *American on Purpose*, Craig Ferguson somehow manages to avoid the pitfalls of self-indulgence and self-importance that plague most (okay, all) Hollywood autobiographies. He has, instead, written a book that is hilarious and irrepressibly daft, yet also kind, poignant, and undeniably wise. It was a joy to read."

—DENNIS LEHANE, AUTHOR OF *THE GIVEN DAY*

"A great read . . . almost as good as my memoir."

—CARRIE FISHER, AUTHOR OF *WISHFUL DRINKING*

"Hilarious and revealing . . . witty and emotional."

—*THE DAILY BEAST*

ALSO BY CRAIG FERGUSON

Between the Bridge and the River

AMERICAN ON PURPOSE

*The Improbable Adventures
of an Unlikely Patriot*

CRAIG FERGUSON

itbooks

AN IMPRINT OF HARPERCOLLINS PUBLISHERS

For my parents

itbooks

A hardcover edition of this book was published in 2009 by HarperCollins Publishers.

HarperCollins books may be purchased for educational, business, or sales promotional use. For information please write: Special Markets Department, HarperCollins Publishers, 10 East 53rd Street, New York, NY 10022.

First It! edition published 2010.

The Library of Congress has catalogued the hardcover edition as follows:
Ferguson, Craig, 1962-
 American on purpose : the improbable adventures of an unlikely patriot
/ Craig Ferguson. — 1st ed.
 p. cm.
 Summary: "Craig Ferguson traces his journey from working class Glasgow to the comedic limelight of Hollywood and, in the process, becomes the one thing he always dreamed of—American"—Provided by publisher.
 ISBN 978-0-06-171954-7
 1. Ferguson, Craig, 1962- 2. Comedians—United States—Biography.
3. Television personalities—United States—Biography. I. Title.
 PN2287.F415A3 2010
 792.7'028'092—dc22
 [B] 2010007864

ISBN 978-0-06-199849-2 (pbk.)
10 11 12 13 14 OV/RRD 10 9 8 7 6 5 4 3 2 1

Contents

I am a Scotsman which means I had
to fight my way into the world.
—Sir Walter Scott

I'm a Yankee doodle dandy.
—George M. Cohan

Preface

One of the greatest moments in American sports history was provided by Bobby Thomson, the "Staten Island Scot." Born in my hometown of Glasgow, Scotland, in 1923, he hit the shot heard round the world that won the Giants the National League pennant in 1951. Had Bobby stayed in Glasgow he would never have played baseball, he would never have faced the fearsome Brooklyn Dodgers pitcher Ralph Branca in that championship game, and he would never have learned that if you can hit the ball three times out of ten you'll make it to the Hall of Fame.

Today I watch my son at Little League games, his freckled Scottish face squinting in the California sunshine, the bat held high on his shoulder, waiting for his moment, and I rejoice that he loves this most American game. He will know from an early age that failure is not disgrace. It's just a pitch that you missed, and you'd better get ready for the next one. The next one might be the shot heard round the world. My son and I are Americans, we prepare for glory by failing until we don't.

I wish I'd known all this earlier. It would have saved me a lot of trouble.

In order to write this book I reached into the darkness for my past and found to my surprise that most of it was still there, just as I had left it. Some of it, though, had grown and morphed into what now appears to be hideous and reprehensible selfishness. Some of it had crumbled into the ruins of former shame.

This is not journalism. This is just my story. There are bound to be some lies here, but I've been telling them so long they've become truth, my truth, as close as I can get to what really happened. I left some tales out because to tell them would be excessively cruel to people who probably don't deserve it, and altered a few names for the same reason, but I believe I spared myself no blushes.

I didn't flee a dictator or swim an ocean to be an American like some do. I just thought long and hard about it.

I looked at the evidence of my life and gratefully signed up.

A Seat at the Table

I see England, I see France, I see the first lady's underpants."

"Shut up," hissed Megan. "I wish I had never pointed it out."

She was giggling so hard her wine squirted out of her nose, and anyway it was true. Laura Bush, the congenial Texan wife of George, the forty-third and arguably least popular president in the history of the United States of America, had just entered the room, her affable spouse by her side. They were graciously acknowledging the fawning Washington toadies who milled around them, smiling and shaking hands and kissing cheeks. Mrs. Bush was wearing an elegant silky frock, but when she stood with the light behind her you could see her undies. Big, comfortable knickers, what are known in enlightened circles as *passion killers*, in what looked like a floral pattern. Ideal for a long night of smiling and nodding and being a good sport at the annual press, showbiz, and politics bunfight that is the White House Correspondents' Association Dinner.

I was there in my capacity as vulgar lounge entertainer. Megan, my date, was there because she loves me and was proving it again. I had been asked to be the guest speaker by the chair of the entertainment committee. I wasn't their first choice, but after Steve

Carell and Ellen DeGeneres turned the gig down I think I became a little more appealing. I might be a C-lister, but I was obtainable, willing, and cheap.

I understand why Ellen and Steve said no, since this is, without doubt, one of the most intimidating and difficult jobs available to a comedian. And there were other reasons why I too should have politely declined. First of all there was the event's recent history. Two years before, Stephen Colbert had performed there and, depending on who you talk to, had either died the worst death ever seen by a comic in the history of comedy and death, or had delivered the most fearless piece of political satire this country has ever seen.

The year after, in an attempt to avoid any repetition of the controversy the WHCA had hired the antediluvian Canadian impressionist Rich Little, who most recently achieved fame in the 1970s with his Richard Nixon impersonation, to be the after-dinner speaker. Little had definitely bombed (no debate needed) in a buttock-clenchingly awkward manner; his material was too archaic and meek for the bloodthirsty crowd.

I also should have said no because it's the granddaddy of all corporate events, a large dinner in a hotel ballroom where everyone who is there secretly hates and wishes misfortune on everyone else. This is not an atmosphere in which comedy usually flourishes, although having lived in Hollywood for fifteen years, I'm used to it.

I should have said no because the sound system in the hotel was so awful it was impossible for anyone in the first two rows of tables to understand what was being said, Scottish accent or not.

But I didn't say no. I didn't say no because between safety and adventure I choose adventure. Plus, I thought it would be great crack, getting to meet all these muckety-mucks, and, truthfully, as a new American I felt it would somehow be unpatriotic to refuse a chance to make a fool of myself in front of the president, who, after all, had no problem doing exactly that in front of the entire world.

It certainly was an impressive and eclectic guest list, with

Salman Rushdie, Condoleezza Rice, and Christiane Amanpour sharing warm chicken cutlets with Pamela Anderson and the Jonas Brothers as they sat around the big circular tables. It was such an unlikely collection of people that it actually felt like a dream. So much so, that more than once I checked to see if I was wearing pants, something I often do, just in case. With a past like mine it's never a bad idea.

Before the meal there had been a little reception backstage for the people who would be seated on the dais, and their partners, although the only spouses at the head table would be the comfortably arsed Mrs. Bush and Mrs. Cheney, wife to Dirty Dick.

It was a chance for everyone to meet and have a chat before we would go out on the stage and sit in a line like that last supper painting.

Anne Compton, the WHCA committee chairman, took charge and whisked Megan and me around the room, introducing us to the other honored guests. We met the diminutive and sassy White House press secretary, Dana Perino, who revealed to me that she was married to a Scotsman and I said that would explain why she was crazy. She laughed. I think she thought I was kidding.

We met Richard Wolfe, the clear-thinking MSNBC political commentator and henchman of the mighty Olbermann, who in a brief conversation assured me that Barack Obama would be the next president of the United States. This still amazes me, because at that point Obama didn't even have the Democratic nomination.

We met José Andrés, the celebrity chef, who seemed to me as if he'd been hanging around the open bar too long and was banging on in a thick Spanish accent about the wonderful world of tapas. We met a few more broadcasters and White House types whose names now escape me, and then all of a sudden we were standing in front of Mr. and Mrs. Cheney and being introduced. I felt a

little awkward; I'm always a bit shy around evil people, so Megan took the lead. She has a knack for dealing with difficult men and is very knowledgeable about fine art, having worked for a time as an art dealer in New York. She and Mrs. C struck up a conversation about Picasso—the Cheneys were the proud owners of a few of his sketches.

"Where do you hang them?" asked Megan.

"Oh, we don't," replied Mrs. C. "They're nudes, and we have grandchildren. We don't want them to see them when they come over."

"But they're Picassos," protested Megan.

"But they're nudes," smiled Mrs. Cheney dangerously.

I put a hand on Megan's elbow. I didn't want trouble. You don't want to be on the Cheney shit list.

Dick himself was surprisingly affable and had a croaky easy laugh, but I did get the very strong impression that I was in the presence of a Bond villain. All he needed was a pussy to stroke, although not in front of the grandchildren of course.

We made small talk for a while before the Cheneys moved on to the next glad-handers. Once they were gone, I told Megan that Dick Cheney had been ogling her breasts.

"Nah," she said. "I thought that for a second, then I realized he was just appraising my diamonds."

The Secret Service guys started to clear the room. Megan wished me luck with the speech and kissed me goodbye. I stood alone at the bar, and that's when I first saw the president of the United States. He was, unbelievably, standing on his own in the corner, looking a little awkward. He saw me at the same time and recognized me. He smiled that big goofy smile of his and walked over, a moment in my life so surreal that it's matched only by the time I was pursued by what I imagined to be killer ducks during a bad acid trip.

"Hi, Craig. How you doin'?" said the leader of the free world, offering a friendly hand.

For months before the event I had fantasized about what I would say to the president if I did have a private conversation with him. Would I take him to task for everything he had done that I so profoundly disagreed with, berate him for his foreign policy, his strategy in the Middle East, his disregard of the Kyoto Protocol and the Geneva Conventions? Would I forcefully harangue him to change his mind on education and the economy and the war on drugs and then remind him of the constitutional imperative to separate church and state? In the end I concluded that it would be a teensy bit arrogant to lecture the president of the United States on the constitution of his own country. And after all, it wasn't as if he hadn't already been assailed by some very clever politicians and journalists, many of whom were much smarter and more informed than an uncomfortable vaudevillian in an ill-fitting tuxedo. However, I was unable to resist the opportunity to voice my dissent, and, throwing caution to the wind, I charged him with a biting . . .

"Hello, sir, nice to meet you."

I mean, what the hell else do you say to the president of the United States of America when you've only been a citizen of the nation for two months? Even if you don't agree with the man and his policies, he's still the fucking president.

He disarmed and surprised me because he wasn't what I expected. I'd watched way too much MSNBC and was prepared to meet a drooling moron.

Mr. Bush was open, friendly, and refreshingly candid about what he thought of most of the ass-kissing that had been going on for the last twenty minutes. He told me that this was one of the more enjoyable events in his year because it was so informal and he got to be funny. He was interested to know what my speech was going to be like; I think he was slightly nervous about what I would

say because he had to sit there and grin and take it no matter what, with no advance warning—the White House didn't get a transcript of my remarks, because this is America, and free speech, and all that.

I told him I planned on ribbing the press as much as the politicos, and he seemed relieved.

After all, he was already a lame-duck president seen as an election liability by his own party and whose approval rating was lower than many thought possible. Attacking him too hard would be like joining a fight after it was over and claiming victory.

I decided to treat the whole thing like the famous incident from World War I when, on Christmas Day of 1917, German and British troops took the day off from killing each other and played soccer in no-man's-land.

I had talked with former WHCA dinner speakers Jay Leno and Drew Carey about what they had done when they had been there and they both gave similar advice. Read the room, don't be too blue but don't be too tame, make sure you smack everybody at least once, and remember it's not really about you, you're just the help.

So that's what I did. When my turn came to speak I first mocked the C-SPAN network for their archaic single-camera coverage of the event, then teased the president and his minions and the assembled journalists in a way I hoped they'd find amusing rather than flat-out insulting, although I did call the New York Times "sanctimonious whining jerks" for declining to attend because they felt it devalued journalism to be too cozy with the administration.

I talked a little bit about why I became an American, and I managed not to cuss, and when I was done they gave me a standing ovation, so I can only conclude that my strategy worked.

I don't think I was particularly sparkling that night, I think the crowd was just relieved, as I was myself, that the whole thing was behind us and nothing too embarrassing had happened.

It was a whirlwind after that. Parties and celebrities and back-

slapping and schmoozing. I felt like I had had an anvil removed from the top of my head.

Megan and I got to our room about three a.m. and had to get up at six to catch our flight back to L.A.

That I became a citizen of this country in January and was at a dinner with the president in March is, I think, in a small way, indicative that we are still the country we hope we are. I had wanted to be an American citizen for a long time; I have felt I was an American since I was thirteen years old and first visited here. Life got in the way, or, more accurately, I got in my own way. I was sidetracked and waylaid by my own demons, but America is the land of the second, third, and 106th chance.

As I dozed on the farty rattly airplane on the way home, I thought about my short conversation with the president.

We had been talking about Scotland; he had visited for a while when he was younger and expressed a sort of puzzled awe at the amount of drinking that was done there, hinting that he had taken part in a fairly major way. We talked a little bit about the dangers of booze. I've been sober for seventeen years and, according to rumor, he himself a little longer than that.

"It's a long way from where I've been to standing here talking to the president," I told him.

"It's a long way from where I could've ended up to *being* the president," he replied.

"Only in America," he chuckled.

We clinked our glasses of sparkling water.

"Damn straight, Mr. President," I said.

And I believe it.

2

Frank Sinatra and Elizabeth Taylor

It probably began when the Germans tried to kill my parents. Every night when the weather suited their purpose, the Germans would fly over in their Heinkels and Messerschmitts and drop their bombs on Glasgow, the city where my parents grew up, just a few miles from each other. My father was only ten years old at the time and my mother was seven, but the Jerries didn't care, they needed to flatten Glasgow because it was the military workshop of the British Empire. All the battleships and minesweepers and frigates that would be used to end the Fascist madness were being built in the massive, dirty shipyards that some idiot had placed right next to my family. So every night they could, the Germans attempted the brutal murder of everyone who was in their way. My parents never forgave them for the nightly assaults that killed more than a few of their classmates. To my mother and father they were always "Germans," never "Nazis." That sounded too impersonal and inhuman, which I suppose was true; also, by calling the enemy Germans it allowed my parents to hang on to the enmity, and if you know

anything about Scottish people, you know that bearing a grudge is something we do extremely well.

Postwar Germans have rightfully been distancing themselves from their shameful Nazi past, but my folks weren't buying it. They felt that those bastards had had the time of their lives and if they thought they could get away with it they would do the whole blitzkrieg thing all over again in a heartbeat. Maybe my parents are right. To this day if I am talking to a German man, I cannot help, at least momentarily, picturing him in an SS uniform, and I wasn't born until nearly twenty years after the war ended. The only time I have ever seen an SS uniform is in the movies. My parents never saw an SS uniform up close, either. They saw U.S. army uniforms instead.

When the American GIs turned up in Glasgow, en route to Europe, they must have seemed like gods for their white teeth and lack of rickets alone.

They also brought items that had been forgotten since the war began. Nylons, fruit, laughter, and hope. With America in the war, my parents' generation began to realize that it would eventually end and that life would go on. Maybe it would get even better, because the GIs brought something else. Something that had to exist before I could. Swing dancing.

Scottish people love to dance. Only certain types of dancing, though. The kind that comes with a set of rules and instructions. We are, after all, the great engineers. Organized stamping and clapping or structured reels and skips are what Scots want—God forbid anything involving sexiness or free expression, no fluid or sensual movements, please. No squeezy buttocks pushing against groins to a salsa beat, that's just the kind of thing that leads to people talking about their feelings. The GIs changed all that. Long after that little Austrian fucker was burned up in his bunker and the liberators had returned to their fabled land of cowboys and Coca-Cola, swing dancing and big band music remained. It became known simply

and collectively as "the dancing," or, in the broad Glasgow dialect, *radancin.*

Even now, every Friday and Saturday night Glasgow pubs and bars are packed with young people who pound down as much Dutch courage as they can before they head out for radancin to try and find prospective sexual partners or future spouses. Like thousands of Glaswegians, that's how my parents met.

My father, Bob, was rake thin when he was young, but he was tall and good-looking, and at six-one a giant for a Scotsman of his generation. Diamond-blue eyes, white-blond hair that was silver by his thirties, a strong nose, and fabulous teeth, though the teeth were something of a cheat since they were dentures. Bob told me he'd lost his own teeth when he was thrown from his Enfield motorcycle at Anderston Cross going eighty miles an hour but it seems improbable because:

(A) No one can get eighty miles per hour out of a 1945 Enfield dispatch motorcycle.

And:

(B) The injuries my father would sustain from such a high-speed accident would surely be more serious than just dental.

Perhaps he was traveling so fast that his poor old gnashers, weakened from no flossing and a lack of fluoride, were sucked out of his mouth by the relative velocity.

Nonetheless, the Great Teeth Incident has now become family legend and that's good enough for me, but the more likely story is that my father lost his teeth at a young age due to the awful diet of his truly Dickensian childhood. He didn't own shoes until he was eleven years old, and for a few years during the war, in an effort to escape the bombing, he was evacuated from the inner city to one of the notorious childhood labor workhouses—sweatshops in the countryside that kept children safe from bombs, but not from horrifying abuse and mistreatment at the hands of wartime opportunists. My father refused to talk about the details of his wartime

experience until the day he died, saying only that it wasn't fun. I believed him.

I also believed that he rode a motorcycle, and he rode it fast. After all, he was a telegram delivery boy in Glasgow in the early fifties, round about the time Marlon Brando starred in *The Wild One* as a troubled and brooding motorcycle gang member.

"Hey, Johnny, what are you rebelling against?"

"What've you got?"

The telegram boys of Glasgow didn't ride Harleys, they rode Enfields and Nortons. Big, British army bikes. They couldn't afford leathers and silk scarves like their matinee idols, so they wore black post office–issue uniforms, wrapping white linen tea towels round their necks to look like American bikers. Bob looked like Sinatra and dressed like Brando. Bob was cool.

My mother, Janet—you can call her Netta—was cursed with great beauty and intelligence. In old photographs you can see it. Her hair was raven dark and her eyes as blue-green as Celtic coral. She was luscious and slightly zaftig, a stunning, clever young woman, which I suspect made her a target for jealousy and contempt from the less genetically gifted. It must have been difficult and embarrassing for her, and my mother inevitably developed a hardness, a shell with which to protect herself. I think she also had to hide her brilliance in order to compensate for her looks, and that ultimately made her angry. Netta looked like Elizabeth Taylor, but Netta was tough.

Their relationship was always a mystery to me. When I was young they seemed to fight a lot, and even their affection was wrapped in little passive-aggressive insults that they would send via their kids. In front of us, over a meal perhaps:

"Yer faither disnae like my cookin'. That's why he's makin' that face."

"Aye, yer mither disnae like yer father, that's why she's makin' *that* face."

And then our parents would laugh in an odd sad way and us kids would laugh just because they were laughing, but even now I'm still not sure what the hell was going on.

Bob drank a fair bit. Lager in the summer, Guinness in the winter, and whiskey all year round. I learned about alcohol from him. I learned that it made him cheeky and funny and different and warm, but if he drank too much he got cranky and weird or fell asleep. Netta never drank, it caused a massive allergic reaction in her. Even a small glass of wine would make her sneeze and trigger a vivid scarlet rash on her neck.

She did not approve of my father's alcohol intake but tolerated it most of the time because it was so socially normal and he never let it get in the way of work. He couldn't. Work, after all, is how my people articulate love, and it's probably not a bad way to do it. Nobody talked about their feelings or, God help us, their *issues*, but I don't believe my siblings or myself ever doubted the love of our parents for us or each other. They proved it daily with their labor. My father put in long shifts as a postal worker, rising in his forty-year career from telegram delivery boy to chief inspector of the main branch in Edinburgh. On retirement, Bob was awarded the British Empire Medal for his achievements. He transcended his own unfortunate background and none of his kids ever walked barefoot to school.

Netta labored just as hard keeping the house and studying to become a grade school teacher so she could bring home extra income and to give herself a continued sense of purpose once her own kids began to bail out. My parents' struggles were different from mine. Their enemy was poverty, not the "Oh shit we can't afford cable" poverty but the "Oh shit we can't afford food" poverty. So they did the best they could for their family, though it left little time for emotional connection. It was as if too many outward displays of affection were a luxury better suited to the rich, or the English. Add to that the influence, even though it was only minor

in my home, of sterile Scottish Presbyterianism (which I can only describe as Catholicism without the elaborate visuals) and you are left with a certain aridity.

The first openly romantic moment that I witnessed between my parents—that's not to say they didn't have them, they had four kids, after all—happened just before my father's death. It wasn't so much the moment's novelty that shocked me, it was the overwhelming sensation I got that it wasn't novel for them at all. These two people had had moments like this countless times. It is a testament to my own selfishness and self-obsession that I had never noticed.

Bob died of cancer in a bleak hospital in Airdrie, in central Scotland. (Perhaps the hospital itself was not so bleak, perhaps it was what was happening there to our family.) The cast of characters from my father's life gathered around him in his final days, coming and going in shifts. He had a full roster of friends and relatives who adored him and just had to say goodbye. During much of this drama and activity I sat in a corner of his busy room, jet-lagged and heartbroken, talking to him sometimes, or respectfully staying quiet when he was talking to someone else, feeling like I was five years old again. Netta would bring him boiled sweets or magazines or whatever he needed from home. She was so intensely focused on him, I don't think she was always aware of my sisters and my brother and me even being in the room with them. She just sat on the bed and stroked his head. (Even aggressive chemo couldn't get rid of his great hair, it just became soft and downy.) On one of her visits I watched as my parents looked into each other's eyes and he whispered something to her that only they could hear and she laughed a little bit and kissed him on the mouth.

On the mouth.

Like they were young and in love.

Like he was Frank Sinatra and she was Elizabeth Taylor.

The Attic

I was born at 6:10 a.m. on May 17, 1962, in Stobhill Hospital in Springburn, at the northern end of Glasgow. A couple of days later my parents took me home to the small rented apartment a short bus ride from the hospital, where my brother and sister waited. I only lived in that apartment for six months because my parents had already applied for and been granted government housing in the new town of Cumbernauld.

After World War II, the city of Glasgow had to rehouse an enormous number of people. The town had been badly damaged by bombing, and many of the tenement buildings had fallen into disrepair due to slum landlording and urban poverty. The 1950s promise of a "New Dawn" and of a peacetime economic recovery had inspired a generation of architects and engineers. They had schemes for the proles. Housing schemes—vast areas of cheap matchbox houses with none of the attendant luxuries of urban life, like a cinema or a store or a library, just miles of miserable towers built on the edge of the city. They looked and felt not unlike the projects on the outskirts of Moscow or East Berlin, with the added bonus of the damp Scottish climate to up the ante of misery.

But Cumbernauld wasn't just a *scheme*. It was a plan. A big plan.

An entire new *town* built about fifteen miles outside Glasgow itself. One of three, in fact. East Kilbride, like Cumbernauld a satellite of Glasgow and Livingston, was built on the outskirts of Edinburgh. It is hard to convey the dreariness of these gloomy wastelands, of which Cumbernauld was and is undoubtedly the worst. These atrocities were designed by pseudointellectual modernists who believed that the automobile would replace feet sometime in the 1970s. Any money they had left over from making boxlike dwelling hutches was spent on horrendous concrete abstract sculptures, totems to the gods of utter banality, which were placed throughout the town in random locations. There were no sidewalks, pedestrians were instead diverted into tunnels lined with corrugated iron (a cheap way to make them) so as not to interfere with the flow of traffic on the empty freeways. The tunnels became useful later for gang violence and glue sniffing as the new towns crumbled.

I doubt the Cumbernauld town planners ever saw the finished product but I'm sure it looked a lot better as line drawings on expensive paper. Fairly recently Cumbernauld was named the second-worst town in the United Kingdom, losing worst-of-all honors to the city of Hull, a dowdy seaport on the east coast of England. I dispute the result; I have been to Hull, and while it is undoubtedly an absolute shitheap, it is no match for Cumbernauld.

Our first house there was on Torbrex Road. I don't recall much of the place since we left when I was five years old, but I do know that it had a garage. Not attached to the house itself but nearby, lined up with the others, one designated to each dwelling. We actually had a car, well not exactly a car. My father at that time was driving a little red post office van. As an infant, not much more than two or three years old, I would hang around at the garage door waiting for my dad as my mother watched from the kitchen window, keeping an eye on me until my father came home. He was an impressive, reassuring creature who smelled of cigarettes and Brylcreem and always had a little box of chocolate raisins for me.

My older brother and sister were already in school, and I remember being on my own a lot. Waiting for Godot, and Raisinets, at the garage door.

It was at this time, according to family legend, that I first ran away from home. My frantic, pregnant mother eventually found me a mile away, standing on an overpass above the motorway in the pouring rain and singing to the cars, trying to figure out which one was my dad.

When I was three years old, Lynn was born. I was shunted off to my grandmother's house while my mother was expecting my little sister and while she was giving birth. Apparently it was a difficult pregnancy so she was away for some time.

My mother's mother, Jean Ingram, was one of those giant-arsed Scottish women who could not be intimidated. Whether it was the Luftwaffe or doctors bearing chilling news, all were powerless against her bitter scorn and her hot sweet tea. She looked like an overstuffed sofa covered in a floral apron and balanced precariously on minuscule pink fluffy slippers. She had hands like a longshoreman's and hair like the cold steel of a bayonet, hard and shiny. She was a stringent woman who terrified me as a child, although she became a friend and guide later. Jean was Presbyterian—all my family are in matters of sex and where babies come from. As a pudgy curious ten-year-old I horrified her when she caught me hiding behind her couch, leering enthusiastically at the ladies' underwear section of a mail-order catalogue in which pictures of giant matrons in whalebone corsets sent thrilling shock waves through my body. Jean went beet red and called me a "filthy wee bugger"—she wasn't wrong of course. As a consequence of my family's shyness about sex, nobody explained where my mother had gone. They said she was in the hospital with "women's trouble," which doesn't mean a great deal to a three-year-old. The hospital, for some reason, had a mad rule forbidding young children from visiting the maternity wards, so according to family legend I got an eye infection

from standing and looking at my grandmother's mailbox for hours on end in the hope my mother would return. This is viewed as an amusing anecdote in my family. It is a miracle I am not in a locked ward eating spiders and yelling obscenities at my testicles.

When my mother did finally come home with my baby sister, I was very annoyed. She was a whiney little fartball who constantly stole my thunder, but eventually she grew up to be one of the funniest people I know, although she can still be both farty and whiney.

She now works as a writer on my television show, where I shamelessly exploit her for my own profit. Sweet revenge.

The family now numbered six in total, and although financially it must have been a struggle for my parents, the kids were never really aware of it. I knew we couldn't afford a lot of luxuries, but neither could anyone else around us. It wasn't as if we lived in Beverly Hills. In fact, when we got our hallway carpeted—a scary vomity-colored tweedish patterned thing supplied by a friend of my father who worked in the shipyards and got a cutting from a luxury liner—neighbors came from far and wide to gaze at its amazing splendor.

The place on Torbrex Road was too crowded with four kids, so when my parents applied for and got larger council housing, the carpet stayed behind.

We headed to 12 L Darroch Way, third from the end of a terraced row. It had three levels. There was a small kitchen on the ground floor that opened onto a tiny garden, a sitting room on the floor above along with my sister Janice's and my parents' bedrooms, and on the top floor my brother and I shared a room, while Lynn had her own room next to us, and we all used the undersized bathroom. Next to the toilet bowl in that bathroom was a little door, and that little door led to the attic.

We loved the attic. It was barely the size of a cupboard but roomy enough to fit four kids and some toys, and it was given over to the exclusive use of the children. We crammed ourselves in there for hours on end, hours that went on for years. The attic was about us talking nonsense, fighting, laughing, and playing. Experiments could be carried out away from harsh parental glare. With the help of a cheap chemistry set my brother and I created the worst smell in the world, yet to be topped in my opinion. I still have a scar on my leg because my brother told me that the game of darts was played by one player throwing the darts while the other held the board. I was the holder.

Lynn and Janice had their dolls up there. Janice favored the more sophisticated Barbie type that drove convertibles and gave off a certain aloof air, while Lynn, who was much younger, played with giant plastic babies that always seemed to have shite on them. The attic was our haven from the rough sectarian world outside, a working-class Narnia, Neverland, and Hogwarts all in one.

After a while Janice stopped coming. She was going to high school and interested in pop music and suddenly seemed to hate the rest of us. Then Scott, her junior by a year, followed suit. They told Lynn and me that after we went to bed, which was of course earlier than they did, the toys in the attic came alive and too bad we would not be allowed to see that until we got older. Just the casual cruelty of teenage siblings typically played on gullible younger ones, but Lynn and I believed it.

I think we still do. Janice and Scott grew up to have steady lives and reliable incomes. Lynn and I take our chances trying to amuse other people, and I'm not sure either one of us has properly grown up or completely left the attic. Lynn, like me, still believes the toys can talk.

4

Astronaut

I don't say this to try and impress you but I was a bed wetter until I was around eleven years old. Then I stopped, but not for long. I started drinking alcohol regularly when I was in my early teens, at which point I returned to intermittent bed-wetting until I was twenty-nine. I haven't peed myself since the 18th of February, 1992, the day I got sober. Therefore I suppose I was a bed wetter until I was almost thirty. But I did stop *before I was thirty*, and I think my family and the people of Scotland should take a great deal of pride in that.

I was a fat kid, too. My nickname was Tubby and I had the expected gaseous emissions of a schoolboy who enthusiastically gorged himself on a diet of what was considered nutritious in Scotland in the 1960s—lard and salt. One would think that a nervous, overweight, incontinent boy might be difficult to love, but it didn't seem any trouble at all for my parents.

For schoolteachers, however, it was different.

Her name was Mrs. Sherman and I still think of her, after twenty-five years in show business and two failed marriages, as without question the most colossal fucking bitch I have ever met in my life. She was a small woman, birdlike and nasty, with a dyed,

metallic-rust-brown "permanent" hairdo and horn-rimmed glasses. (I still associate horn-rimmed glasses with rage and steer clear of anyone who wears them.) She wore tweed the year round and thick flesh-colored stockings and too-shiny brown shoes. She was the infant mistress at Muirfield Primary School in Cumbernauld and she was the first person, other than my mother, who ever hit me.

My first day at Muirfield, an ugly prefabricated building with the appearance of a small, dowdy factory, she belted me. It was 1967 and I had just turned five years old, but corporal punishment would remain legal in Scottish schools until the European Court of Human Rights banned it 1979. When I started school it seemed almost mandatory.

"The belt," as it was called, was a custom-built leather strap (they had a factory that made devices for hitting children!) that came in three strengths—soft, medium, and hard. I could never tell which one was being used on me, they all hurt. A lot. You had to hold out your hands in a grotesque parody of begging, and then the teacher would whip the weapon down with all her might on your outstretched palms. The fact that it stung so much was bad enough, but that you had to be complicit in your own anguish was horrifying. Occasionally a kid would refuse to hold out his hands, but that would only send him up the chain of command through the academic hierarchy until he reached the headmaster's office, where presumably something even worse than the belt awaited— the rack? the iron maiden? we ruled nothing out—and so defiance was rare indeed.

Mrs. Sherman took me and a couple of other kids, barely more than toddlers, into her small dark office and yelled at us in a shrill falsetto until we cried, and then she belted us ferociously across our chubby wee hands. I can't remember what the specific offense was, but I am at a loss to think what any five-year-old could do to warrant that degree of rage and hatred. I don't know what she expected to achieve with her tactics; probably she was just enjoying herself,

but she set me up nicely. For the rest of my school days I was convinced that teachers were a fearsome and unpredictable enemy and I loathed them. There were exceptions, of course:

Mrs. Fraser, my sixth-grade teacher, a lovely warm blond woman with an easy laugh who wore lots of tight, cozy knitwear over her spectacular breasts, which I remember still with awe. Or the earnest and inquisitive Mr. Biggins, the high school guidance counselor/PE teacher whose name alone was a wondrous comedic gift and who either really gave a shit about every kid he dealt with or was an extremely talented actor. These two were far from the rule; most of my teachers were erratic sadistic nutcases who had no business being around children.

I ratted out Mrs. Sherman (first name unknown, but I suspected something cruel like *Agnes*) to my mother when I got home that day, and although I got a fairly sympathetic hearing, the general feeling was that I must have somehow deserved it. (I didn't think so then and I don't now, but perhaps after forty years it's time to move on.) My parents came from a generation that trusted doctors and teachers and policemen, trusted that the system was always right and would never let you down. They allowed the schoolteachers to beat us because they believed teachers knew best, and also, compared to their own childhoods, mine seemed pampered and idyllic. (Attitudes change over generations, of course. I believe the system is flawed and that it protects the corrupt and the lazy, and any teacher who lays a finger on a child of mine better have medical insurance or a fucking secure hideout.)

From Mrs. Sherman's office on, the predominating theme of my childhood outside of the house was: fear. That's what I remember: being afraid. The teachers of course scared me. The other kids did, too, but that had to be hidden. There was a merciless Darwinism in the schoolyards although until the teenage years it was less about real violence and more about bluff. The teachers were the only truly violent ones early on. So I learned to bluff. I tried to appear alter-

nately aloof and enigmatically dangerous, which is no easy feat for an anxious, corpulent, farty preteen, but I got by. I think the armor I have used to survive in Hollywood was forged back then. Appear tougher or cooler or funnier than you feel and there is a chance you'll make it.

What was especially perilous to do at school was to stand out in any way. If you excelled academically, there would be hell to pay in the playground. I always made sure I got a few answers wrong on tests so that I would pass, but not by too much. You couldn't fail by too much either or you'd be tormented by the other kids for being a moron. Obviously you couldn't be a teacher's pet, but it would also be a mistake to be too much of a rebel, because then the teaching staff would single you out, and every time they needed someone to belt, it'd be you, guilty or not. The only way to endure a public education in Scotland in the 1960s and seventies was to remain anonymous. Don't fail. Don't succeed. Don't appear. Just *don't*. Any movement was potentially dangerous. This will tend to quell a child's natural ambition. I certainly learned to shut up about any dreams I had. It astonished me to learn, later on, that education wasn't always like this.

School did give me one of the greatest gifts of my life, though. I learned how to read, and for that I remain thankful. I would have died otherwise. As soon as I was able, I read, alone. Under the covers with a flashlight or in my corner of the attic—I sought solace in books. It was from books that I started to get an inkling of the kinds of assholes I was dealing with. I found allies too, in books, characters my age who were going through or had triumphed against the same bullshit. Tom and Huck dealt with no end of injustice, and Huck's pappy was a dead ringer for one of my teachers. Richmal Crompton's "William" was a resourceful and hilarious guerrilla against adult tyranny. Tom Brown had suffered awful indignities but finally had a gratifying retribution against Flashman. According to Enid Blyton, some of the posh kids were

so fucking cool they didn't even go to school, they just farted about riding their bikes and solving mysteries.

From very early on, possibly my first day, I wanted out. It seemed to me that school involved too much physical abuse. Better to be in the workplace, where at worst your boss could only fire you. I had no idea what profession I would ultimately end up in, though I do remember having the vague notion that famous people didn't have to go to the dentist. There might be something in that idea; plus, if I were a pop star or something, I'd show *them*. "Them" of course being the other kids. And the teachers.

It seems to me now that this profound sense of isolation, resentment, misanthropy, and fear in a prepubescent child is an extraordinarily ominous portent. I should have put my name down for rehab then.

One night when I was seven years old I was allowed to stay up past one o'clock in the morning. My whole family was gathered round the television—even my baby sister, who was only four, and I didn't know why she should be allowed to stay up so late since I had never been allowed to at that age. My brother pointed out that I was only seven and that he himself hadn't been allowed to stay up this late (and he was *nearly twelve!*) so put a sock in it.

I put a sock in it anyway. Not because he told me to but because the door opened on the lunar module.

When Neil Armstrong, who we all knew was of Scottish ancestry, put his foot on the moon, I knew what I wanted to do with my life. From that moment on I would do whatever it took to be Scotland's first astronaut. (I must have really wanted to get away.) I had enough innate practical sense, though, to realize that Scotland would be unlikely to develop its own space program in my lifetime, so I decided I would throw my lot in with the Americans. My amused mother helped me draft a letter to NASA headquarters informing them of my decision, and then walked me to the big red post office box at the end of our street, where I mailed it.

I think my mother was as surprised as I was when the big buff envelope containing NASA's response landed on our doorstep two weeks later. NASA was, I suppose, on something of a high at the time and had sent me a book of photographs of Saturn 5 rockets and astronauts along with the two wall posters that would obsess me for years. One depicted the moon, up close and detailed with the names of all the craters and rock formations indicated. The other was of the galaxy, the planets and their moons all accounted for and showing their placement in relation to the sun. It still amazes me that this kind of stuff was sent out to any kid, American or otherwise, who wrote to NASA expressing an interest in space. (I'm sure by now some fuckwit corporate bean counter has put a stop to it, but these posters changed my life.)

I hung them above my bed in the room I shared with my older brother, and even though his choice of wall art at that point was Raquel Welch in a fur bikini, he admitted my NASA posters were cool. They certainly drew me closer and closer to the U.S.A., and, perhaps just as important, they bonded me with Gunka James.

James the First

My mother and my father both have brothers named James. My father's, James Ferguson, was the first of our family to emigrate to the United States. He arrived in New York by boat, having worked his way over as a deckhand on a freighter in the 1950s. He was an immense influence on my later life. But in childhood the most influential James was my mother's brother, James Ingram, or Gunka James, so called because one very young nephew or niece (perhaps even me, no one remembers for sure) had great difficulty pronouncing the word "Uncle." It came out "Gunka," and it stuck.

Gunka is an odd bird amongst my kin. He didn't marry until much later in life, never had children, has traveled all over the world, and was the first person to give me a firsthand account of what the mythic kingdom of America was like. He is a mathematician who is also literate and loves music and the arts. He is an extraordinarily charming gentleman, tall and elegant, with a huge infectious laugh that trumpets out of him after even the very first dram of Laphroig. He's worn thick glasses since he was a teenager, his hair sticks up when he's thinking, and there is nothing about our planet,

our universe, or human relations that doesn't interest him. If you meet Gunka James and you don't like him, you're a dick.

Gunka taught mathematics at the high school I would eventually attend, where he started an Astronomy Club for the students who wanted to go on field trips to study the stars. To my knowledge, he never once belted a kid yet had no problem with the unruly teenagers in his charge.

Gunka was thrilled to learn that I was taken with the space program, helped me make a big pastel drawing of an astronaut, showed me the rings of Saturn through the small telescope that he bullied the school into buying, and told me about his forays into America and Canada. I suppose Gunka had time to spend with his nieces and nephews because he didn't have children of his own, and we all venerated him. My brother and my sisters and many of our cousins think of him as the person who first got them interested in something, sparked their enthusiasm about stuff, even though being passionate about anything other than soccer left you open to derision from the ever-present bitterness of many of the Scots I grew up around. Gunka never paid any attention to those assholes. He still doesn't, God bless him.

I have felt indebted to Gunka ever since my eighth birthday, when he took me by bus to a music store in the center of Glasgow. This was like nothing I had ever seen before. Studious guys in their twenties dressed in black were leafing through racks of albums, girls were wearing dresses even though they weren't at church or a party. In hindsight I realize I was wrong—to them this place was both.

Everyone seemed very tall; plus, I had never seen so many skinny people in one place. In fact, Gunka and my father were the only skinny people I knew. But here there were dozens of them, clicking their russet, nicotine-stained fingers in time to what I assumed to be complicated and indecipherable jazz piped through on the big roboty headphones they were provided by the store. I'm

almost certain I heard the word "groovy" uttered in a thick Glasgow accent when I was in this store, but that hardly seems possible. It may have been 1970, but the word "groovy" has and never will be a word in common Glaswegian parlance. I desperately wanted to be one of these cool people when I grew up. They seemed engaged, occupied, interested.

They seemed calm.

Gunka got me a set of headphones and we sampled some music. He played me a selection from Edvard Grieg's *Peer Gynt Suite* and I thought it was grand, especially after he explained the story to me. His version of what was going on in the music may not have been the same as the composer's but I loved it. Gunka explained that when I heard sweet, light violin and flute melodies I should imagine wee fairies dancing around in the meadows, and when the booming brass and timpani sounded it meant that giants had charged in and were attacking the helpless sprites.

Giants and fairies was how he described classical music. He could just as well have been talking about show business.

Gunka said he'd buy me one of the big waxy discs for a present, yet as much as I had enjoyed the Norwegian composer's opus, I wanted a pop music album instead. Gunka agreed that that might be a good place to start, and we whittled the options down to two: the Beatles' *Sergeant Pepper* or a Monkees album called *Headquarters*. To my eternal shame, I chose the Monkees. This was because I was only eight and the Monkees looked cheerful and friendly on their album cover, whereas the Beatles had beards and my father had told me that you couldn't trust a man with a beard because you didn't know what he was hiding. Crumbs, for instance. I believed men with beards were evil.

Years later I made the acquaintance both of Mickey Dolenz, the Monkees' drummer, and Ringo Starr of the Beatles. Mickey, still clean-shaven, is in fact very cheerful and friendly. And although Ringo still has some kind of whiskerish arrangement going on, he

doesn't seem so evil to me anymore. Shy and maybe grumpy, but not evil. Then again, I hardly know the man.

Gunka paid and the salesgirl put my album in a brown paper bag for me. Then we headed off for fish-and-chips. Glasgow has the best fish-and-chip shops I have ever been in, probably due to the enormous influx if Italian immigrants driven from their own country by poverty in the late nineteenth century. Many of them went to America, of course, but for reasons that have never been satisfactorily explained to me, some wound up in Glasgow, serving superlative Italian cuisine much appreciated by the natives. It's no secret that the Italians know a thing or two about food, and the Scots, well, maybe not so much.

Gunka and I went to a café, where he ordered a cappuccino and I had a birthday feast. Fried cod, chips, and green peas followed by something called a "Knickerbocker Glory," which was three scoops of ice cream with raspberry sauce and sprinkles. I washed down the whole thing with a giant glass of Irn Bru, a sort of Scottish hybrid of Dr Pepper and maple syrup. It's a beverage much adored by children and hung-over alcoholics. I have drunk gallons of it in my life.

I was replete and food-stoned as Gunka held my hand and helped me to waddle like a chubby duck back to the bus station. The offices and factories were emptying by then and rush hour was in full swing. We sat in the back of the bus as it filled up with apprentices and shopgirls, bank clerks and tradesmen, all talking and laughing, and every one of them smoking a cigarette.

Then, as the bus pulled out of the station, it started raining, so they closed the windows. The dampness outside, the smoke inside, and the jiggling of the rattly old bus worked bad juju on my tubby wee body full of potatoes and lard and fish and sugar. Gunka saw the look on my face, or maybe just its color.

"Do you feel sick?" he asked.

I nodded.

"Are you going to be sick?"

I shook my head. I'm not much of an upchucker. I can and have eaten pizza on heroin.

"Do you need to go the bathroom?"

I nodded.

"A pee?"—he hardly dared say it—"or something else?"

"Something else," I squeaked guiltily. "Really bad."

By the time we had this conversation we were almost halfway home. Out of the city center and crossing the green fields and country roads back to Cumbernauld.

"Can you hold it?" he inquired tentatively

I shook my head. I couldn't speak now. All my concentration was on clenching.

He sprang to action: reeling up the center aisle of the bus like a sailor in high seas as it careered around the winding roads, he made his way down to the front and talked to the driver.

I couldn't hear what they were saying but it seemed the conversation was getting a little heated. I was a little heated myself. I had been judiciously letting out teeny cautious farts to relieve the pressure, but even that now seemed too dangerous. Eventually the driver pulled onto the side of the road at the tiny village of Moodiesburn, which seemed to consist of two cottages along with a bus stop sign.

We got off, me moving very carefully like a miniature John Wayne because the pressure was excruciating. As soon as we'd cleared the door it hissed shut and the driver sped off as the mystified passengers stared back at us through the little peepholes they had wiped in their steamed-up windows. The argument had been with the driver, who didn't want to stop at all. "This's ra express. Naebdy gits aff here."

Gunka had only persuaded him by explaining there was another sort of express headed his way on a collision course charted by me, and not only was my express on board but it would be ar-

riving at any moment. This threat was sufficient to make the driver not only stop but also write a note to the driver of the next bus so that Gunka would not have to pay another fare.

Outside the rain was bucketing down and it was utterly miserable, but if Gunka was bothered by this he hid it well. He marched me over to one of the cottages and rapped on its yellow door. A frail old woman in a quilted housecoat answered and seemed only slightly alarmed to find a lanky, wet beatnik in Coke-bottle glasses standing on her doorstep with an uneasy portly midget in tow. She directed me to her bathroom, which I remember was a symphony in pink. Lots of tchotchkes and pictures and little framed needlepoint mottoes on the wall. Souvenirs from Scottish seaside towns and lace curtains. A little dolly bagpiper in a clear plastic tube. It didn't look like a bathroom, it looked like a shrine. To me, it was heaven.

After I was finished she sent us back outside to wait for the next bus in the rain. I didn't want to stay in there, anyway. I wanted to get as far away from what happened in that bathroom as I could, and the sooner the better.

I was as deeply embarrassed by the whole incident as a sensitive little boy could be, but Gunka was cool and funny about it, making up a story about the mad old lady in the house and telling me I'd made the right choice on the album (I *know* he was lying about that). He put the whole sordid incident down to adventure, and best of all he never mentioned it to my brother or sisters. They still don't know.

6

Brick House

Muirfield Primary was loathsome but at least the violence only really came from the teachers. Cumbernauld High School, which I entered at the age of twelve, was a whole new box of crabs.

Because of where my house was situated I was to attend that redbrick gulag even though all of my confederates—and I use that term with a defeated army in mind—would be attending Greenfaulds, the town's other protestant high school. There was also Our Lady's for Catholics. Only Catholics.

Sectarian lines were still drawn very strong then. The "troubles" in Ireland were raging hotter than ever, and the West of Scotland and the Northern Counties have always been very closely linked. Tensions between Catholic and Protestant factions, though not as extreme as in Derry or Belfast, were certainly there. Fertile ground for street violence among young and not so young men and women. A plump wee proddy dog like me in Our Lady's would not have lasted two weeks.

In the mid-seventies, Cumbernauld High School's student body was vast, close to three thousand pupils spanning the ages twelve to eighteen. It was only mandatory to attend school until age sixteen,

but anyone who had hopes of a university education or even of entering a decent trade had to stay on for another two years. Needless to say, the thugs and the losers left at sixteen, so if you could get through the first four years you were in clover. People said that the classes were small and the teachers less jumpy and belt-happy. I wouldn't know, I never made it that far.

I was terrified from my first day there. None of the other kids in my class had gone to Muirfield and I knew no one. It quickly got out that I was the nephew of a teacher—Gunka James to me, Mr. Ingram to them—putting me in an extremely precarious position, although I could never figure out if I was marked for extra hassle because my uncle was on the staff or whether it would have been worse if he hadn't been. A bit of both, I suppose, depending on the teacher or the pupil I was dealing with.

Of course my brother and older sister were already at the school, but that was anything but help. They had filled my head with dark imaginings about the likes of Big Jimmy—the assistant headmaster who, my siblings told me, could belt so hard sometimes kids ended up in the hospital, or their hair went white with shock. Rubbish, as it turned out. Big Jimmy did have an arm, but he was one of the decent ones.

To be fair, my sister Janice walked me to school many times in my first year, but I knew that once we were inside the gates she was no longer related to me. She was a fifth-year, and *Head Girl* for God's sake, with a metal lapel badge and some kind of vague authority bestowed from on high. She was out of my league. My brother Scott was a fourth-year who wore desert boots and listened to Zeppelin. His hair was long and he had a girlfriend with breasts. He was busy.

Neither of them could be seen with the likes of me, and I totally understood. The only time all three of us were together was when my father was on a decent shift and could drive us to school in his used, metallic-blue Vauxhall Victor. Thank God he'd moved

on from the wee red post office van; arriving at school in that would have been asking for trouble.

Gradually I got to know the thirty or so kids in my class. We wandered from lesson to lesson together and were forced to sit wherever the teacher wanted us to sit in any given class. Soon there was a pecking order established, all very incorrect by today's taste. Popularity for boys was calibrated according to perceived toughness and nothing else; for girls it was looks. The system gradually morphed into something slightly more civilized, but for the first few months that was it.

Ronnie Souter, a fast, whippetlike bright kid who smelled of digestive biscuits, would be best fighter in class; Stewart Laurie, who even the girls knew was prettier than most of them, would be second-best fighter; then came me. Early on, this was all established on bluff, no fights, and I always thought if push came to shove I could have taken Stewart, but before the end of the year Ronnie would prove I was wrong to ever think the same about him.

The faceoff began as we were sitting in science class taught by Mr. Weir, a taciturn ghoul with a lightning-fast belting style. To impress Maxine Hawthorne, the raven-haired class beauty, Ronnie Souter implied that I was a homosexual because my uncle was a math teacher. I said in no uncertain terms that Ronnie was far more likely to be gay, given that he dressed like one of the Bay City Rollers—a condition which he presumably had some control over. Maxine laughed. Ronnie blushed. The gauntlet had been thrown down.

On the way to PE, just outside the boys' gymnasium, Ronnie jumped me. He pulled my hair, forcing me to bend double, then kicked me a couple of times in the face. It didn't really hurt as much as you would think, but the shock of the attack and the anxious urgency of the viciousness startled me and left me shaking from the adrenaline rush. I suppose I could have prolonged the fight but he seemed happy to let it go at that and I was just relieved it was over.

I didn't cry, so I wasn't viewed as a public disgrace, and Ronnie's honor was preserved, so it ended there.

I was left with bruising on my face and a nasty shiner. But it was 1975. I was to get a much more significant kick in the eye that year.

The next one came from America.

7

Satori in Long Island

A man called Freddie Laker changed the course of my life. We've never met, I don't know if he's alive or dead, I wouldn't even recognize him in a photograph. I know nothing about him other than that he used to own an airline offering ridiculously cheap flights from Prestwick Airport in Scotland to JFK in New York. They were available only for a short period, but the timing of these flights was remarkably lucky for me.

In the 1970s there was a program open to first-year high school students in Scotland called the "School Cruise." Parents who paid fifty pence (about a dollar) a week throughout the year—within the meager budget of most but by no means all families—would earn their children a trip at the end of the term.

Pupils from dozens of schools all over Scotland, sailing aboard a shoddily refitted WWII-era British minesweeper (the SS *Uganda* or SS *Nevasa*), were to be ferried around various European ports for a couple of weeks in the interest of making them better citizens of the world. The whole thing was probably a scam by unscrupulous travel agents, but by 1975 it had become a tradition at Cumbernauld High and both my older siblings had been allowed to go. My sister sailed the murky North Sea to Leningrad and brought

home matrioshka dolls and Communist Party propaganda extolling the virtues of Soviet potatoes over their meager, decadent capitalist rivals. My brother went to the Canary Islands and returned with tanned skin, a postcard of a topless girl on a beach, and a comb that looked like a switchblade. The whole idea seemed impossibly glamorous to me. It was the only thing that excited me about going to high school.

When the time finally came my parents sat me down and asked if I would forgo the cruise for a trip to America instead. My father wanted to visit his brother and the nephews and nieces he'd never seen and we could take advantage of those stupidly cheap flights out of Prestwick to N.Y.C. I was thunderstruck and agreed immediately of course. The whole idea of traveling alone with my father was amazing, but to go to America with him was beyond my wildest dreams. The seventies pre-Internet world was much bigger, and to a thirteen-year-old working-class Scottish boy the notion of traveling across the Atlantic was unheard of.

I told the kids at school that instead of going on the cruise I would be going to the U.S. They didn't believe me, the very idea was too fantastic. They just thought I was another one whose parents couldn't afford the school trip.

I had to have a passport, so I went to the local post office in my scratchy, Sunday-best tweed trousers, a tight green-and-yellow cable-knit sweater, and a green silk tie, looking for all the world like a pocket-sized plump pimp with crabs. I practiced what I imagined to be my winning smile in the Photo-Me booth and sent the strip of four black-and-white pictures to the passport office in Glasgow. A few weeks later I received my giant dark-blue British passport. I felt like James Bond.

My father sent off for the airplane tickets and when they arrived I was allowed to pin mine up on the wall next to my bed. I would lie in bed at night gazing at the waxy little pamphlet by the light of a luminous plastic model of Count Dracula I had made from a

kit. It had a drawing of the world on the outside cover, red countries on a blue sea. Scotland was tiny and the U.S. was gigantic. My name was printed inside along with miles of wondrous small print about baggage restrictions and regulation quotes from sections of the Warsaw Pact. I read the ticket restrictions over and over again in the pale green glow of Nosferatu.

We left one bright clear morning. Prestwick Airport is situated in one of the more picturesque areas of Scotland, and Scotland is not short of picturesque areas. In the terminal I could hear the American accents of some of my fellow travelers—you could tell which passengers were American before they spoke. They looked so different, with their strangely white teeth crammed together with no gaps and their gum-chewing and gregarious friendly natures not fired by alcohol. My dad let me sit by the window and I watched Scotland get smaller as the big DC-10 lumbered upward. Before the old country could shrink to the size of the map on the airplane ticket cover we entered bumpy dark clouds. A moment of fear and then a bright-blue sky.

We arrived after dark and JFK smelled deliciously of beer, cigarettes, jet fuel, and sourdough pretzels. Outside it was hot and damp in a way I had only experienced on bath night at home. It was fascinating but it was also frightening. My father took my hand as we waited in line for customs. I was way past the age when I would normally have allowed this but I was tired and scared and I think he probably was, too. After a brief interrogation by a ridiculously affable, burgundy-faced Irish customs guard we were through.

The noise of New Yorkers going about their business is a hell of a shock to the uninitiated. To this day when I visit New York City it seems to me that half the people on the street are overacting for an unseen audience or they've just seen one too many musicals.

It was easy to spot my other Uncle James at the barrier among all

the anxious yelling faces since he looked just like my father, except his hair was more stylish—his dark-brown locks styled in what my gran would have called a *blowjob* haircut—and he had a *tan*.

I loved James from the moment I met him. He's the Ferguson family version of Steve McQueen, handsome and tough and doesn't take any shit from the likes of you. He drinks Dewar's on the rocks, works outdoors, wears plaid shirts and work boots, and, back then, chain-smoked Marlboro reds. He was the first of my family to emigrate to the U.S., working his way across the Atlantic on a cargo vessel and then using some creative license on his résumé to secure a job taking care of the Blydenburgh family's parklike estate on Long Island.

James Ferguson has loved only one woman his whole life, my Aunt Susan. They met when they were teenagers and are still happily married. They already had two kids when James sailed for the New World, and the moment he'd made enough money he sent for all three of them. Susan was with him at the barrier that night to welcome us. She is beautiful and confident and she immediately made me feel not too afraid to be away from my own mother. After all, Susan was made of the same stuff—another movie star. James has always said the reason their marriage has lasted so long is that he knew early on he could never do better, and he's right.

They bundled us into their car and drove us to the family home in Smithtown, Long Island. My first ride in a station wagon. Wood-effect panels, leather seats, automatic transmission—an upholstered land-boat a child could drive. I loved the term itself: *station wagon*. It sounded so American, like the *Wild West*, as if it had something to do with the railroads and avoiding hostile Indians. Thankfully we made the voyage across the borough of Queens unmolested by the local tribesmen.

James and Susan's family was almost exactly like my own. Of their four kids, Stephen and Lesley were about the same age as my older brother and sister, Karen was a few months older than

me, and young James (Jamie) was born a year before my wee sister, Lynn. We looked alike, too, except the Americans had braces on their teeth and were frecklier from seeing sunshine more than a few weeks a year. Everyone was so friendly and such fun. They all lived in a big white clapboard house on the edge of the estate where James worked as a groundskeeper/handyman. It was an idyllic scene, as if I had traveled to an alternate universe and met the new improved Technicolor version of my own family. The MacWaltons.

For three weeks I got to experience life as a suburban teenager in the U.S., and it seemed a lot more attractive to me than home. Karen and Leslie took me to their junior high school for a day, where one of their teachers put on a peculiar version of show-and-tell in my honor. To my crimson-faced, buttocks-clenching embarrassment, *I* was the show-and-tell. I will forever remember the teacher as a merry buffoon named Glenn. It almost certainly was not his name, although in all other aspects he was most assuredly a Glenn, jocky and stupid. He brought me out to the front of the class and told all the kids that I was from "Scotchland," where golf had been invented. He asked me to say something typically Scottish, so I mumbled, "It's a brawbricht moonlicht nicht thenicht."

The other kids looked confused and Glenn asked me what it meant and I translated for him.

"It's a beautiful moonlit night tonight."

I don't know why I said this, it's just a stock phrase that Scottish people use sometimes. Men, I suppose, in the company of tiddly, amorous foreign women. It even worked for me, the fleshy out-of-towner. I was immediately popular with the ladies. American women seem to be attracted to the Scottish accent for reasons I have never understood but remain grateful for.

At recess I found myself surrounded by giggling teenage girls. I told them lies about Scotland which they seemed to enjoy. I told

them lies about how I had bested Ronnie Souter in a fight and became, officially, best fighter in my class, how I was thinking of being an astronaut or Egyptologist. Even the boys were friendly. They asked me to play touch football with them and though I didn't really understand a game called football where everybody ran around throwing and catching the ball with their hands instead of kicking it with their feet, I did my best. I fit right in.

And nobody wanted a fight. Not once.

I would think about that often in the years that followed back at Cumbernauld High.

My cousins took me with them wherever they went. I went bowling for the first time, feeling like a local in my rented two-tone shoes and sucking on my giant fizzy soda. I ate hamburgers and hot dogs and french fries. I went to a McDonald's for the first time, this was of course before Micky D's march to global domination. It was certainly before there was one in Glasgow.

My dad took me to New York City.

Now that . . . that was love at first sight. I loved it then and I love it still. Even now, overloaded with sanitized bullshit Trump glass towers and condo-yuppie pseudoculture, it is still a complete mindfuck. As a Scottish schoolboy that first time, New York City was the Big Rock Candy Mountain. It was smoggy, bright-hot, filthy, and wonderful. It was Disneyland, Oz, and fucking Jupiter. It was noise and smell and lights and people looking like they were in a movie. Fat cabdrivers chewing wet cigars and talking about the exotic sport of baseball, unbelievably sexy women in outfits that Scottish girls would not have dared to wear even on a carnival float. Individuals wearing colors I had only ever seen on soccer uniforms or sectarian parades. The people themselves were different colors. Black people, brown people. (My dad once told me about a black guy who lived in Glasgow but I had never seen him.) We took the elevator to the eighty-sixth floor of the Empire State Building and looked across Manhattan. North to Harlem, east to the

river and all the airplanes landing and taking off in Queens, west
to the Hudson, and south to the colossal new World Trade Center
towers.

We took a ferry to Liberty Island and climbed to the head of the
statue. It was wicked hot inside the metal goddess—110 degrees
the raspy, sweating Fiersteinesque tour guide told us gleefully as we
trudged slowly up the iron stairs. We stood in Liberty's crown and
looked out over the harbor as the guide droned on through the heat
about the poor and unwashed masses yearning to be free.

I made a promise to myself and told my dad.

"One day I'm gonnae live in New York, Da."

He nodded and did that half-smile thing of his, but he be-
lieved me.

As the holiday progressed I bonded with my American teenage
cousins over clandestine nicotine. I had been surreptitiously smok-
ing the occasional cigarette since I was ten years old, thinking myself
quite the dangerous bastard, and though certainly there seemed to
be other kids in Scotland who shared my love for life on the edge, it
was in America that I was introduced to something a little wilder.

My cousins took me to my first-ever rock concert. Blue Oyster
Cult at the Nassau Coliseum. We were driven there in the station
wagon by James and Susan and my father, who were cool enough
to drop us off in the parking lot and go to dinner on their own, ar-
ranging to pick us up after the show.

The noise of the huge crowd was audible as we walked across the
parking lot. As soon as the adults were out of sight I produced the
gold packet of Benson & Hedges ("Benny Hedgehogs") cigarettes,
a British brand that I snuck over in my luggage. We all lit up and
walked into the arena, where the air seemed to be blue, the lights
from the support band's meager display shining through a smoky
haze. The smell was sweet and exotic and kind of frightening, like

the incense joss sticks my brother sometimes burned in our room at home when our parents were out and he was listening to Pink Floyd and trying to be all mysterious and arty.

We met up with some other kids from Karen and Leslie's school, all of us yelling the traditional abuse at the support band. As the main act arrived onstage—and I confess I had never heard of Blue Oyster Cult before that day—the crowd went wild. Then one of Karen's friends handed me a joint. I had watched some other kids smoking it, that odd sustained inhale and the holding of the breath. I was a teen and I wanted to fit in so I did exactly what I'd seen them doing. I sucked on that doobie until someone crossly snatched it from me and snapped something about Humphrey Bogart. I knew it was marijuana but I was unaware of any sensation of drugginess. I expected it to have horrifying side effects like all the antidrug horror propaganda said it would, that things would change shape and I would hallucinate angry demons and such. Perhaps I would even drop dead on the spot, but if I wanted to fit in this was a risk I had to take. Of course nothing really happened, but I did start to feel pretty good. And the band sounded great. And everybody was funny. Hilarious in fact. And I was starting to get a little hungry, then really hungry. Karen got us hot dogs and they were the best hot dogs I had ever tasted and this band was fucking BRILLIANT and this was the best night of my life and it was then that I had my satori. My kick in the eye. My sudden and profound realization. My on-the-road-to-Damascus revelation.

From this moment on I would dedicate my life to rock and roll and take as many drugs as possible.

What could possibly go wrong?

8

Running the Gauntlet

My plan to be a drug-addled American rock star by the time I was sixteen began to fade on the drive to JFK. I was very quiet in the car, I didn't trust myself to talk without crying, and I didn't want to take that chance. Just bidding my cousins farewell at the house had caused tears to well up unexpectedly and embarrassingly. I was comforted that Karen and Leslie cried too, although Steven seemed to hold it together pretty well and young Jamie genuinely didn't give a rat's ass.

On the drive, Uncle James asked me if I would ever move to America when I grew up and I gave the stock answer that any thirteen-year-old would give to a direct question.

"I don't know."

But I did. I wanted to move to New York and smoke marijuana and live in an apartment and play the guitar and make out with girls and mush their boobies together.

My dad and I didn't speak much on the flight home and we really didn't ever speak much about that vacation ever again. I can't be sure, but I think if things had been different in his own life, my

father would have liked to live in the U.S., but my mother would never have left Scotland, and my father never really spoke about things he couldn't have, he found it pointless. I understand, I'm the same way. I never go window-shopping, unless it's for windows. Strip clubs don't appeal to me for the same reason. If I was inclined to seek the company of a bunch of angry drunk women who hated me, wanted all my money, and were determined to tease me but not have sex with me, I would just open a bar in Edinburgh.

When I got back to school, things were different. Over the summer many of the boys had grown much taller and older-looking, myself apparently included, because my nickname changed to Skinny Malinky Longlegs, a delightful transformation from the hated "Tubby." A lot of the girls had changed shape too—radically—and seemed a lot more confident, sensing the power which they held over the drooling, awestruck boys.

I gained a little notoriety by being the kid who'd gone to America, and a few of the real hard tickets, guys who were known psychopaths, like Shug McGhee and Billy Thompson, sought me out and included me in their grumpy little mob. I was invited to stand behind the school gym at recess with the bad guys and wild girls and smoke cigarettes. I was happy to be there but I had to be careful not to mention America unless asked about it, lest they thought I was bragging, and for that I would be shamed. This would mean challenging anyone who insulted me to a fight or else I'd lose face, and losing face was a terrible curse. You could end up like Gordon Macfarlane, the skinny kid who was the butt of all jokes and was once spat on by Margaret Cameron, an older girl who had once gotten so drunk she had to have her stomach pumped and, rumor had it, when they were carrying her out to the ambulance Stewart Campbell saw her tits fall out of her bra.

Smoking cigarettes behind the gym was forbidden by the

school, of course, and periodically the teachers would attempt a raid on our little outdoor speakeasy. Anyone they caught would be belted viciously, but it didn't happen too often because at recess the teachers were usually huddled in the staff room, smoking their own cigarettes.

Smoking was cool and it was a way to meet the older kids and the great fighters of legend like Stevie McGhee, the aforementioned Shug's older brother, who was finally expelled for head-butting a teacher, or Gus Armitage, who once beat up three Feinians (Catholics) when they jumped him outside his girlfriend's house. Gus had supposedly just shagged her, too, though the prevailing wisdom among boys my age was that this was unlikely because the girlfriend was Catrina Royce and she was way too beautiful to permit sex.

My family didn't have much extra money to throw around, so in order to pay for my cigarette habit and to purchase the correct high-waisted trousers and garish designer jackets that were so important for a junior would-be thug on the rise, I had to find a job. I didn't have the nerve for shoplifting, and in any case thievery of that sort was considered somewhat dishonorable. I didn't have the connections to get the premium occupation available, which was working on an ice cream van, nor had I the money to buy my way into the paper-delivery business. (Established paper routes changed hands at a great price.)

I eventually found a job delivering milk. Every morning at four-thirty a big flatbed truck driven by a moonfaced dairy farmer called Bob Clyne would show up at my front door and I'd shuffle out, shivering inside my army-surplus nylon parka. The climate in Glasgow in the winter is similar to Moscow's, so you have to have protection.

The Cumbernauld area was made up of mile upon mile of tenements, high-rise blocks, and council-rented terraces with no shops or amenities in between, so milk delivery was an essential service to

a populace who used a little of it in every one of the billions of cups of tea they drank every day.

I would sit on the back of the truck with my two teenage coworkers, coughing from the black diesel exhaust and jumping off when the vehicle slowed and grabbing crates of bottled milk and fresh rolls to leave on the doorstep for the occupants to collect when they awoke. It was punishing physical work, and by eight-thirty, when I finished my rounds and headed to school, I was exhausted. It wasn't too bad on a day when there was a double French or Chemistry class, which I could nap through, but lessons with a teacher who was vigilant were tough.

The money was great, however. Not just the base pay, which wasn't bad at four quid (about eight dollars) a week, but also the tips which we could make on a Thursday night when we'd go door to door along the delivery route to collect on the weekly amount owed to Clyne's Dairies by the customer. Most blue-collar workers got paid on Thursdays, so that night was the time to collect, before other creditors, or the pub, beat you to it. I have always found that, contrary to stereotype, Scottish people are very generous, especially to individuals whose jobs seem more menial than their own—like milk boys—so some weeks I could double my basic pay with tips given by grateful, admittedly slightly tipsy, customers.

Because I was a workingman I always had a few quid in my pocket and I always had cigarettes, which is how I met Stuart Calhoun. I had heard of him, or rather I knew he existed—it was his older brother, Sandy, I had heard of. Sandy Calhoun was a legend, a celebrated warrior who drank whiskey, fought the police when he got arrested, got into real fights with real weapons, and even though he no longer went to school, the teachers feared him. They knew Sandy was just the kind of violent and unpredictable lunatic who might return to settle a score with someone who had belted him when he was younger. He graffitied his tag—"San-D"—all over town like some kind of Caledonian outlaw Trump. Sandy Calhoun

both terrified and fascinated all of us. I have no idea where he is today, my guess is he's either in jail, dead, or heading a large multinational corporation.

I was hanging out behind the gym one day when Stuart Calhoun asked me if I had an extra cigarette. Normally the stock answer would have been no, but, knowing who his big brother was and being something of a weasely politician, I handed him one of my Benny Hedgehogs and allowed him a light from my plastic Bic.

Stuart, as it turned out, was nothing like Sandy, or at least not like Sandy was reputed to be. I think Stuart was probably the first natural comedian I ever met. He had a gift for mimicry and a highly infectious sense of fun, and the girls liked him, too. Soon we became friends. We would hang around after school, playing football—the real kind, using our feet—smoking cigarettes, and talking about the violence we'd be sure to dish out if we were to be provoked by, say, Catholics guys, or English guys, or English Catholic guys. We would chat up the really pretty girls, like Dawn Harrison or Maxine Hawthorne, even though they had rumored connections to boys even more dangerous than we imagined ourselves to be. Sometimes we would just sit on a wall and spit.

There was a lot of spitting. It was the Scottish version of gum. Everybody spat. It looked kind of mean and suggested you didn't care for the bourgeois attitudes held by people less cool than yourself.

Stuart and I hung out in a little posse with some other boys. One was David Simpson—a freaky-looking kid with a giant nose who lived in a wealthy part of town and eventually married and divorced Dawn Harrison. Stuart Gillanders was another rich kid who was so blond he was almost albino and had the worst acne I have ever seen on a human. I also hung with the badder kids— Shug McGhee and Billy Thompson, personality types I would later recognize as uncannily similar to characters played by the actor Joe Pesci in Martin Scorsese films. Guys who could be your friend one

minute, then turn on you violently for no reason the next. Small evil men who had a kind of bloodlust I didn't understand. I imagine Stalin and Hitler were pricks like these, on a slightly larger scale perhaps, but with the same essential rottenness.

The rallying ground for the diminutive tyrants of my neighborhood was that ever-present fertile shiteheap of religious bigotry.

Sectarian violence was an odd little civil war where I grew up. Kids who you knew and liked could become your enemies under the right circumstances. Protestants supported the Glasgow Rangers soccer team and wore orange in allegiance to Protestant Holland, which had battled with Catholic Ireland in the late 1600s. Catholics supported the Glasgow Celtic soccer club and wore green in support of Catholic Ireland who . . . etc., etc., . . . blah, blah, . . . late 1600s. It was just an excuse for gang colors really. Morons battling from an early age over medieval religious hairsplitting that they didn't really know or care about. It's a popular pastime in many parts of the world.

There was plenty of encouragement for this hatred from shameful clergy who stoked and provoked the fires of conflict, and from striving needy politicians who used the discord for their own advancement and should have known better. One day during a routine battle with the boys from Our Lady's High School, with the usual pushing, shoving, cursing, kicking, punching, and sectarian blasphemies, I observed the gear-change from pubescent swaggering to a more mature brutality. I saw Billy Thompson pull a sword from beneath his coat, a giant fucking broadsword, not a toy or a prop. A battle weapon. As he started swinging wildly he cleared a circle around him, everyone desperate to get out of the path of the blade. Billy grabbed a Catholic guy, Paul O'Conner, who I knew a little bit. He was the paper boy for our street and he lived near me, a nice guy, I liked him. Billy threw him down and held the sharp edge to his throat.

"Don't, Billy, fucking don't, fucking don't, man!"

Everybody was yelling, our guys, their guys. Billy pushed the blade against the skin.

"Beg for yer fucking life, ya poof!" Billy screamed at Paul, who was white with shock and was crying. Some of our guys laughed. I was terrified but hid it. No one was looking at me anyway. Paul begged for his life.

"Please don't kill me, please don't kill me."

Billy looked at him, put his face close, hocked up a giant mustard-colored ball of phlegm, and spat it fiercely into Paul's face. Then he got up, put the sword back in his coat, and kicked Paul in the head as he walked away.

"Fucking Feinian prick. Did ye see him? Greetin' fur his fuckin' ma!"

We said we did and ha ha and all that shite but I never ran with these guys after that. I felt that their reaction would have been much the same had Billy killed Paul instead of leaving him relatively unharmed but humiliated on the pavement. I remember thinking then, at around fourteen years old, that if there was any God or church that endorsed and inspired this fucking madness, then I wanted no part of it.

I still feel the same.

That's why I believe in a constitution which separates church from state. I've seen what happens when they get in cahoots.

I avoided the real hard guys as much as I could after that. I stopped smoking at school in order to steer clear of them. My absence was noted, but it didn't matter much until one Saturday Stuart Calhoun and I were on our way to the center of town to look for girls. We were halfway across the footbridge that traversed the railway line near my school when a crowd of about thirty or so guys, some

of them classmates, appeared at the far end of the bridge, singing songs proclaiming their love of Glasgow Rangers Football Club and their hatred of the pope. They had been drinking beer and were on their way back from a soccer match in the center of Glasgow. They were riled up and looking for a fight.

They saw us so we couldn't run, they would have given chase and kicked our heads in if they caught us. Flight equals guilt; at least it alarms and angers animals. The only hope we had was to appear delighted at the Rangers victory while expressing our common distaste for the Vatican.

It didn't really work out that way.

When they met up with us a few guys started calling me a shitebag coward because I wasn't running with them anymore. I said I was just doing my own thing but matters got heated, especially when a few of the guys who I knew (and they knew) I could take in other circumstances were putting it over big on me because they outnumbered us.

The mob decided that because Stuart's older brother Sandy was a "good guy" (they were afraid of the crazy bastard) he'd be spared, but that I would have to "run the gauntlet."

This meant that they would form two lines of equal length facing each other, creating an aisle that I had to run down. As I ran down the gauntlet they would kick and punch the living shit out of me but if I made it to the end I would be free to go. It wasn't a great option but it was the only one I had, so I ran as they thumped and yelled and kicked. Animal instinct allowed me to push and move and at least feel the satisfaction of a few punches of my own landing but I'd seen enough gauntlets to know that there was no escape. And the idea of it all being over once you reached the end of the line

was rubbish. Violence of any kind, once it starts, is like fucking a gorilla—you ain't done till the gorilla's done.

So I got to the end of the line and jumped over the side of the bridge, dropping onto the sloped grassy embankment, my heart pumping hard. I ran toward the tracks, convinced they would chase after me. I had the tunnel vision of prey.

I heard the horn before I saw the train, it was deafening. I looked up into the eyes of the horrified driver of a giant British Rail locomotive that could not have been more than ten feet away as I leapt over the rails out of its way.

I hid in the bushes on the other side of the track until I was sure none of those fuckers was coming after me or were going to throw bottles or rocks on my head.

I was pretty banged up from the beating and the jump, but I wouldn't really feel much of that until later, when the adrenaline crashed.

Stuart was waiting for me on the bridge. Protocol demanded he watch silently as his friend was beaten up.

"If that train'd hit you you'd be fuckin' deid, man," he observed sagely.

I knew that. It spooked me how close I came to starring in my own neighborhood ghost story.

I still have dreams where I see the driver's face.

9

Eldorado

William Blake wrote that "The road of excess leads to the palace of wisdom," and I suppose for me this turned out to be sort of true, although in my case I wouldn't call it a palace, more a studio apartment. Or maybe just a cabin of understanding rather than wisdom. If I had known just how convoluted and scary the journey to my little shed of enlightenment would be, I don't think I would have embarked on it in the first place. Not that I had any idea that's what I was doing. I just wanted to live in America and be cool and have adventures.

It began with Eldorado. Not the lost city of gold. Another one.

Eldorado, affectionately known as El-D, was a cheap fortified wine favored by low-end derelicts in Scotland in the 1970s and eighties. It was imported from South Africa in a flagrant disregard of the anti-apartheid embargo. Not that many people who drank El-D really concerned themselves with the injustices of the political situation in the deep south of the Dark Continent. Anyone who drank El-D on a regular basis was dealing with a whole mountain of trouble closer to home, generally known as chronic alcoholism. El-D and its less

romantically named competitors, Four Crown and Scotsmac ("The Bam's Dram"), were dark, sherrylike wines laced with cheap rum, and they had the approximate octane rating of aviation gasoline. Buckfast, a similar rocket fuel from Buckfast Abbey in England, was another brand but kind of off limits for my clique since it was made by monks, and monks are, of course, Catholic. I myself have drunk Buckfast, though, and if Catholics have been drinking this stuff throughout history, that would certainly go a long way toward explaining the luminosity of some saintly visions.

All of these so-called wines tasted absolutely fucking terrible—like syrupy-sweet cough medicine—but no one was drinking them for their flavor or how nicely they complemented a fine Camembert. They were drunk straight from the bottle to "get the job done." The Scots are born engineers, even in matters of intoxication.

Eldorado, then, was my baptism by fire, the wretched preamble to my life as an active alcoholic. Stuart Calhoun and I were fourteen when we first observed the Friday-night tradition of drinking alcohol in the woods behind the school before heading off to the local YMCA disco—Cumbernauld's Studio 54 for the teenage fast set—and since the legal drinking age in Scotland is eighteen we obviously needed an older confederate to make the purchase for us. We wanted three cans of lager and a bottle of Woodpecker hard cider.

Enter Sandy Calhoun.

Stuart's by-then legal older brother agreed, for a small fee, to be our buyer. We met him early on Friday night, about six p.m., just enough time for us to run home from school, take a bath, put on our ridiculous seventies trousers and our plastic-and-rubber platform shoes, and head out.

We both smelled of acne cream, hair gel, and way too much Brut aftershave when we connected with Sandy outside of Templeton's, the only supermarket in a twenty-mile radius. Templeton's had a wine and spirits section, off limits to us but not to Sandy. He took

our cash and we waited outside in the gloomy drizzle. In Scotland it gets dark about four p.m. in the winter.

We waited for what seemed like an hour but was probably closer to five minutes before Sandy returned with the "kerryoot." Kerryoot is Scottish slang for, literally, "carryout" food or drink purchased in one place and then carried out to be consumed elsewhere, although it almost always means alcohol and you would be very unwelcome at most house parties if you did not arrive with a kerryoot. Our kerryoot that night was not the beer and cider we asked for. Sandy gave some flimsy story about none being available, so he got us a bottle of El-D instead and kept the change as his payment. That was the deal, essentially, though it should be noted that with the substitution of El-D his cut was substantially larger. This was Sandy Calhoun, though, what the fuck could we do? We thanked him and skulked off to the woods near the school to consume our dangerous contraband. He went off to cheat or beat someone else.

I remember standing with Stuart in that damp Mirkwood, feeling the thrill as we broke the seal on the bottle, unscrewed the cap, and smelled the treacherous brew, the dark elixir of the ring.

I remember retching as I took my first swig from the long, dark-green, glass neck. I remember holding my nose and trying to push past the awful taste in order to feel drunk for the first time. I had tasted alcohol before, sips offered by tipsy grown-ups at family gatherings, or by my dad when he was drinking beer and in a particularly genial frame of mind. This time was different, there was no restraint, no authority figure standing between me and my thirst for knowledge. I remember the excitement, and I remember feeling grown-up, and then I remember nothing at all.

Nothing.

I completely blacked out that first time. The next conscious thought I had was coming to on the couch in the living room of

my own house with a sense of dread and fear and confusion that I would later become way too familiar with.

Someone—my mother, I hoped—had removed my clothes and put blankets over me. I had peed myself during the night and the coldness of the old piss had crept up my back. I had a thumping headache, so I reached up and touched my forehead, sending a shock of pain through my system that rapidly accelerated the waking process. I got up, wrapped myself in the driest blanket I could find, and shuffled over to the little mirror above the TV. I had a giant purpling bruise on my forehead, and the mother of all black eyes. That was nothing compared with my deep sense of shame. I had never felt so lousy in my entire young life, and at that moment I swore off alcohol forever.

I learned later on that the best thing to do after waking up in such a state was to drink some alcohol as quickly as possible in order to numb the psychic and physical pain, but at that point I was still a rookie.

It was still dark outside, but light was threatening. I had no idea of the time. I thought the rest of the house must be asleep, but not my mother, who must have heard me shuffling around. She came into the room and turned on the light, which I shrank from like Gollum. I still recall the look of anger and concern as she stood there in her pink quilted dressing gown, her arms folded across her chest and her hair restrained by rollers and a net. Even if she were not my mother, I would love her forever for what she said.

"Are you okay?"

I expected dire recriminations and yelling and maybe a slap or two (and certainly I got a bit of that later), but her first concern was that I was okay.

"What happened?" I said.

"You were steamin' drunk. Mr. Elmslie brought you home."

This was very bad. Mr. Elmslie was a police sergeant who lived a few doors away from us.

"Did he arrest me?"

"No, but he could have. You punched him in the face. Right here in the house. I was a witness."

"Oh fuck!"

My mother was outraged that I had sworn in front of her, so I apologized immediately. She told me to clean myself up and get the wet blankets into the wash. Then she went off to make tea, which is what Scottish women do in moments of high drama. I imagine she served Sergeant Elmslie about four cups the night before.

I crept into the bedroom to get some clothes; my brother was, of course, awake.

"Da is gonnae fuckin' kill you when he gets home frae night shift."

I said I knew. And I did. But I was wrong, as I often was about my father.

As it turned out I had woken up at about six and my dad, who was working the night shift, wasn't due home till about seven-thirty. By that time I'd had a bath and helped my mother clean up in the living room, though the cushions from the couch, scrubbed and leaned up against the wall outside to dry, advertised my disgrace. Before Dad arrived, my older sister, Janice, filled me in on what she knew. She'd been at home with my mother when Sergeant Elmslie rang the doorbell, about nine o'clock. Janice answered to find him standing there, holding me up by my collar. I had been picked up by two beat cops who found me lying in a gutter in the Kildrum area of Cumbernauld, near the YMCA. I had vomited on my clothes and was unconscious. When the officers woke me I was abusive and attempted to be violent, but they were local tough guys and found me hilarious as opposed to dangerous. They did, however, take me to the local station and lock me up so that they could keep an eye

on me until they could find out who I was. (No one carried ID back then.) When Sergeant Elmslie came onto his shift and looked to see what he had in the cells, he recognized me and, being a good egg, decided to take me home in his car rather than put my parents and me through the official nightmare of an arrest and charge. For his kindness, Janice said, I'd taken a swing at him when we got to the house. Then I vomited a few more times before falling asleep.

Nobody knew how or why I had the black eye or the bump on the head, but later that evening, after the tea-sodden Sergeant Elmslie had left my house, Stuart and Sandy's mother had turned up to accuse me of getting her son drunk and leading him astray. Stuart, by then, was at his own house and apparently in a state much the same as mine. My mother was outraged by Mrs. Calhoun's accusation and turned on her, blaming Sandy for the whole sorry fiasco. It seems that, in my stupor, I'd ratted Sandy out to my mother as the source of the booze. The two women stood there yelling at each other on the doorstep, providing gossip and entertainment for almost the entire town for weeks to come. I was in deep shit, Janice said. She still has that special flair for the obvious.

My father arrived home a little late that morning, closer to eight. My mother had made a cooked breakfast to add to the dramatic tension, and the entire family had gathered in the kitchen. My father had been told all when he made his usual night-shift call home. The bacon and fried bread and flat sausage were eaten in terrible silence, and when Dad was finished my mother brought him his cup of tea. He dismissed everyone except me. He had never hit me before, and I figured this was the time. I still had a dreadful hangover, and the smell of food that was hanging in the kitchen was making me gag.

"You feel pretty rough, eh?"

"Yeah."

"You do that again I will chop yer fuckin' heid aff, you understand?"

"Yes, Dad. I'm sorry. I won't ever drink again," I said, and I meant it.

"I know," he said. "Okay. Go and apologize to Mr. Elmslie."

I went.

And that was it.

I thought for a few awful moments that my dad was going to forbid me to work on the milk truck in order to curtail my available funds and thus cut off any possibility of the purchase of alcohol, but he didn't. I should have known better—work is always a virtue and a sign that there is nothing fundamentally wrong. That's what we believed, and I think I still labor under that myth. So I kept my job.

Years later, when my father came to visit me in rehab, we talked about this first episode under the watchful eye of a concerned counselor. He told me I looked so bad he couldn't in all conscience add to my misery.

And so I believed my drinking career was over.

It was, for a month or two.

10

The Filth and the Fury

When I did drink again it was not El-D, and I was careful, consuming just a few beers before I went to the Y disco, and I soon began to see what the fuss was about with regard to alcohol: it was fun. If you got the right buzz on, it really could make you feel like a giant as you took that Friday-night saunter into the darkened church hall where the girls were already dancing in little circles around their handbags.

The Y disco was run by a well-meaning but pragmatic social worker called, I think, Stuart. Half the population of Scotland it seems is named Stuart, most of them men. Y-Stuart was one of those altruistic poet types that are produced by slightly upper-class family life and a liberal education. Y-Stuart actually wanted to live in areas like Cumbernauld so that he could help the local teens. He was a genuinely good man, but we considered him odd, and even libeled him heinously amongst ourselves as a predatory pederast, which he was not. He did have some strange ideas, though. Y-Stuart gave all the teenagers free rein once they got inside the hall. He didn't stop people making out or fighting, he just sort of let it happen. If things got out of hand he'd call the cops, but things never really did. We all knew that if the cops were called too often

the place would be closed down, and nobody wanted that. Y-Stuart didn't let everyone inside the hall. He would insist on smelling your breath first, figuring this was the way to detect if anybody had been drinking alcohol or partaking of the only other mood modifier available, glue. Glue sniffing was wildly popular among a small group at that time. It was still a few years before the British working classes discovered hashish, which would come in cheap and plentiful supply from Afghanistan, Pakistan, and Lebanon, and it was way before heroin arrived and took the whole fucking thing ten notches lower. In the mid-seventies, kids who wanted to get high would buy a bag of potato chips and a tube of Evo-Stick. They'd either eat the chips or throw them away, squeeze the glue into the empty chip bag, cover their mouth and nose with the bag, and inhale its contents deeply, quickly, and often. The effect was hallucinatory and was speedily followed by a strangely ethereal, giggly buzz, but with the nasty side effect of killing people every now and again. It was seen as kind of low rent, so only the real wackos did it.

However noble Y-Stuart's motives were for smelling the breath of approximately one hundred teenagers every Friday night, the result must have been foul, all that boozy or gluey breath covered over with gum or cough drops, not to mention the fact that Scottish dentistry in the seventies was borderline medieval. The guy must have destroyed his sense of smell and caught every virus going, but there he was every Friday.

"Smell your breath."

"Haaaaaaaaah."

"In you go."

The music my friends and I listened to in those days seemed incidental to dancing with or staring at girls. It was just background noise, the same tired old crap that had been around for years. Every Thursday night on the BBC's *Top of the Pops* we'd watch the usual bouffant-haired crooners in bedazzled jumpsuits singing about

Mandy or Boogaloo or Rainbows and shite like that, accompanied by session guys playing Fender Rhodes pianos. There was some good stuff, of course. Everyone loved Bowie but he seemed too strange with all his songs about aliens, and he was way too effete for us at the time. Zeppelin rocked, and The Who were adored, but they also had that long hippy hair that implied, if not homosexuality, then certainly sensitivity, which was just about as shameful. The Beatles had broken up years before, and the Stones were already consigned to the dustbin of middle age. We would listen to the music because we had nothing else, but we didn't identify with the groups. They were distant, rich, and smug bearded fuckers who belonged to our older brothers and sisters, or the younger cooler teachers. Not to us.

The music I really loved at that time was the old stuff Gunka James and my Auntie Betty had listened to when they were younger. Fifties-era rock and roll from the U.S.—Eddie Cochrane, (young) Elvis, Chuck Berry, Little Richard, Gene Vincent, and the like. My generation was in the no-man's-land between the baby boomers and generation Xers and we were practically disenfranchised from contemporary rock music.

Then came punk rock.

We'd been hearing about the Sex Pistols on the news and in the tabloids, this outrageous London band that was offending everyone with their disgusting antics. To a teenage boy this was a call to arms. Here were people I could relate to. They didn't have cars, they didn't have money, they didn't have girlfriends, and they were angry. Perfect.

The first punk rock band I ever heard was not in fact the Pistols but the Damned. I heard their double-A-side single "New Rose/Neat Neat Neat" at Craig Keaney's house after school, and even with the volume down because his dad was sick it was an astonishing and dramatic revelation. The energy and sound was like a fight. It was adrenal and thrilling. Punk had arrived and I was in.

Our parents and teachers despised punk, which made it even better. By the summer of 1977, I would leave my house in the evening to go and hang around street corners, spitting and smoking with my friends. I was forbidden by my parents to wear the painted ripped uniform that proclaimed my allegiance, so every night I went to my secret lair under the freeway bridge near my house to change in full view of old ladies riding the buses that trundled past. A lot of kids had a similar routine. Everybody had a little hideout in which to transform themselves into their punk alter ego. We called it getting "punked up." We had punk names, too: Davie Vomit, Johnny Shite, Harry Bastard. I chose Adam Eternal because my great grandfather Adam had died in the First World War and I thought the word "eternal" sounded cool.

Dressed like our nihilistic heroes from the London punk scene, we would broodily sulk at the sidelines of the Y-Disco until the DJ (Stuart again) would play a punk record, then all the girls would flee and the punky boys like me would rush the dance floor so we could do our punk dances, which were the Pogo—standing very straight with your arms glued to your sides then jumping up and down, as if heading an invisible soccer ball—or the Dead Fly— lying on your back and waving your arms and legs around as if you were a bug that had just been sprayed with some lethal toxin.

I wanted to dye my hair but it would have got me belted at school and would have made me stand out too much from the other kids, inviting a kicking. Not all of my peers had embraced the new wave of music and fashion. I read somewhere that hair could be colored on a temporary basis by using food dyes, so I went to the kitchen cupboard, where ingredients for my mother's occasional forays into baking fairy cakes or clootie dumplings (a heavy fruitcake much loved in Scotland) were kept. I didn't find any food dye but I did locate a tiny bottle of vanilla essence. Reasoning that vanilla ice cream was blond in color, I thought vanilla flavoring would probably have the same effect on hair. I shampooed it in and of course

nothing happened except that I smelled fabulous and I was followed around by every dog in the neighborhood for about a month.

Like all youth movements, we were sure that ours was striking terror into the heart of the establishment, but I think all we really did was give them a fit of the giggles. The music was sublime, though.

I had never been very interested in playing music before punk arrived, but to really be into it properly then you had to be in a band. My brother had commandeered the attic with an old drum kit he had acquired from somewhere. He had played along with albums by his favorite groups, ones that I hated, like Yes and Emerson, Lake, and Palmer. After a while he lost interest, so I seized my opportunity and kissed his ass until he let me use the kit. I taught myself rudimentary thumping beats and fills from whatever albums I could lay my hands on—British acts like the Rezillos, the Damned, the Skids, the Clash, 999, Johnny and the Self-Abusers, the Adverts, Souxsie and the Banshees, the Buzzcocks, and of course the Sex Pistols.

Suddenly there were hundreds of punk bands. The American scene was developing too, and I followed it obsessively, groups like Talking Heads, the Cramps, the Dead Kennedys, Blondie, and the incandescent Ramones. I tried to learn techniques from drummers who played with more established artists that were still considered acceptable. There wasn't much. Zeppelin was out, the Stones were out, likewise most of the giant stadium bands. Roxy Music was okay, Iggy never stopped being hip to us, and Bowie and Lou Reed skated through this era with no damage to their cred simply by being too cool to be affected.

I formed or joined a slew of different but always awful bands with memorable names such as Night Creatures, the News, Prussia (what the fuck!), and the Fast Colours. Truly woeful outfits that would rehearse in garages. They were literally garage bands, and they had the trademark of all fledging rock outfits, the one

kid crowbarred into the group despite playing a hopelessly inappropriate instrument (flute/oboe/accordion) because his father had a car and was willing to ferry our instruments to practice. You have never heard "Anarchy in the U.K." butchered until you hear it with a clarinet solo.

Sometimes we'd rent little side halls in churches until we made such a racket they closed us down, often literally pulling the plug, about ten seconds into the first song. There were no bona fide public performances, but girlfriends and buddies would come to rehearsals and help the band members smash up their instruments. We all thought you had to smash up your instruments during rehearsal; I suppose that's why many of these bands never got past that first practice. I never let anyone smash or damage the drum kit, though; sometimes I even had to fight to protect it, but I did because:

(A) It was still technically my brother's,

and

(B) I had found something to be genuinely enthusiastic about.

I loved drumming and I actually got to be pretty good at it. What I lacked in technique and precision I made up for in volume and energy, which went a long way with my fellow punkers.

Meanwhile the London scene quickly moved from punk to the shameful New Romantic period, with bands like Culture Club, Spandau Ballet, Duran Duran, and the truly ghastly Visage, but being in the provinces we were a little behind the curve and thankfully stayed pure a little longer.

It wasn't just the music, it was also the attitude. A real fuck-you to that sanctimonious, whining sixties mob with their Love and Peace and suspicious tolerance of folk music. Punk rock felt like it belonged to us, that it had no rules and no leaders. It was, in fact, pure anarchy, and I loved it. I knew at the time it was an immature adolescent fantasy, but I didn't care; I was an immature adolescent fantasist. It was ideal for me. It was the engine that drove me off the treadmill that was being constructed for me without my per-

mission—go to school, let the bastards beat you up, learn a trade, find a job, marry a wife, have some kids, acquire some bills, grow fat, become disappointed, and blame the whole fucking mess on the English or the Catholics or your wife or your kids or the government.

Punk rock put an end to all of that. Punk rock said:

"No crime if there ain't no law."

Obviously with my new weltanschauung I began to have real problems at school, but I found a solution.

I left.

The Real World

My parents were shocked and horrified by my decision to leave school at sixteen, which was the youngest age the state allowed. My older sister, Janice, and my brother, Scott, had gone on to higher education, with Scott going as far as to move out of the house—he decided he wanted to be a journalist and took a flat with a bunch of mock hippies in the unfashionable (and therefore fashionable to some students) Denniston area of Glasgow. Scott attended the University of Strathclyde during the week and brought his laundry home on the weekend. Janice, now a budding scientist, commuted to the same university from the family home every day on the don't-stop-even-if-a-kid-needs-to-crap bus that I had taken with Gunka James.

I tried to figure out over the years why my siblings handled school better than I did, but I have never really found a satisfactory answer. Obviously they kept company with the same teachers and kids and were surrounded with the same violence and threats, but somehow were able to navigate it all with much greater ease. My younger sister Lynn says it was just as hard for her as it was for me.

My mother had a theory that my loud voice made me a conspicuous target. When I was ten years old and being dreadfully perse-

cuted by a monstrous old harpy of a teacher named Mrs. White, my mother tried to give me whispering lessons so that maybe Mrs. White wouldn't notice me so much. I think perhaps the real reason is that I was a needy little cur who liked attention, and in my environment, unfortunately, if you were noticed, you got hit.

Whatever caused my misery, I couldn't take it for a moment longer than I had to by law. The day I left school I was approached by two teachers. One was a ghastly macho, closeted phys-ed guy who told me just how much of a shit I was and how much of a disaster my life was going to be. The other was my English teacher, who said I was squandering my intelligence by not remaining in school. I thanked the phys-ed guy for his wisdom and asked the English teacher if he had such a regard for my intelligence then why did he always use corporal punishment rather than appeal to it. He gave me a funny look and said, "You know the answer to that."

I didn't. Not then and not now.

I did have a love for literature that overpowered my hatred of the people who taught it, and I think because I had no respect for the teachers, their attitude didn't poison the writing that I was discovering for myself. I'm grateful for that. I've often talked to well-schooled men and women who have a disdain for the classics because they *had* to read them. I understand this. No one forced me to read *Crime and Punishment*. I read it because I chose to. I didn't write a paper on it but I did find it entertaining and thought-provoking. I was horrified by how much I could identify with Raskolnikov's whiney self-justification—clearly there was a warning here.

Raskolnikov led me to the Karamazov brothers, who were in the same part of the bookstore as Ishmael and Queequeg, who were pushed up on the shelves next to Winston Smith, Jem Finch, Joseph K, Mr. Scrooge, and Dracula. My education continued, haphazard and informal, American, European, and Russian authors all mixed together with no regard to any syllabus or any geographical or historical time frame.

I believe in education, and sometimes I wish, usually when an embarrassing gap appears in my knowledge during a conversation with someone who is well educated, that I had somehow managed to stick out my schooling and follow a path into a structured college or university course, but I didn't. Yet most of the time I now think that being an autodidact—a dilettante, I suppose—has given me just as much as it has robbed me of.

Once out of school, I had no idea what I was going to do for a living. I wanted to be a rock star, lauded and adored and worshiped, drunk, laid, gorgeous, and dead by the age of twenty-five, but that was too Byronic and romantic for a Protestant, working-class boy, so I put that idea on ice for a while and went for something similar but more in my price range. I became an apprentice electrician.

I managed to get "a real job" at Burroughs Machines, a U.S. firm with a huge factory just outside of Cumbernauld. I was to go through the four-year recognized union training to become what was then called an "Electronic Technician." I worked in various areas of the factory to learn all about the adding machines that the company built there. Digital technology had not yet arrived but I do remember talk from the brighter and more committed apprentices about the new "binary," or "digital," systems that were coming in. I wasn't interested in the future of electronics, I just wanted to make enough money and play drums and not get belted every time I pissed off a teacher.

Joining the adult world did have some interesting side effects. On the factory floor I met Bert, a small, bearded American guy who had served in Vietnam and then left the U.S. in disgust on account of the way he was treated when he returned. His angry trek through Europe eventually brought him to Scotland, where he had met a redheaded girl and stayed. Bert told me all about

acid and Vietnam and the Summer of Love and San Francisco and L.A., and although he was cynical about America you could tell he missed it.

I met Alex, a guy who had suffered polio as a kid and as a result walked with sticks and leg braces. He drove a little three-wheeled blue car that the government issued to disabled people and smoked the best hashish in Scotland. He would get some for you, too, because the cops never stopped a handicapped car.

I also met Willie.

Willie was one of those assholes that everyone who wants to get high on illegal drugs has to deal with. Willie was an electrician at the factory but he said he was really a keyboard player. The truth is, he was just a dealer. He was a chubby fellow with thinning long hair, and at the time I was sixteen, and he would have been around thirty. He liked hanging out with my friends and me, and he even became the keyboard guy for a band I was in. He would dribble his wiggly synthesizer solos over the guitars and drums.

Willie had a house, a real house that he didn't share with his parents, so every Friday night, after getting drunk on beer in the Reo Stakis Steakhouse and Pub (though never once had I even smelled, much less seen, a steak in there), we would go to Willie's house for a "band meeting," meaning we would smoke hash and listen to Willie talk shite.

What Willie really did was open up the world of drugs. He seemed to have access to everything, although he remained cagey about where it came from. Through Willie I got to try Red Leb— hashish that came in dry, burgundy-colored cubes smuggled in from Lebanon—and Paki Black, another type of hash, thick, treacly, and opiate-laden, that you crumbled into a joint and smoked with tobacco. I loved hash for a while, it made me feel goofy and fun and introspective and deep all at the same time. Hash made you the maharishi.

Then came "sulph"—amphetamine sulphate, the poor man's coke, an off-white powder that was snorted in a line. Sulph had a speedy and adrenal high which I initially loved because it let you drink as much alcohol as you liked without passing out, but coming down from it was catastrophic; it made me horrifyingly paranoid and twitchy. I only took it a dozen times or so. I have an addictive personality, I'll try anything a hundred times just to make sure I don't like it.

Acid was wild. Whenever I took an acid trip, and I suppose I have taken about twenty or thirty—all of them before the age of twenty-one—I always thought that it went on way too long. The insane giggling, the otherworldliness, the ridiculous meaningless insights. It just overstayed its welcome. Always. Anyone who has taken acid will know what I mean. It's horrible, and when you have an unpleasant experience—a bad trip—it's hellacious. The first bad trip I had with acid was the last time I took it, but that wasn't until much later, when I would be stalked by ferocious yet partially imaginary killer ducks in Kelvingrove Park, Glasgow.

There was no crack, it wasn't around yet, though there was some opium, which we smoked in a bong. And, of course, eventually—"You gotta at least try it, man"—there was heroin.

I never responded well to heroin. I tried it a few times in my life, but it made me kind of nauseous and sleepy and I wanted to eat. This pissed off my fellow users because they felt sick and didn't think it was right to order pizza when you were on the nod. I felt it was hypocritical to have rules given when we were on heroin, but I guess even junkies have their conventions. I never shot smack (thank God), just snorted the fumes from a burning line laid out on some tinfoil, a procedure known as "chasing the dragon" in the ridiculously melodramatic vernacular of opiate lovers. Even recovered junkies often refer to themselves as dope *fiends*—as if using heroin made you scarier and more "out there" than a blackout drunk. Addicts can be very competitive about their wretchedness.

Another reason I never got into heroin was because of the others who did. They all seemed so fucking self-righteously corrupt. They put me in mind of my little buddy Raskolnikov.

I probably would have gotten into more trouble with Willie and his pharmaceutical smorgasbord but I met Gillian, and not for the last time I was saved by love. The two great loves of my life.

Women and alcohol.

Love and Sex

had kissed girls before, of course. I had flirted and made out and fumbled with them. A magnificent large-breasted blousy lass called Fiona had even given me a hand job behind the power station on the way home from school one day. I had worked at a fairground during summer vacations and sometimes the girls who were on holiday would let you feel them up, but it was tough for them because, in the hypocritical custom of the time, they had to try and keep some sort of reputation for chastity, while any boy they even kissed would report and exaggerate the encounter to all the other boys, using the following lingo:

1. *just winching*—Kissing only. A boy would say this if he wished to protect the girl's reputation at the expense of his own. This was rare, but it did happen.

2. *upstairs outsidies*—Feeling breasts through the girl's sweater or coat. She'd often be unaware of the thrill she was giving, since boys often mistook elbows or purses for the real target.

3. *upstairs insidies*—Hand inside bra, or even fully unhitched bra. Unheard of in the winter months.

4. *downstairs outsidies*—Hand on vaginal area through clothes. Similar to TSA check at U.S. airports.

5. *downstairs insidies*—Getting your grubby teenage hands on a girl's bare genitals. Fingers would be sniffed to corroborate any claim made of this.

6. *shag*—Full intercourse. Any claim of which was generally viewed (correctly) as a lie.

Among my peers, the idea that any normal female would genuinely desire to have sex was dismissed as nonsense. We'd been taught from an early age that sex was shameful and bad, that men wanted it all the time because they were slaves to their appetites, and that women were good, they didn't like or want sex but would allow it in order to have babies, or because they were drunk, or English. No one actually said this out loud, it was just hinted at. I was given absolutely no sexual education at school, and there was never any "talk" from my parents, so in that area I am also an autodidact. I feel I approached my studies with a verve and enthusiasm that was unmatched in other regions of my life.

Gillian saved me from druggy Willie. She was my first real girlfriend, and she wasn't much of a drinker, but her father was an alcoholic sportswriter for the Scottish *Daily Record* so she accepted my excessive alcohol consumption in a way that she would never have tolerated drug-taking. Any drug-taking. Drink as much whiskey as you like, but don't even think of smoking a doobie. This is still not uncommon as a prejudice. I suppose in Scotland, at least, alcohol has the historical advantage.

If I wanted to be around Gillian, then, I had to forsake the drugs, and this was no problem for me because I really wanted to be around Gillian. Before I met her, all the girls I had kissed or

fooled around with were not people I was attracted to, they were just available and willing to put up with my breathy attempts at sexiness, but Gillian was different. She was beautiful. Voluptuous and charismatic like a young Loren, with deep, dark-brown eyes and dark-brown hair as shiny as the shampoo adverts on TV. She smelled a little like peaches, and there wasn't a trace of acne on her skin. I met her at a party just after I had dropped out of school and got to talking with her. I asked if I could walk her home and she said yes. She also said that she couldn't be my girlfriend because she was going on holiday the next day with her parents and she might meet someone, but I didn't care. It was a cool, light summer night and I wanted to be around her for as long as I could. I walked her back to her house—she lived in a good part of town, near the other protestant school, the one she had attended. I stood outside her front door and she kissed me hard on the mouth and I could feel her desire, not like a favor or a blessing, but like something she wanted. I was shocked and confused, but before I could attempt even upstairs outsidies she had said goodnight and had gone inside, leaving me breathless on her doorstep.

I saw my buddies on the way home. "Just winching," I told them, but they didn't give me too hard a time. Even just winchin' somebody who looked like Gillian was a triumph.

She was away three weeks. Her family had a little money and had gone to the impossibly exotic location of San Francisco for their annual vacation. I tried not to think about her making out with spectacularly toothed American boys, but it was hard. I had been there, I had seen the promised land of dentistry.

The night Gillian got back there was another party—house parties became frequent in the summer, as the more gullible liberal parents went on holiday and showed their trust by leaving their teenagers at home unsupervised.

She arrived before me that night. I had been drinking hard cider and Breaker malt liquor in the woods beforehand with some

Stuart or other, but I wasn't drunk, just a little buzzed, enough to be confident. When I got to the party somebody told me she was in the kitchen, talking to some other girls. I wandered in to say hi and almost keeled over. She had a deep golden tan which made her even more luscious. I asked her if she had a nice time.

"It wiz awright. San Francisco wiz great."

I told her about my trip to America and how I planned to return there and shamelessly hinted that she could come with me if she played her cards right. Then I got to what I had to know.

"Meet any boys?" I asked.

She smiled. She had a terrific smile.

"Naw."

Funny, but I kind of knew she wouldn't. It was San Francisco, after all; if you are a guy and you're worried about the girl you like hooking up with someone on her vacation, I suppose San Francisco is the safest bet, assuming she doesn't give her heart to a lesbian—and who among us hasn't done that?

Gillian said that she had got me a present. It was at her house but we could go and get it if I wanted.

I did.

We were inseparable for about two years. She worked as a secretary in the Inland Revenue tax-assessment center in East Kilbride, and I continued to con Burroughs Machines with my feigned interest in the emerging computer business. We watched TV in each other's houses; she came to see my crappy bands play shitty local gigs; she ruefully dealt with my growing alcohol intake; our parents met, we talked about running away to America, but she liked her job and her family and was worried that she'd lose contact with them. I don't believe she ever left Cumbernauld, although we did go on a fantastic trip to London.

We stayed with my Uncle Davie and Aunt Sylvia, who lived

in Romford. We saw Big Ben and the Houses of Parliament and did the whole touristy thing. We were in love, and during that trip Uncle Davie and Aunt Sylvia let us sleep in the same room. They assumed we had been allowed to do that in Scotland, and although that was not true, both Gillian and I kept quiet about it. We had fooled around a lot in Scotland but the trip to London was when we finally consummated our relationship. We lost our virginity to each other.

We were both seventeen and were impossibly cozy, safe, and romantic together, but by the time I was nineteen the momentum of our relationship had taken me over and I felt trapped. There was talk of an engagement, and I thought that I would be with her forever, but if it came down to Gillian versus America she would lose. One night we went to a birthday party in the Rock Garden in Glasgow.

It was a twenty-first for a friend of Gillian's from work and we were excited because the Rock Garden was a trendy bar that we'd heard about but had never been to. I'd also heard of the band that would be playing, a notorious art-school punk group once called the Bastards from Hell and now known as the Dreamboys, more in deference to the singer's adoration of H. P. Lovecraft than to any of his bandmates' dreamy looks.

Their sound was very exciting, rocky and wonderful and creepy and loud. Kind of like the Cramps but stranger. Their lead singer, Peter Capaldi, had the most commanding stage presence I had ever seen. At the end of the set he announced that this was to be the band's last show because they couldn't find a permanent drummer.

And with that, Gillian and I were doomed.

13

Dreamboy

Peter Capaldi was the first person I ever met where I was instantly aware I was in the presence of a star. Someone who was somehow *different*, with that ineffable quality of a born performer. Tall, very thin, and very handsome, fine featured with strangely pale clear skin and a shock of dyed carroty hair. Charismatic, confident, funny, and charming, he was few years older than me, which added to his glamorous air. He was dressed in black clothing that was styled to look as if he had just stepped out of a cheesy Universal science-fiction movie from the 1950s. Peter was *Technicolored*—an ambassador from Planet Showbiz.

He was wearing *eyeliner!* which shocked me and made him seem even more alien. His demeanor, though not aloof, suggested he was smarter than the rest of the world and found it vaguely amusing.

Gillian and I saw him outside the party, still sweating from the performance as the roadies were loading the band's gear into the back of a rental van. He was leaning on a parked car, talking to some excited girls who laughed at everything he said and seemed to be fighting over the right to inhale the smoke from his menthol cigarette with the gold filter.

At this point in my life I would never have instigated a conver-

sation with a man in makeup—I had never seen a man in makeup apart from posters of Bowie and Marc Bolan and I was terrified of Peter—but Gillian had been drinking, and whenever she was tipsy she got a little mouthy.

She marched up to Peter, elbowing aside his restless, tubby groupies, and told him how great his band was and how great a drummer I was and how we would be a perfect match. To my amazement, he seemed interested. He asked me if I had my own drum kit, and when I said yes he took my number.

I auditioned for the band one wintry Wednesday night in a tiny recording studio located in the basement of a derelict tenement building near Glasgow city center. The studio was terrifying; it was like the lair of a serial killer. It had low ceilings and red lightbulbs, and there was even a decrepit old dressmaker's mannequin propped in the stairwell that curved down into the dark damp cellar, where grimy, battered Marshall and Orange amplifiers had been stored by the various bands that frequented the place. The air was moist and heavy with mildew and stale from cigarette smoke. It was called the Hellfire Club—named for some fabled den of iniquity from long ago.

Since it was a weeknight, I would never have had the time to pick up my drums after work and bring them into town, but when Peter phoned me he said I could use a kit already set up at the studio.

That was a big mistake. The kit was awful—I had terrible difficulty playing it, and much to my shame I failed the test. They would rather break up the band than have me in it, or so they told me when we went to the pub for a pint after the audition. It was a shock, but I begged them for another chance because by now I knew I really wanted to hang around with these guys. They were older than me, they wore black, and they were all students at the prestigious Glasgow School of Art. These were the fuckers who had been in the record store with Gunka James all those years ago. They were different from any other people I had ever met. Sophis-

ticated and hilarious, thoughtful and cool. I was already taken with Peter, but the other two guys were equally impressive.

There was Roddy Murray—the guitarist whose first language was Gaelic. He was a native of the Isle of Lewis, off the northwest coast of Scotland, what Glaswegians dismissively call a *teuchter*. An intense, brilliant short man, he was gaining a little notoriety at the art school for his peculiar intestiney-looking abstract sculptures in sandstone and marble. And there was Temple Clarke, the bassist. I had never met anyone with such a cool name. It was his real one, too. (For a while I believed it was his punk moniker and thought it was spelled "Tempo.") Temple was from a wealthy family in Edinburgh and was movie-star handsome, with James Dean hair and the giant white slab teeth of a rich kid. He was comfortable in his own skin and it was very obvious that he'd never have to work too hard at anything.

They relented and allowed me to audition again that Friday using my own drum kit. Gillian was pissed off because we usually went out on Friday, but she let this one slide. My father drove me into town and helped me unload my drums at the Hellfire Club. He questioned the wisdom of hanging out in such an unsavory-looking area but relaxed after he met Peter and spoke to him for a few minutes. He found out that Peter was the son of the Capaldi family of Springburn, Italian immigrants famous for their ice cream business, and then it came up in the conversation that my mother had worked for Peter's father as a secretary before I was born. I had been unaware of this but it seemed like a happy little piece of kismet. My dad drove away placated, and I set up my drums in the studio.

By now I was no longer borrowing my older brother's crappy kit. I had used my earnings at the factory to purchase a real set, and, much to the dismay of the neighborhood, spent long hours practicing after work and over the weekends.

We started to play, and I was much better this time. We did

some Cramps and Iggy covers and moved on to the band's original stuff. I was rockin', I was a perfect fit. I knew it and so did they. In fact, after about an hour we took a break and went out to buy beer and whiskey to celebrate.

When rehearsal (that's what the audition had become very quickly) was over, they took me to an Indian restaurant. I had never tasted Indian food and had to be led through the menu by my amused companions, who delighted in my reactions of horror at the taste of the hot spicy dishes. I drank gallons of cold beer to cool my throat and we all decided it would be tedious and bourgeois of me to go back to Cumbernauld that night, so I slept on the floor of the large, drafty apartment in Glasgow's trendy, bohemian West End where both Temple and Roddy had rooms.

Next day, Gillian was mad; she thought I'd been with a girl. I hadn't. It was far more serious than that.

14

Art School

There seem to come times when certain towns find a rhythm and a style that defines them and fascinates outsiders. San Francisco and Liverpool in the sixties, L.A. in the seventies, Manchester and Seattle in the nineties. For a short while in the eighties, Glasgow enjoyed that kind of a groove. It was alive with creativity and expression, not just in music but also in art with painters like Steven Campbell, Adrian Wisniewski, and Peter Howson, and in film and theater with forces like Bill Forsyth, Bill Bryden, Michael Boyd, and Peter McDougall.

Glasgow theaters were performing the works of Jean Genet and Dario Fo when they were considered too outré or politically touchy for the mainstream stages elsewhere in the U.K. Local novelists like Iain Banks and Alasdair Gray were coming to prominence on a national, and later international, stage.

Glasgow's image as a violent working-class town is only true in part. It's also an extremely literate and artistic city. The only other place I've been to that seems comparable to me is Moscow, where the cold, the vodka, the misery, the literature and ballet, the depression and violence, the music, art, and humor all combine in a very familiar recipe.

Glasgow began buzzing in the early eighties, and the Dream-boys were right there in the middle of it. A plethora of new groups got noticed nationwide, and some were even breaking in the U.S.— bands that had rehearsed and recorded demos in the dark, stinky, wee Hellfire Club.

Before I joined the Dreamboys they were viewed as a weird art-school group, and before that, when they had been called the Bas-tards from Hell, were dismissed as poseurs. By the time I arrived on the scene, Peter was beginning to bloom as an artist. He was developing his own style, and I watched him, fascinated.

The figurative oils he painted on canvas at art school were florid and intricate with an odd gothic yet cartoonish menace, and this was the direction the band drifted in, too, but with a very singular twist. Peter was also a devotee of American stand-up comedy. He had albums by guys I had never heard of—Steve Martin, Richard Pryor—and Robin Williams, whom I knew only as Mork from Ork on the imported sitcom that everybody loved for ten minutes.

Peter had a strange need to have people laugh at him, so the Dreamboys were a dark, gothic, and bizarrely funny band, kind of like Peter himself.

Peter was the first person who told me that being funny was a gift, and, when done well, was an art form. Up until this point, I had learned that being funny, particularly in school, was stupid and could get you physically injured.

Peter had such a joy of performing that it was infectious, and it was he, more than any other person, who led me into stand-up comedy. He insisted that my natural boisterousness evidenced a latent talent for stand-up, and that that would be a far more healthy way of expressing myself than hitting drums, or occasionally people. During a festival of new Scottish groups at the ICA art galleries in London, he persuaded me to go up and introduce one of the bands, a real tough-guy outfit from Glasgow known as James King and the Lonewolves. I prepared a few crummy jokes and dressed up in

a kilt and tuxedo and went out to try my routine in front of three hundred drunken cockney punks. I was terrified and all I can remember is that some girls in the front were trying to look up my kilt and noticed that I was so nervous that my knees were actually shaking. They started shouting, "Iz kneez are knockin'," and the chant was picked up by the crowd.

"Iz kneez are knockin'!" they yelled in unison. I was humiliated. I gave up, yelled the name of the band, and slunk off. I don't recall ever failing so spectacularly at anything before that, except perhaps in my first brush with alcohol. I liked the idea of being a comedian—it seemed to be the fast track to the romantic failure that I suspected I would eventually become—though I was in no hurry to get on stage and try it again. I preferred the protection and anonymity that the drum kit provided, but Peter talked me into giving it another go, this time with much more satisfying results.

A favorite haunt of the Hellfire Club bands and groupies and art students was a nightclub in central Glasgow called Maestros. Every Friday and Saturday night this small, dark club was packed with art students and rockers. Local bands would play, or the occasional London group who hadn't quite made it big enough to fill the larger venues. The Maestros clientele was its own demographic. It wasn't a huge community, and over time most people got to know each other; actually, most people got to sleep with each other, but the club itself was a safe-ish place to be at night in an otherwise dangerous city.

One Christmas, Peter had the idea that he and I would perform a drag act and sing a couple of songs from the movie *White Christmas* to the assembled Maestros trendies. He came up with the stage name of Bing Hitler (I later stole this name and used it to my own nefarious ends), and I was Nico Fulton (a combination of the names of the junkie singer from the Velvet Underground and Rikki Fulton, an old Scottish vaudevillian). We wore big colorful ball gowns and delivered lames gags and patter, but the audience

was good-natured and half in the bag already. They laughed and we laughed and I liked that feeling. I didn't think there was a career in here but it was fun and you could do it drunk. These conditions were essential to any enterprise of mine at that time.

The freedom of my hip new world was exhilarating. Whereas my drinking and especially my drug taking had been deeply frowned upon in Cumbernauld, amongst my rock-and-roll compadres in Glasgow it was a thing of celebration. I was witty and brave when I was liquored up. I could tell a good story and roughhouse with other angry young men in bars, which made me popular with the arty set, most of whom were middle-class tourists amid the hard tickets that frequented even the trendier Glasgow bars. I was tough enough to be faintly cool, yet not crazy enough to be psychotic. I never sought trouble but could handle it when it turned up, most of the time, although there was no shortage of diminutive, whippet-like scrappers who could kick my arse in a bar fight. Booze, the great catalyst, made me gregarious and outgoing even though I always felt less interesting than the people I was running with. I hugely overcompensated for my sense of inferiority by being as much of a wildman as I dared. The crazy moonish rock-and-roll drummer. A buffoon. That was the role I cast myself in.

The two years I spent with the Dreamboys were my art school. I began to spend more and more time with the band and the fascinating cast of characters surrounding it. I tried to include Gillian, but she was uncomfortable around these bizarre artistic types, and that made me uncomfortable, too. Inevitably we broke up and she wisely found someone more stable.

Soon, the mighty Burroughs Machines company felt that they could embrace the coming digital revolution without the help of

a certain surly young Goth type who arrived late with a hangover most mornings. I tried to maintain some kind of work ethic but my heart was not in it and I was let go before my apprenticeship was completed, causing more shock and shame in my family. I moved into Glasgow and took a room in the same flat as Roddy and Temple. Almost immediately I started dating a punk goddess called Tricia Reid, the guitarist of an all-girl band called Sophisticated Boom Boom. Tricia was from the rough Blackhill area of Glasgow and was a fascinating mixture of competing philosophies. She'd been raised a Catholic and was very committed and knowledgeable about her faith, yet she also loved the old rock and roll and reveled in the wildness and anarchy of the clubs and gigs that we went to. Tricia was extremely well read and academic but hid that beneath two pounds of eye makeup and spiked-heel boots. A good Catholic girl, she decided when I met her that I would be her introduction to sex. I adored her even though I think I was probably a little intimidated by her obviously superior intellect, and being her boyfriend gained me greater acceptance among the in crowd. Through Tricia I met David Henderson, the legendary owner-operator of the Hellfire Club. David was about six-five, rake thin, and an engineering genius. He cajoled the two primitive four-track recorders of his studio to work harder and more efficiently than their inventors could have imagined. Thus he made a lot of bands sound much better than they actually were, the Dreamboys included.

David's sister, Jayne, also became a friend of mine, and she was even more intimidating. As tall as her brother, and with a classic eighties supermodel look, Jayne seemed to be painted from the same brush as Peter Capaldi. Vivid and alien, she was Linda Evangelista from Mars. David and Jayne had grown up in another Cumbernauld, the ugly new town of East Kilbride. Having lost their father, who died tragically young, they spent a lot of time with their mother, whom we all called, naturally, Mrs. Henderson.

Mrs. Henderson looked and sounded a little like my own mother, but she came to clubs and drank and smoked joints with us. I thought then the Hendersons may have been the coolest family on the planet. I think I still do a little bit.

I went on tour with the Dreamboys which I thought would be my first experience of the rock-and-roll lifestyle but was actually more like my job delivering milk from the back of that shitty old truck. We rode the motorways of Britain in rented transit vans, Roddy driving, as he was the only one with a license, and the rest of us trying to get comfortable on top of amplifiers or drum cases as we rattled along. We played in awful, seedy clubs, places like the Limit Club in Sheffield. It was part bar, part swamp. The carpet was so moist, you could see puddles of some strange liquid coagulate around your shoes as you walked on it. The bathrooms looked like they had been catering to a population that was afflicted by some awful strain of explosive dysentery.

We stayed in dreadfully cheap bed-and-breakfasts or boarding-houses. Sometimes we slept in the van. Once we were the support act to another Glasgow band, Altered Images, who had a chart hit at the time. Those gigs were amazing—town halls and theaters and girls coming backstage to get their breasts signed and make plaster casts and all that malarkey. On that same tour we ran into a band at Aylesbury Friars, a biggish venue in Oxfordshire, England. They were a four-piece from Ireland called U2. They seemed like nice fellows and they sounded pretty good, but we didn't keep in touch. They're probably taxi drivers and accountants by now.

Peter and Roddy and I became very close, but Temple always remained something of an outsider. He was from Edinburgh, which made him a little suspect to most Glaswegians, certainly to me, and he was always going off and having little meals or visiting junk stores and flea markets with his girlfriend. He talked about money and property and was fast becoming what would later be called a yuppie. His name was on the lease of the apartment where Roddy and I rented rooms, though, so we saw him in the communal kitchen from time to time. Peter and Roddy and I took acid or mushrooms together, got drunk and endured hangovers together. We never seemed to have any money and were always uncomfortable, dirty, and cold, and I loved it.

I still sometimes wish I were back there—eighteen, nineteen, twenty years old, the whole world in front of you, a seemingly consequence-free intake of alcohol and drugs in copious amounts, and the inevitability of megastardom just around the corner.

It was at this time I heard the first blast of the trumpet. The overture to the madness that was coming.

One night there was a science-fiction movie marathon at Mrs. Henderson's house in East Kilbride. A small group of groovily attired punky vampires and a Scottish housewife got together to watch *This Island Earth*, *Eraserhead*, and *Between Two Worlds*. To enhance our viewing pleasure we had large amounts of whiskey, beer, and amphetamine sulphate. A good time was had by all, and as the evening drifted on a little bit, Mrs. Henderson graciously offered to let us all sleep over and she would drive us back into town the following day.

When we awoke late the following afternoon, we attempted to eat breakfast—many felt fragile, me included—and then Roddy,

Peter, and myself all piled into Mrs. Henderson's small car to return to Glasgow. (Jayne and David had left earlier because there was a session booked at the Hellfire Club.)

About halfway back into town, I was looking out of the window when I suddenly felt a little dizzy. I tried to shake it off and only felt worse. Immediately I felt a wave, no a tsunami, of absolute terror flood my system. I looked at my companions, nothing seemed to be changing in their world but something very wrong was happening in mine. The terror was unbelievable and the lack of any apparent cause made it even worse. Clearly I was going mad. I began to feel as if my jaw were not connected to my face. I rubbed at it frantically, twitching and fretting and squirming in my seat. I had broken into a running flop sweat. I had to get out of that car.

My traveling companions began to notice I was behaving oddly and asked what was wrong. I said I felt sick, maybe it was the flu or something, and I just had to go home.

But I knew in my heart it wasn't the flu. I knew instinctively that there was only one way to stop the nightmare that was occurring inside of me. For the first time in my life, and I remember this as clearly as if it happened this morning, I *needed* a drink.

As soon as we got back to town, I ran to the Hurricanes bar on West Nile Street and pounded down three or four pints of lager very quickly. The sweating and shaking abated and I felt a little anxious but a lot better. In rehab, years later, I reread *Dr. Jekyll and Mr. Hyde*. I equated that moment in Mrs. Henderson's car to the awful realization Henry Jekyll has when he grasps that he no longer needs the potion to transform into the monster, Edward Hyde.

He needs the potion to remain the ordinary Henry Jekyll.

A Clever and Patient Monster

I have spoken to a lot of people in my life. I've read a lot of books, I've seen a lot of movies and plays, and I've heard a lot of opinions on a wide variety of topics, but on no topic have I encountered more uninformed random bullshit than alcoholism. To me alcoholism is a little like L.A.: everybody thinks they've been there and they know the place because they've seen *Entourage* or visited Disneyland, but only the people who have lived there for a few years really get it. Alcoholism is like this. You don't know shit about it if you drank a few too many beers in college or once blacked out or fell off a bar stool. Even people who have suffered from alcoholism for years can't comprehend it if they are still drinking, and those who have recovered from this seemingly helpless condition of mind and body seem to agree on only a few things. It is cunning. It is baffling. It is powerful, and it is patient.

People still ask me how much did I drink every day and the answer is, I don't know. I didn't keep a journal. There is no tally sheet be-

cause it wasn't fucking Weight Watchers. I drank what I had to, every day. That's how much I drank. And here's the sneaky part. It's not linear. I didn't drink every day, not until the end. I simply could never guarantee or even guess what my actions would be after only one sip of alcohol.

Understand this, if nothing else. It's not about how much you drink. It's not about the alcohol really at all. It's about what the alcohol does to the alcoholic. That's why I would never advocate temperance for those who don't need it or prohibition for those who don't want it. If I could drink like a normal person, then I would drink. Since I can't, I don't.

Here is something else that proves, to my mind, anyway, that I am an alcoholic. If I could drink alcohol like a normal person, *I would not be interested in drinking alcohol.* This is sometimes very difficult for nonalcoholics to understand. That's what makes them nonalcoholics.

Alcohol ruined me financially and morally, broke my heart and the hearts of too many others. Even though it did this to me and it almost killed me and I haven't touched a drop of it in seventeen years, sometimes I wonder if I could get away with drinking some now. I totally subscribe to the notion that alcoholism is a mental illness because thinking like that is clearly insane.

What is true is this: every decision I made from the first panicky craving in Mrs. Henderson's car, which according to my best guess would have been sometime in 1981, until the 18th of February, 1992, was the decision of an active alcoholic. I do not believe that this absolves me of any guilt or moral failure. I do not believe either that it means everything I did in those years was wrong or every emotion I had was false. It is only, perhaps, something of an explanation for my more flamboyant choices.

The shift in my alcohol intake was noticed by others. I never used to drink before a show, but now I had to have a beer or three

just to settle my nerves. There was a kind of panic that stalked me nearly all the time. As long as I was occupied by drumming or dancing or listening to very loud music or doing drugs or having sex or, of course, drinking, then I felt okay, but as soon as I was left with no money or opportunity to get out of myself, I would feel the terror creeping up. I felt that I might go completely insane at any moment. I couldn't sleep unless I was drunk, and when I did pass out I was tormented by awful dreams. Decapitations and stabbings and mutilations. One nightmare rolled around every few days. I would be walking toward Buchanan Street bus station in Glasgow on a clear day and see, in the distance, the unmistakable shape of a mushroom cloud forming in the clear blue sky. I was seeing the end of the world twice a week.

Then, for a few hours, or a even few days, it would stop. Just like that. I did sleep, I didn't drink with quite the same urgency, and I began to feel a little more human. It returned just as abruptly. I would never know when the terror would strike. In a car, on a bus, in bed. Sometimes I would wake up screaming. I knew something lived inside me that was out of my control. It could be sedated and calmed with alcohol, but one of the side effects of that particular medicine was that when I sobered up, the panic would be worse. A very vicious circle. I have been asked many times since then why I didn't seek help, but the truth is, I didn't really know what was wrong with me. I thought, "This is just who I am, a terrorized man, a lunatic, a neurotic," and thought the only way through was to try to maintain some outward semblance of normalcy or else I'd be locked up forever in a padded cell. Internally, I lived in almost constant panic.

The Dreamboys began to fall apart, which broke my heart but was inevitable. The filmmaker Bill Forsyth spotted Peter and offered

him a big role in the movie *Local Hero* with Burt Lancaster. It was a
huge break for Peter, who had always harbored the notion of being
an actor, but to shoot the movie he would have to leave town for
three months. This seemed as good a time as any to break up the
band. Peter and Roddy and I had started to hate Temple anyway
because of his sunny disposition and wealth. He really was a smug
prick. I heard he went into advertising, best place for him. His art
was bland and derivative. He was a mediocre bassist and just too
damn cheerful to be trusted. Also his teeth were creepy—too big,
like a cartoon horse.

The rest of us tried to remain friends. We even started another
band called the Guests for a little while, but Peter's heart was no
longer in it. He wanted to be in the movies, and Roddy wanted
to go back to the Western Isles to live among his own hobbit-like
island people, so it bled out pretty fast. Peter made the effort to
include me in his new world of actors and filmy types, but I was
insanely jealous of his good fortune and huffily refused to be happy
for him. I decided to feel patronized by him instead. Without band
practice I had nothing to do, so I signed on the dole and used my
unemployment check to get drunk as often as possible. One night
Tricia came to my flat and found me passed out in bed with another
woman and poured a bucket of ice water over us. She correctly sur-
mised her life would be better if she didn't squander any more af-
fection on me and moved on.

Lo and behold, I was in the first of the free-falls. Sober alkies are
often asked: "When did you hit rock bottom?" but a more informed
question might be: "How many times did you hit rock bottom?"

For the first time since leaving school I had no job, no band,
no girlfriend, and no brakes on my behavior. I still lived in the big
apartment with Temple; the Dreamboys bassist and I would arrive
back there hammered and angry at all hours of the night with all
sorts of company, sometimes even more unsavory than myself.

There was no love between Temple and me now that we were no longer bandmates, and as it was his name on the lease of the place, he had all the power.

He suggested—quite rightly, I might add—that I leave and never come back.

He did it cheerfully, of course.

16

Tripping

had made friends during the two years I was tubthumping in the Dreamboys. I had played with other bands and recorded demos and worked on a single or two as a session player. As a fixture on the alternative-rock circuit in Glasgow, I had plenty of places to crash for a few days. A couch in a communal flat, the floor of a buddy's room, sometimes in the warm bed of a friendly barmaid who should have known better. Occasionally I would slink back to Cumbernauld and mooch cash, food, and laundry services from my parents, but that didn't sit too well with me. I felt a failure when I was there, and my family's obvious concern for me made me uneasy.

My reputation as a bit of a wild drunk actually helped a little in getting work with other bands. It was true in punk rock as in other areas of showbiz that bad behavior is often rewarded instead of chastised. A dipsomaniac train-wreck drummer was just the kind of thing that some groups were looking for. I joined up with a camp, artsy outfit called On a Clear Day that was getting some attention. Their singer was a flamboyant queen, which, in Glasgow at that time, was pretty unusual, not to mention courageous.

I became great friends with the bassist Robbie McFadyen, a

rickets-thin fellow alkie who loved to party as much as I did and in fact had more of a constitution for it. He must have weighed less than 150 pounds with his coat on, but Robbie could drink anyone under the table, and on those rare occasions when he passed out before me I could easily throw the man over my shoulder and carry him home. Unfortunately for poor Robbie, he had to do this a lot more for me than I did for him, but, luckily for me, his slight physique concealed a remarkable potency.

At thirty, he was almost ten years older than I and had his life together a little more. He worked part-time waiting tables at the Spaghetti Factory, a restaurant in Glasgow's West End that was hip with illiterate gastronomes. The type of people who'd ask for a *giraffe* of red wine to go with their *spagbol*.

Robbie was hilarious and smart. He was also gayer than a parade, although when I first met him he was still pretending to be straight and professing great lust for the impossibly glamorous Jayne Henderson, the beautiful and willowy sister of the Hellfire Club's owner. Robbie sent Jayne flowers and took her out to dinner and to the movies, but it was very clear to all of us, Jayne included, that Robbie didn't want to sleep with Jayne, he wanted to *be* Jayne. Or at least play with her hair.

Robbie and I became roommates when he found a sublet that was available in a large basement flat near the art school. The place was available for a year, and the only problem was that while the owners were out of the country we'd have to look after Ken, their enormous white cat. Ken was a sonofabitch, he must have weighed forty pounds and could actually open the refrigerator door by himself. I would never have believed this had I not seen him go into the kitchen, open the fridge with his big, meaty paw, and steal a cooked chicken that Robbie's mother had sent as a care package. I yelled and tried to catch him but he grabbed the chicken and jumped on top of the cupboards, out of my reach. He stared me down defiantly as he enjoyed his lunch. He hated me, and I, in turn, loathed and

feared him. Sometimes I would wake up in my small damp bedroom and find him staring at me, a look of smug pity written on his whiskery face. I always felt Ken was judging me, and I think I was right. Ken thought I was a lazy alcoholic stoner who would never amount to anything other than babysitting cats, to whom I was an intellectual inferior, and I don't suppose I can blame him, given the evidence. My continuing distrust of cats stems from my dysfunctional relationship with Ken.

One night, while stoned out of my gourd on fine Pakistani black hashish, I was lying in bliss on the moist, plaid sitting-room couch when I heard Robbie enter the flat. He had gone out drinking after he had finished work and he tumbled into the room drunk and in the company of a mulleted, tattooed muscleman named Colin. Robbie said Colin was going to sleep on the floor in his room, would that be okay with me? I said I didn't think it had anything to do with me, and then Robbie told me he wasn't gay.

"Okay," I whispered. I was really too wrecked to carry on a conversation. Even one with so rudimentary a subtext.

"Colin's not gay either. He works on the oil rigs."

"Right-o," I smiled stupidly.

The two not-gay men went off to Robbie's room to not sleep together and to not have sex. Ken gave me a knowing look from his perch on the mantelpiece and I nodded in agreement before drifting back into my opiate-laden reverie.

In the morning, after Colin had sneaked out, Robbie told me that although nothing had happened, he thought Colin might be gay.

"Even though he works on the oil rigs?" I asked.

There was a bit of a beat. Then we both laughed and Robbie cried a little bit and he was out and that was it.

After this, the partying ratcheted up a notch because Robbie started frequenting the Glasgow gay scene and would take me along with him. Those discos were a riot, I had no idea that anyone

from Scotland could dance that well, or that enthusiastically, and for some reason there always seemed to be at least a few beautiful women in these clubs as well. At least I think they were women.

Robbie loved his new gay buddies, and I thought it was very cool and daring to be homosexual. I would have tried it but could never find a man I wanted to have sex with, they all seemed so . . . not womanly enough.

On one particularly memorable evening I even made out, after a fashion, with some dude called Stu. He had managed the Dreamboys for a while but I had no idea he was gay until he sat next to me in a notorious club Robbie had taken me to called Bennets. We were catching up, talking about the good times with the Dreamboys, when Stu suddenly planted his big scaly lips on my face and stuck his meaty tongue into my mouth. I almost shat my pants. I pushed him away and I remember how surprised he looked, although I'm sure I looked a lot more surprised. I also remember feeling physically ill at the sensation of the bristle on his chin against mine and I'm still haunted and creeped out by that. My gay male friends tell me they have felt the same about experimental physical encounters with women.

Stu told me I was a cock teaser, expecting me to be insulted. The weird thing is, I kind of was.

I got fired from On a Clear Day when the guitarist found out I was shagging his girlfriend, a thin, clever girl, Jill, who also managed the band. For a brief time she and I shacked up in a pokey apartment, and though the sex was flamboyant and athletic, she was older than me and I think she wanted something more. Intimacy, for example, and I was a long way from being capable of anything like that. She dumped me and I moved out.

Although I'd been booted from the band, Robbie and I remained close, and to help me get over the breakup with Jill he got us a few tabs of acid one Saturday night. We dropped the little pink pyramid pills in a pub about half an hour before it closed, eleven p.m. in those days. We were heading home across the gothic expanse of Kelvingrove Park just as the acid began to kick in. It was powerful stuff—I had tripped many times before and never been close to the intensity of this. The Victorian statues in the tree-lined roads followed us with their eyes, the wind in the leaves was whispering vague sinister threats, and mysterious ripples bubbled up from the myriad of dark ornamental ponds. Robbie for some reason kept turning into Adam Ant. I asked him to stop but he said he couldn't help it. Terror flashed like lightning. Then it passed, then it came back a couple of more times, then quiet again. Then it switched on and stayed on like a fluorescent light. Blinding terror. Robbie felt it, too. We started running but to our horror we found that, even going flat out, we were traveling painfully slowly. Then we heard them. A long way off at first, behind us and getting closer.

Ducks.

First one rogue quack. Then another. Closer still. One of us shouted, "Killer ducks!" We were petrified and doubled over with laughter at the same time. Very unhinged. Very bizarre.

We redoubled our efforts to escape the domain of the man-eating mallards, and just as we reached the park gates it started to pour down rain.

What fresh hell was this? I felt I would drown. I looked in panic at Robbie, which was a bad idea at the best of times, given how thin and scary-looking he was. The exertion and rain was making his eyeliner run and he appeared, for all the world, like a walking Jolly Roger. I shrieked like a wee girl and ran away from him; he tried following but I threw him off.

I stumbled, weeping uncontrollably, through rainy cobbled side streets until I found myself wandering Great Western Road, an ancient and wide thoroughfare that leads out of Glasgow to the Highlands. The rain had transformed the streets into black mirrors, which was hugely disconcerting because they reflected the green of the traffic lights, turning my whole world green.

I have never been that scared, lost in a town I know like the back of my hand, and about to asphyxiate in a color.

Then things turned from green to orange, then red, then green again, and I ran as fast as I could to God knows where.

I needed help. I was in a very bad way, so I decided I should call home. I found a phone booth and before dialing I looked at my watch. It was four a.m. I had been in this state for five hours. I listened as the phone rang and rang in my parents' house. Finally my mother picked up, her voice fuzzy with sleep.

"Hello?"

I didn't say anything. I couldn't. I covered the receiver so that she wouldn't hear me breathing and think I was some kind of weirdo, which of course I was.

"Hello?"

Silence.

"Craig, is that you?"

I hung up.

The storm had passed.

I think just hearing her voice was enough to pull me back into myself. Years later I finally admitted it had been me on the phone that night, although I suppose she always knew.

I wandered back to the flat with my head zinging and popping but not quite as bad as before. I was terribly anxious and stayed awake for about three days afterward, watching crappy television or staring at Ken. At last I finally drifted into oblivion and slept for sixteen straight hours.

I vowed never to take acid again, and I haven't, but just writing

about this experience, twenty-five years later, makes me feel uneasy and afraid, like I could fall back into it.

Something happened inside my mind that night that should not have happened. Acid gave me a clinical, unblinking look at madness, and I discovered I wasn't brave enough to be insane.

17

Anne

Given that the threatened onslaught of a thunderous LSD-induced psychosis had introduced me to a whole new level of disquiet, it seemed only logical that I increase my alcohol intake to stay calm. Even at this stage, my drinking was not recreational, it was already medicinal. Alcohol evened me out, until I drank past it, blacked out, and did something crazy, annoying, disgusting, or all of the above. It helped in my next gig, too, because after being sacked from On a Clear Day I was hired as a drummer by a group that was its artistic and philosophical opposite, James King and the Lonewolves. These were the notorious tough-guy rockers I had introduced with my naked shaky knees in front of the heckling cockneys at the ICA gallery show in London. It was arduous being in this band, even though it was by far the most successful group I'd ever played with. The music was relentless and driving, melodic but anarchic, and people actually came to see us in droves. The music press wrote loving articles about us; we even had a deal at London Records, but it was no fun.

The guys in the band reminded me of the kids I had grown up with, harsh and angry and sectarian. This was nothing like the gentle drunken bohemia of the Dreamboys. It was more like run-

ning the gauntlet. The lead singer, James King, wrote the songs and was undoubtedly some kind of rock-and-roll genius, but offstage he was so drunken, twisted, and profane he made me look like a fucking Mormon. It was embarrassing to be in his company, he'd spit and drool and mumble and cuss in front of the most attractive girls—he was way ahead of me on the alcoholic timeline. Jake, the lead guitarist, while extremely talented and prodigiously handsome in a James Dean kind of way, was always going to jail for *real* crimes, creating the need for stand-in musicians who would play along nervously for one or two gigs but never last longer than that. On numerous occasions I had to leap from the stage to break up fights that Colin, the bass player, had started with an audience member he didn't like the look of. It was like high school all over again, and even though we were playing the cool gigs like the Clarenden Ballroom, and the Rock Garden in London, and the Hacienda in Manchester, I wanted out.

The last straw was night the pope visited Glasgow. Colin and I had been drinking all day and when we left the pub he told me that every policeman in the city had been drafted to protect the Holy Father and they were all out at Hampden Stadium, where he had been saying mass. Colin suggested that we take advantage of this by stealing something and I agreed readily, but what to steal?

Pointing out a parked car, he stated that, in all likelihood, there would be some kind of swag in the backseat for us to plunder. So we approached the car and were pulling on the door handles just as a patrol car came around the corner. We were arrested quickly, without a fuss, handcuffed, and taken to the notorious Stuart Street police station. In Scotland even the jails and roads are called Stuart. They processed us, confiscated our shoes and belts, and threw us into a filthy cell with another unfortunate soul who, the turnkey assured us, had mugged an old lady and was a right little shit.

"If this prick got his fuckin' heid caved in during the night I don't think there'd be any complaints," the cop told us.

Thankfully neither Colin nor I was interested in dispensing jailhouse justice, and there was no way of knowing if the copper was telling the truth, anyway. We just sat, miserable in the windowless, urine-smelling chamber, until they let us go the following day.

I knew that if I continued hanging with these guys there'd be more jail in the future, and I was not enthusiastic at the prospect. Maybe next time I would be the prick the cop thought needed a beating and maybe my cellmates wouldn't be as apathetic as Colin and I had been.

I was scared to tell them; getting out of the Lonewolves was like getting out of the Crips—no mean feat. I waited until Jake, the one most likely to actually kill me for leaving, got sentenced to jail for another six months, and I used the band's enforced downtime as an excuse to get a job in a bar. I said I needed the money and was giving up the music business. I didn't mean it at the time, but it turned out to be true.

The Chip Bar, my escape hatch from the Lonewolves, is something of an institution in Glasgow. It is situated above, and affiliated with, a gourmet restaurant called the Ubiquitous Chip, a hippy, dippy, and pretentious, but also fantastic, restaurant which for a long time was the only place in Glasgow where you could get a decent meal that wasn't Italian, Chinese, or Indian. It still attracts an artsy, if sometimes pedantic, clientele from the local university and from the BBC station located nearby. The bar itself is known for its Furstenberg Lager on tap (thanks especially to the beer's titanic alcohol content) and for its cool, young, and good-looking staff, which I suppose I fit into enough at the time to warrant employment.

I loved working there. No one swings harder than bombed intellectuals. People in the bar business were even more forgiving of drunken behavior than those in the music business. One night I was walking to work with Robbie, who was headed to his shift at

the Spaghetti Factory. We were discussing what would happen now that the lease was up on our flat. I was a bit put out because Robbie had just announced that he no longer wanted us to be roommates. Not that there was any cooling of his affection for me he explained, but because Colin, the tattooed love monster who had burst open Robbie's closet door, was returning from the North Sea oil rigs and he and Robbie wanted to try living together. This was a considerable hassle for me, having relied heavily on Robbie's maternal instincts (he'd even fixed me up with the job at the Chip), but now it sounded as if I would actually have to do something for myself.

We rounded a corner and bumped into a cute, ever so slightly chubby, blond girl with blue eyes and a terminally hip look. Of course she knew Robbie, they said hi, and then he introduced me as his roommate. "Not for long," I told her, as he was leaving me for a man with larger muscles and more tattoos.

"And a bigger cock," added Robbie with a grin.

The cute blond girl, whose name was Anne, said that this was a remarkable coincidence since she was looking for someone to replace one of her two flatmates who was leaving to get married. I could come and see the room if I wanted.

I did want, so we made arrangements for me to see the place the next day.

After Anne had walked away I told Robbie I thought she was sexy. He said she was crazy, and anyway she had a boyfriend, and if she was going to be my landlady I had better forget about any funny business.

I nodded. He was right, of course.

The flat was on the top floor of a four-level Victorian sandstone building—you could get in shape just staggering up the stairwell. It was ideal, a small bedroom off of a large hallway, living room, and kitchen that was shared with the two other occupants, Anne—

whose father actually owned the place—and John Corrigan, a delightful and earnest hippie who put me in mind of a bearded, diminutive version of my Gunka James.

Over dark tea and sweet oranges in the kitchen I told Anne I'd like to take the place, and she agreed. We fixed a price on the rent and then got to talking about other things. Anne was and is a great talker, she's funny and interested in people. She told me about her work with a group of young Glasgow artists who called themselves "The Intolerants." They had caused something of a stir when they built a shed out of trash from Dumpsters in the main lobby of the art school. Every day at three p.m., six Intolerants would sit in it and have a tea party in dinner jackets and ball gowns. For their next project they were planning to build a man made of rubble in the Kelvingrove Art Gallery. It all sounded very appealing and cool to me.

Anne asked what I really wanted to do with my life and for some reason I told her my guilty secret. That I had been to America as a kid and wanted to go back and live there and make movies or some such ridiculous nonsense. She didn't laugh, didn't think it was ridiculous at all. She seemed almost impressed that I had such lofty ambitions. She herself was a movie *nut*, even working part-time as an usher in the Glasgow Film Theatre in order to see the obscure pieces of European and American cinema screened there.

She told me that she was a Highlander, one of that strange ancient northern breed viewed with some suspicion by my scrappy, less noble, lowland type. She was from Campbeltown, on the Mull of Kyntyre, where her family still lived, and was a former student at the Glasgow School of Art but was now seeking work as a graphic designer at the BBC. She told me she would cut my hair if I wanted. She was pretty good at it, she told me. In fact, she had given the groovy floppy haircuts to the band Orange Juice that had become all the rage amongst the indie rocker set. She told me she had friends in Manhattan, loved the Gotham art scene, and really wanted to

go and live there, which, as you can imagine, really caught my attention.

I liked her but I remembered Robbie's warning. We could be friends and nothing more.

I moved in on a Friday morning, we had a cup of tea together at lunchtime, and that night I bumped into her at Maestros. She was wearing a fifties-style yellow dress with little blue flowers on it. Her breasts looked huge. We were both pretty drunk when we got back to the apartment. In the hallway I held up my hand to wave her goodnight but she walked over to me, looked me in the eye, and then took my fingers and put them in her mouth.

"What about your boyfriend?" I said.

She kept kissing and licking my fingers like they had chocolate on them.

"I broke up with him," she said.

"When?" I said.

"Right now," she said

Six months later we were married and living in New York City.

New York

I was twenty-one when I married Anne. She was twenty-six and had been warned, by her family and mine, that I was too young and crazy to be anyone's husband. I had also been warned, by my family and hers, that I was too young and crazy to think I could be anybody's husband. Basically everyone said that it was a terrible idea and that I should not go through with it. So, as is my wont, I resolved to do just that.

We genuinely cared for each other, too, and I think we were both excited at the prospect of escape and adventure. Our families met, our friends met, and everyone accepted the inevitable. So we hired a preacher, and on October 20, 1983, we took our vows in a small suite of the cheesy downbeat Grosvenor House Hotel in Glasgow's West End. The Fergusons of Cumbernauld were all grumpy and pissed off because they felt I was being impetuous; the Hogarths of Campbeltown, Anne's family, were all gloomy and afraid because they believed she was embarking on a doomed marriage. Anne's father, Archie, was a kind, thoughtful fellow who actually said to my dad at the wedding, "Craig and Anne won't stay together, he's got other places to go in his life."

He didn't speak in an angry tone, rather with a sadness that I

understand now that I am a parent. There are some mistakes you just have to let your kids make.

The great Scottish denial system, fueled by alcohol and the national attitude of stoic bitterness, won the day, and everyone, including in-laws, punk rockers, and gays, all had a fine time and wished us well. My brother Scott was best man and Robbie was a sort of maid of honor. He was the one who pressed play on the cassette player so that Erik Satie's *Gymnopedie no. 3* could accompany Anne's walk down the ten-foot aisle between the plastic chairs. Word got around there was an open bar and most of the hotel guests and staff found their way to our reception, too. It got kind of wild. I don't remember much after the first hour or two.

We left the following day for a two-week honeymoon in Amsterdam. Anne really loved hashish and van Gogh, so she felt she would enjoy it there. The night we arrived she still had a terrible hangover from the wedding, so that night she smoked a giant reefer, putting me in a huff because I had stopped smoking hash after my acid scare and felt everyone else should, too. We fought, she went to bed, and I wandered around the red-light district, getting hammered with some sleazy German dude I met in the hotel bar. That was the first night of our honeymoon—Anne passed out, alone, in the hotel as I drunkenly ogled the hookers who display their wares in the brothel windows.

Things did pick up after that, though. We made up and spent the rest of our honeymoon getting wasted together around Amsterdam. A high point for me—in a very high two weeks—was the french onion soup served in the grand, ornate dining room of the American Hotel, in the city center. It remains one of the top-ten soups of my life.

Back in Scotland, we packed up the stuff we were taking with

us to the U.S. and put the rest in storage. Anne's father decided to sell the flat, leaving us no place to come back to should the whole thing go pear-shaped. I made a brief court appearance concerning my alleged thievery during the papal visit. The judge declared me a drunk, not a crook, and threw the case out. I was lucky.

Anne and I breathed a sigh of relief and headed off to our new lives in America. We had saved a little money from our jobs and had been given some as wedding presents, so we could get by for a month or two. We had a plan; it wasn't good, or even lawful, but it was a plan. It was pretty simple. Though we both had tourist visas, we would work illegally until we could afford an immigration lawyer, and, at least for a short time, my Uncle James and Aunt Susan had agreed to let us stay with them, so we wouldn't have to pay rent right away. By then they had moved to the Westchester County town of Rye, less than an hour by train from Manhattan.

Susan and James didn't have a lot of room in the new place, but they fixed us up with a makeshift bedroom in the garage and made us very comfortable. All their Scottish expat friends came to see the new arrivals from the old country. Whiskey was drunk and the usual tall tales were told. I rekindled my friendships with my American cousins, who adored Anne from the moment they met her. Karen and Leslie were much as I remembered them, only taller and better-looking. Stephen wasn't there. He had butted heads with his father and left to join the army, but young Jamie had grown into a long, thin dude, making a brave attempt at a mustache. He drove a silver Camaro and considered himself very urbane.

I worked with my uncle for a little while, helping out with care-taking duties around the estate he now looked after, but I was keen to get into the city. Anne and I took a train in one day to meet Jamesy Black, a guy she had known in Glasgow. He was a fellow student of hers at the art school and had married an impossibly glamorous American fashion model named Lucy. They lived on

Avenue B between Ninth and Tenth streets, which, during the early and mid-1980s, was one of the more dangerous neighborhoods in New York City.

We met Jamesy at the Odessa, that wonderful café on Avenue A. I had never been to the East Village before. I thought I'd died and gone to punk-rock heaven. There were Goths and junkies and rockers everywhere, mixed in with the scary street-life people. The whole neighborhood seemed alive with a tangible, cinematic danger. Everywhere I looked was a movie set—there really was steam rising from the sidewalks, the Checker cabs really were driving frenetically down the avenues. The noise the car horns make is unlike anywhere else on earth, as is the smell that is absolutely unique to New York City—the delicious aroma of pizza mixing with the acrid stench of urine.

In 1983, the East Village was New Yawk Fuckin' City at its fuckinest.

We sat in a booth and ordered cold borscht, which immediately rocketed into my soup top ten, right next to that french onion in Amsterdam.

Jamesy turned up late, and I liked him immediately. He was very handsome and fashionable, a real hipster. He wore a little porkpie hat and wore a lot of rings. He smoked Marlboro reds from a soft pack and somehow managed to be both funny and cool. We jawed a bit about the old country, drank some beers, and then he asked if I had any experience in construction, as he was earning money working as a carpenter. I told him that all I had ever done was deliver milk and play drums and he laughed and said that sounded about right. He said he could get me a job working on a construction site on 122nd Street. All I had to do was carry Sheetrock all day with a bunch of Jamaican guys—could I handle it? It was three hundred bucks a week, so I told him I'd be delighted.

And we were in. That simple.

I borrowed a thousand dollars from my ever-patient Uncle James for the deposit and first month's rent on a tiny apartment Anne had found. (I will never forget the look of genuine surprise on his face when I actually paid him back a few months later.)

Apartment #11, 334 East Eleventh Street, had a small living room with the freakiest green shag carpet that ever survived the seventies, a dirty little bathtub in the petite kitchen, and a small toilet off the bedroom. It must have been about 500 square feet total and cost 625 bucks a month, but it was worth it because we were on the top floor and could sit on the fire escape and look at the Empire State Building while inhaling the wondrous smells wafting up from Veniero's Italian bakery at the end of the block. Anne found a job pouring coffee in a Gramercy Park diner, and we settled into our new American lives. The first few months were magical. We worked hard—I had to leave the house at five-thirty to get to Harlem in time for work, and Anne pulled ten-hour shifts, but we were happy enough. I was too physically exhausted at the end of a workday to throw myself too much into drinking, and after a couple of beers I was out. Unloading and carrying Sheetrock all day was my first rehab.

The site in Harlem was a big renovation job on a burned-out building near Grant's Tomb. It was being run by a couple of big-timey contractors out of Jersey, Lee and Bob, and both seemed to take a liking to me. They thought the world of Jamesy, who was a competent and diligent carpenter, and so his recommendation rated highly, plus there is something about a struggling immigrant that seems to appeal to blue-collar Americans, many of whom are of course the children or grandchildren of immigrants themselves. Lee and Bob told me that if I bought a screw gun and a saw and a few other tools they could promote me to laying floors and installing the stud-and-track support beams for the Sheetrock.

I invested in the equipment and soon was earning the unbelievable sum of four hundred dollars a week, tax-free because I was illegal. Every time a city inspector in a suit turned up at the site I was convinced it was the INS and broke into a flop sweat. The last thing I wanted was to be deported. I remained convinced that my future life and happiness lay in America, and getting kicked out would make it almost impossible ever to return.

For a brief spell it seemed as if the madness of the drinking and drugging in Glasgow had finally abated. Anne and I explored and delighted in our new neighborhood. We saved some money and bought some essentials for our apartment. Jamesy introduced us to guy named Rick, who owned a vintage furniture store on Avenue A, across from the junkified no-go zone of Tompkins Square Park. Rick was a tubby English gentleman who loved fifties-style plastic chairs and would set them up outside of his store. I don't know that he ever sold anything, but people loved to congregate there and chat.

There, on the plastic chairs, I met Jamesy's strangely aloof wife, Lucy, who was a very beautiful girl but seemed always to be in a far-off place. Later, after they broke up, Jamesy explained that she used heroin to keep her weight down. I met and became great pals with a small dark-haired Jewish actor from Long Island called Roswell. Ros was fantastically funny, but deadly serious about the craft of acting. He worked with Jamesy and me during the day on the construction site, but at night he took class after class to improve his sense-memory techniques and other such actorly bullshit. I adored him.

When Dimitri Solzhenitsyn, stepson of Aleksandr, opened the trendy nightclub Save the Robots, on Avenue C, Roswell and I were hired as the doormen. I don't know why—we were hardly the scariest duo ever to hit the East Village—but it may have been because together we looked a bit like Jon Voigt and Dustin Hoffman in *Mid-*

night Cowboy. We were fired pretty quickly, first or second night, I can't remember, but we kept hanging out at the club anyway.

At Save the Robots, or on the chairs in front of Rick's store, I ran into just about everyone who was anyone in the East Village in the early eighties. People like Spacely, the legendary one-eyed smack dealer who didn't seem to comprehend that self-promotion and his chosen profession were at odds with one another, and the rapper Grandmaster Flash, who was a neighborhood icon and on the verge of becoming an international star in his role as one of the founding fathers of the emerging world of rap. I was deeply impressed with his ankle-length gold-lamé coat.

I met Jean-Michel Basquiat, another neighborhood luminary then being fêted by Warhol and the New York art world as the bold new face of neo-expressionist American painting. He seemed like another vague junkie to me, but his paintings were and are transcendental in their beauty.

Being around the heroin vibe of the neighborhood got me interested in the drug again. When I mentioned this to Jamesy he told me that heroin was bad shit, and anyway there was a much better drug that was cheaper and more fun—and best of all, it wasn't addictive.

Cocaine.

19

Adventures in the Big City

I thought coke was a wonder drug. It let you drink as much as you wanted without passing out or blacking out. If you took some in the morning it would kill your hangover and set you right for a hard day's work at a construction site. It cost sixty bucks a gram, which was expensive but didn't seem unreasonable given its magical properties. Since Jamesy had a good coke contact, I bought my supply through him regularly. Anne liked it, too, and though we were far too Presbyterian to throw ourselves into penury and debauchery over a narcotic, we made sure we had some on hand most of the time. At this time, strange as it may seem, coke helped—I can only guess that my relationship with alcohol is so bizarre that at first the introduction of cocaine alleviated the negative effects. At least that's what it felt like. It didn't stay like that, of course, but that's how it began.

I was happy for a time in New York. The energy and vitality of the city inspired me and helped me become confident, and the streets of the East Village seemed to be teeming with people who valued artistic expression and eccentricity. It felt dangerous

and welcoming at the same time. Every night at one a.m., lying in bed, I'd hear a woman sing the most beautiful operatic arias. She sounded like an angel floating between the sirens and over the tar rooftops. I later found out that she was an aspiring opera singer who worked in a local bar and on the way home at the end of her shift she would walk through the streets to her apartment singing at the top of her voice. She did it for protection, figuring that any lowlifes on the street who wanted to do her harm would think either that she was too crazy to approach or that she would attract too much attention. This delighted and impressed me. It seemed indicative of the beat of the locale—art as the best defense in a dangerous but exciting world.

Roswell, my actor/construction buddy, told me on the subway one day as we were heading uptown to work, that they were having open auditions at a local off-off Broadway theater. He knew the director and suggested I go.

"You're funny, man. And different. You'll get cast just because of that. No one else sounds like you."

"But I'm not an actor."

"Who gives a fuck? There's a million nonactors in Hollywood making movies."

I said I would go, for a laugh, but only if he would. He agreed.

On Saturday at eleven a.m. I went to a local bar on First between Ninth and Tenth streets called the Last Resort where the auditions were being held. I had passed the place, later to become the famous Coyote Ugly, many times before, since it was right next to Rosemarie's, still the best pizza parlor in New York. (Forget about all that Ray's bullshit.)

The Last Resort was a gay joint, so I hesitated for a moment, but I figured I could always bolt if I found myself in an unpleasant situation, so in I went, and knew immediately it was where I should be.

There must have been fifty or sixty stunning-looking girls sitting in rows, reading scripts. There were good-looking guys there, too, but that was no surprise—it was a gay bar. Roswell was a no-show, which pissed me off and made me feel terribly awkward, because I had never been to an audition before. I'd thought it would be like a job interview, so I had worn a suit, and the other actors eyed me suspiciously.

The auditions were being held in the back room, which doubled as a dark place for anonymous gay sex during the week and a genteel off-off Broadway theater on weekends. Woe betide you if you arrived on the wrong night, you might inadvertently have to sit through a horribly amateur performance of *Our Town* when all you wanted was a strange man's penis up your arse.

I sat up at the bar and ordered a beer from the bartender, a very camp black dude named Stanley.

"My stars! That is an adorable accent. Where are you *from*, sugar?"

"Scotland."

"Oh, I have always wanted to go there. . . . Where is it?"

Stanley was funny. He was from New Orleans and wanted to tell me *all about it*. I yakked it up with him for a while, but it seemed like the line of actors was taking forever to move, so I told him I was gonna go. He told me to hang on because he knew the director and was convinced that he would love me. He ran to the back room and came back a few minutes later, smiling triumphantly.

"You're next."

I was ushered in to meet a tall, thin, excitable creature in a purple Donny Osmond cap. He was sitting behind a small desk in the dark, smoky room, and next to him was a Peter Pan look-alike who was holding a notepad. He introduced himself as George Stephenson, the artistic director of the American Modern Dance Theater. He told me Peter Pan's name but I forget what it was. I said hi,

and George asked me if I had prepared a piece. I didn't understand what he meant.

"An audition piece. A scene from a play or a movie that you've memorized."

"No, I'm sorry. I didn't know I had to do that."

For some reason he thought this was adorable and funny, so he gave me a script and asked me to read through some lines with the Peter Pan dude, who was an aspiring actor as well as a full-time henchman. The play they were going to stage, by Lewis John Carlino, was called *Telemachus Clay*. It's the story of a midwest farm boy who travels to Hollywood and finds redemption after adventures in debauchery. I read the part of Telemachus, and the Peter Pan look-alike read the part of the manipulative Hollywood agent. I don't know how good I was, but I knew that Peter Pan was fucking awful. If this was the competition, I was in clover.

George thought so, too.

"I wanna cast you. I don't know for what, but I want you in the production."

"Great," I said. "What's the pay?"

Peter Pan snickered. George gave the earnest showbiz speech, variations of which I have heard many times since.

"There's no pay. It's off-off-Broadway and we don't have any financing, but if it's a hit—hey, who knows? Anyway, the exposure will be invaluable for your career."

I didn't see how being in a play would get me more carpentry work and said so to George.

He told me that if I wanted to be in show business, and he recommended that I should be, then people had to see what I could do. Talent agents and the like—they would all come to this production. That's why there were so many young actors waiting outside.

I told him I couldn't rehearse because I had a job.

"Don't worry about that," he said. "We rehearse weekends and

on weeknights before nine p.m. After that this room is booked for other activities."

Peter Pan gave another creepy little chuckle.

I didn't know what to do, so George gave me a copy of the play and said I should read it. He'd assemble his troupe at one p.m. the following day, Sunday, and would be really delighted if I turned up.

I said I'd think it over. I thanked him and left.

When I got there the next day I met the rest of the cast. They were an eager collection of young hopefuls, about six guys and six girls, all of us under the age of twenty-five. George told us he was going to "workshop some ideas" and "go through some exercises," whatever that meant, and from there he would make his casting choices.

He had us improvise scenes he conjured up, which always seemed to end with guys fighting each other or making out with girls. If this was what being an actor was all about, I wanted the job. Fuck the pay.

Eventually, and rather unwisely in my opinion, George chose me to play the lead, the part of the midwestern farm boy, Telemachus. I told him that I couldn't do a midwest accent and he said it didn't matter because a Scottish accent would brand me theatrically as an innocent, the main quality the part required. I didn't know whether to be insulted or grateful, but I accepted.

I went off to work at the construction site every morning at five a.m. with a breakfast bump of cocaine—by then it was like coffee to me—and I hammered and sawed until three-thirty. Then I took the subway home from Harlem, changed, grabbed a slice at Rosemarie's, and rehearsed with the theater group every night till nine. Then I would toot a few lines and drink beer until I fell asleep, around midnight. Some nights I would go uptown to see Anne, who by then was working in an Irish bar we'll just call O'Tooles,

because many of the chaps that I became friendly with there value their anonymity.

If I wanted to talk to Anne, this was my only chance, because otherwise, given our schedules, the only time we were together was in bed or for an hour or so on weekends. This wasn't as bad as it sounds because at this point we'd started arguing a great deal. Anne felt I was getting up to nonsense with the girls in the cast, and that was partially true. I wasn't actually sleeping with anyone but some of these improvised acting games were just an excuse for the cheap thrill of *frottage* and making out with someone you shouldn't be making out with.

Anne was threatened by our unavailability to each other, so in order to placate her I started going to O'Tooles every night after rehearsals. Often she would be busy serving customers. It was an Irish bar, but an upscale one on the Upper East Side, so there was food and waitress service.

Inevitably I got to talking with the other members of staff who worked there, mostly Irish immigrants from Belfast and Derry. There were two brothers we'll call Finn and Callum who ran the place, and they were an excellent font of tall tales about life and the troubles in Ireland. They were Catholic and I was Protestant but we all agreed that even though that shit carried heft in the old countries it had no place in the New World, so our relations were very cordial. We would sing each other's sectarian songs while drunk, but I don't recommend singing "The Sash My Father Wore" in an Irish bar in New York. Even if you do have the glassy-eyed permission of the owner, other patrons with less of an understanding of the New World rules may take offense.

It was rumored that a few of the boys of the IRA would drink in the bar when on fund-raising trips to America, and although I drank with many Irish expats, I was not aware of anyone who was

openly affiliated with the IRA. Still, there was an incident that was something of a clue.

One night Roswell came with me to see Anne at O'Tooles. We brought a few grams of the old Bolivian marching powder with us and she took a line or two but couldn't hang out with us, the place was too busy and she worked for tips. She put us in a back booth with Finn and Callum and a few other Irish transplants. It was one of those nights when the whiskey and coke were flowing like the fucking Mississippi, and after a spell somebody suggested we get out of the noisy shitheap full of drunken yuppies and go to a real bar. If Callum and Finn were offended they never let on, and after explaining to Anne that I was going out for a wee drink with the boys we all got in a taxi and headed over to Hell's Kitchen.

My memory is sketchy as to what bar we ended up in but a few red-faced soldiers from the Six Counties were there that night. We toasted and drank and sang together, and as we were leaving to go back to O'Tooles we saw three or four ladies of the evening standing on a street corner.

With the cheery altruism of a drunk, I decided I was going to talk these girls out of their chosen profession, much to the amusement of Roswell and the assembled Irishmen, who insisted it couldn't be done.

As I was chatting to the ladies, whom I remember as being giggly and delightful, their pimp interrupted. He was a very tall black guy who was dressed like Huggy Bear. He told me to leave his hos alone.

"Pay 'em and you can do what you like with 'em, but don't be costing me money and interrupting my business."

I told him what I thought of his business and how I felt the girls deserved a better class of employer. Things got a little heated between me and this fellow and we both knew it was gearing up

for a scrap, but before I could lay a finger on him he reached into his fur coat and brought out a shiny black handgun that seemed oddly large. He smashed me across the face with it and I fell to the ground, dazed and drunk, but through my fuzzy vision I saw him point it in my face. Then he pulled the hammer back with his thumb.

"*Well, well,*" I thought, "*this is it.*"

I don't remember being afraid, only a bit sad, although the guy with the gun looked more scared than I was. His eyes were huge and I could see spittle at the edges of his mouth. I still dream about this, and in the dream I can see down the barrel of the gun to the waiting bullet. I don't know if that is possible or it's just a little garnish added by my imagination.

I heard someone speak in an Irish accent. For legal reasons, let's say it wasn't Finn.

"*Hey, bucko. Look at me!*"

The pimp glanced at the speaker. I can't be sure of the exact words but the voice was strangely calm and sober, saying something like:

"*Look at me. You know who we are. He's with us. You know who we are. You pull the trigger and we will kill you and your mother and your father and your friends. We'll kill your girls, your kids, and your dog and we'll piss on the fuckin' bodies. Now put your popgun away before you bring the fuckin' Apocalypse on your house.*"

The pimp made the right choice for us all. He pocketed the gun and took off. By the time we were in a taxi I had the makings of a stupendous black eye, which we all agreed was a fine trophy from a terrific night out.

Setting the Tone

The work on the site in Harlem was drawing to a close by the time *Telemachus Clay* premiered. Thankfully my eye had returned to normal by then, somewhat to the regret of Stanley, the bartender, who said it made me look dangerous and sexy. Anne, though, was not a fan of the black eye, or the story, and she was getting very tired of my drinking. I don't blame her, I was getting a little tired of it myself, but what could I do? If I didn't drink I would be worse—I'd be locked up in a psych ward, or so I believed. Anne never tried to get me to stop drinking, though, she was a Highland girl. It's not like she was a stranger to whiskey and she snorted just as much coke as I did, which, in real cokehead terms, was not that much, I suppose. We were more drunks really.

Telemachus Clay is not a great play, and the American Modern Dance Theater's production did nothing to enhance its reputation. We had been rehearsing and working on our odd dancey show for months, and by the time it opened I was bored with the whole thing. The first night was fun, though. James and Susan came in from the burbs, Anne was there of course, and also Jamesy and his junkie

wife, Lucy—she had taken to talking to me a little more since she realized I was in a play. Roswell and a couple of guys from the construction site showed up. So did the painter Steven Campbell from Glasgow, who was causing quite a stir in the New York art world at the time. Anne had been friendly with him and his wife, Carol, at art school but it was a tricky social situation. Steven loathed cocaine and had absolutely no time for Jamesy, another classmate at the Glasgow School of Art, whom Steven dismissed as a worthless trendy. It was an unfair assessment, and Steven could be a pretty opinionated guy.

Afterward we all went to the funky Pyramid Club on Avenue A and watched the trannys dancing on the bar and heard a new band called They Might Be Giants, who were onstage in the back room. Everyone was very nice about my performance in the play, even if they didn't quite get why a midwestern farm boy prancing around a pretentious makeshift set meant to depict the debaucheries of Hollywood would speak with a Scottish accent. I told them it was because my character was an innocent, but they didn't seem to get it. To be honest, neither did I.

Steven and I got to talking, and I liked him. He had come to New York on a Fulbright scholarship, which he told me was a big deal for a painter. He was about to have his first solo show at a place called the Barbara Toll Gallery and asked if I would come along because it would be nice to have someone around with my kind of midwestern accent. I said I'd be delighted.

Steven called me up on the day of his opening and asked me to meet him in some bar in the Bowery. He said it was important, that he was very nervous. It was only about four-thirty and I had just gotten home from work so I jumped into a cab, still in my overalls. When I got to the bar, a fashionable yuppie hellhole, he was perched on a stool at the end of a long counter.

"I've discovered something. Try this."

He handed me a frosted glass containing a clear syrupy liquid. I sipped it. It was terrific, clear and clean, and it thumped you in the chest.

"What is it?"

"Stolichnaya. Genuine Russian vodka. The Soviets just started exporting it."

"Hey, Comrade!" I yelled to the nervous male model/bartender who had been trying to figure out if my overalls were a fashion statement or not. He walked over and smiled thinly.

"Yes?" he said.

I pointed to the Stoli bottle behind him.

"Time to redistribute the fucking wealth!"

By the time we arrived at his opening we were pretty toasted and the whole New York art scene was already there, cooing over the giant canvases that Steven had painted. He completed one a week, commuting to his studio in Bed-Sty, Brooklyn, and from his SoHo loft Monday through Friday. Each day, he took the subway and ate the sandwich his wife made for him at lunchtime. He was a very cool guy.

At the gallery we propped ourselves against a wall as he gazed unbelievingly at the sight of his triumph. We watched his wife, Carol, a very down-to-earth Scottish woman with a fantastic shock of blond hair and extravagant black horn-rimmed glasses, small-talk with the rich and the fashionable. A weird-looking old fella in a bad wig came over and told Steven his canvases were astonishing. He droned on oddly for a while, then drifted off on the arm of some pterodactyl-like woman in a silk printed dress that clung to her bones.

"That guy thinks he's Andy Warhol," I said.

"That guy *is* Andy Warhol," said Steven.

Anne and I would have dinner with Steven and Carol occasionally, but it was hard to find time, and they had just had their first child so they were kind of busy. Jamesy and I still occasionally worked together on carpentry and renovation jobs, but we didn't see much of each other. I had started working on made-to-order loft beds for customers on the Upper East Side that I had met through Finn and Callum. Jamesy had decided he was going into the motorcycle business—bikes had always been a passion for him—and he wanted to open his own store. Plus, he was also busy dealing with whatever it was he had to deal with with Lucy.

Then Roswell started getting into smack, and I had very little patience for that scene, so things got pretty quiet for a while. Then Chad Moran came to town.

Chad is mad. Genuinely and certifiably. He's smart and talented and kind and funny, he can be good fun to be around, but he's full-tilt-batshit-tonto. When I ran into him in San Francisco in 2007, after not hearing about him for many years, I was genuinely astonished to discover that he was still alive.

Chad had fronted a successful pop group from Scotland called The Tonesters, a kind of Thompson Twins–esque funky group. Think Depeche Mode, but with humor and sex. The group also had a girl backup singer called Esther Okimbo. Esther's family was originally from West Africa, but her father had had to flee due to some kind of political unrest and for some reason had chosen to raise his children in the tiny Scottish village of Auchinleck. Therefore Esther, while looking as African as anyone could, had a provincial country Scottish accent. It was an intriguing mix—Chad certainly thought so, considering he had left his wife for her. He and Esther had turned up in N.Y.C. from Scotland, keen to replicate their previous success in a bigger market.

I had never met Chad when we were both in Glasgow but I'd

heard about him. He had a reputation as an electrifying performer and an amazing front man for his band but was also known as being a dangerous and unpredictable lunatic. Not in a bad way, he wasn't violent, but he was renowned for climbing up buildings or jumping out of cars or streaking whenever the fancy took him. He also disappeared from time to time. Once, a scheduled television performance in London had to be canceled when he went AWOL, only to surface a few days later in the locked ward of a mental hospital in Aberdeen—six hundred miles away. A drunken bender, a little bit of amphetamine sulphate, and lack of sleep had launched him into a temporary psychosis and he had been captured by the police as he "shot" imaginary monsters with a pretend gun in Aberdeen's railway station, much to the alarm of respectable commuters. I could relate to Chad. I had been that nutty from time to time. I would have shot the killer ducks of Kelvingrove Park if I had been smart enough to hallucinate a weapon.

His band had done well, sold some records and filled some biggish theaters, but eventually the record company grew tired of Chad's antics. That kind of behavior is applauded only if you are making really big money for these bastards.

He knew Anne from Glasgow and we met up with him and Esther in a bar on Sixth Street just after they came to town. Chad had just discovered Captain Morgan's Old Jamaican Spiced Rum and was drinking a large bottle of it by the neck. The bar staff looked on apprehensively but were prudent enough not to interfere.

Chad explained to me that this rum tasted so good to him that he suspected that he *had been* Captain Morgan in a previous life—his last name was Moran, after all—and proposed that we drink the stuff until we fell down and talked like pirates all day. It sounded like a decent plan to me, so that's just what we did.

Chad was fearless in his pursuit of a good time and I found it infectious, spellbinding even. I wanted to be around him. He made

me look like the sensible one. I only realized some years later that Chad was not crazier than me, just a few stops ahead of me on a train going nowhere.

We were inseparable for a while, Chad and I, drinking and carousing all over town. I became the drummer in his new band, also called The Tonesters, and although we never played a single gig or even rehearsed or were even alone in a room with musical instruments we had a few meetings at record company offices in Manhattan on the strength of Chad's U.K. reputation. My other friends couldn't stand him. Steven the artist had no time for that kind of nonsense, he was too serious and dour. Jamesy thought he was just another New York morality tale that was waiting for a bad end, and Roswell found him more frightening than the IRA guys from uptown.

Anne was not a big fan, either, even though for some reason that I have never been able to fathom, women loved Chad. He was rock-and-roll Rasputin, the mad sexy monk. Maybe it was because we were insane and drunk and funny and had accents, I'm not sure exactly what, but whenever I hung out with Chad, we were surrounded by girls looking for a party. They got one, too.

It wasn't my friendship with Chad that ended my marriage to Anne—I did that with my behavior—but running around New York with him surely accelerated the process. At three o'clock one morning, after drinking and snorting coke in my Eleventh Street apartment, Chad and I decided to find out which one of us was the better fighter. So we left the apartment and jumped the chain-link fence into the yard of the elementary school that faced our building. Anne and Esther watched from the fire escape as Chad and I proceeded to good-naturedly knock the shit out of each other, eventually declaring a draw when we were both sufficiently bloodied.

When I got back to the apartment I was exhausted but not as exhausted as Anne. She had had enough, and not just of our

schoolyard brawl. She wanted to move back to Glasgow, where she thought we stood a chance of being a normal couple leading a conventional married life.

I realized she was right, that it would be the smart thing to do. Things did seem to be spiraling dangerously out of control in New York. My tourist visa had run out ages ago, and it would only take one arrest to have me deported and never allowed to return, and anyone with half a brain could see—even I could see—that an arrest was definitely in my immediate future. So after just over a year in the East Village, Anne and I gave away our stuff, said goodbye to our friends, and headed back to the old country.

Like many people who come to New York to live and then have to leave before they really want to, I spent the next three or four years with the vague feeling that there was a great party going on somewhere and I was not at it.

The Gong Show

Anne and I agreed that returning to Glasgow was going to save our relationship, but we were mistaken. The move actually ramped up our problems and, if anything, hastened the demise of the marriage, although I am not quite sure that, given my selfishness at the time, it could be called a marriage in any but the technical sense.

At the Chip Bar, I not only got my job back, I actually got a promotion. They made me "chargehand," meaning that, in addition to bartending, I had to supervise the other staff members and balance the cash register at the end of the night. Strangely, having to work hard in the presence of so much booze was not a challenge for me. I liked being the boss, and because the bar was always so noisy and crowded I rarely had time to stop and have a drink myself. It wasn't something you could do drunk, anyway, it was just too focused. Although, of course, I did have some beers when I was working, figuring if it looked like I was having a good time then the clientele would, too.

I approached the job as something of a performance, laughing and joking with the customers and trying to create a welcoming and comfortable environment for folks who came there to forget

about their own bullshit for a little while. Bartending taught me more about being a stand-up comic than anything else.

I worked long hours, sixty or seventy a week, and Anne and I only occasionally bumped into each other in the dingy single room we had rented from a bitter divorced landlady who lived in the same building with her large collection of incontinent and surly cats.

Anne had found work at the BBC as a graphic designer—the position she had always wanted—and was happy to be among her old art-school friends. We were living separate lives—when I finished work, I wouldn't go home. I'd stay in the bar, getting drunk with the staff from the restaurant downstairs. Inevitably this routine led to infidelity, and infidelity led me to drink more to drown my guilt. So the only time I was sober was when I was actually working.

The work was my escape. Certainly I felt it was all I had. In my unhappiness with my life and myself there had to be one thing I was good at. Working hard was my only shot at self-respect.

The folks who owned the bar seemed to appreciate my efforts. They even sent me to a local college to learn about wines so I could discuss them knowledgeably with the more pretentious—and wealthy—patrons. Each Friday my day began at a tasting class. The problem is, of course, that when you've got an alcoholic in your wine-tasting class, it can be a challenge to persuade him to spit out the sample after he has been swooshing it around his mouth. My whole being rejected such a barbaric ritual, so I was hammered on fabulous, expensive plonk by eleven a.m. every Friday. But somehow I passed the course. To this day, the only academic credential which I have ever achieved is the completion of a basic wine-tasting course certified by the Wine and Spirit Education Trust of Scotland. Ah the irony. The framed certificate hangs in the Chip, and I go and look at it whenever I'm in Glasgow.

There's also a copy hanging in the green room of my TV show.

Given its proximity to the BBC, the Chip was a favorite haunt of actors and creative types who worked there. These people in turn brought in other actors and creative types from the theater and film world. It was a very showbizzy crowd, and that's the reason Michael Boyd, the new artistic director at the Tron Theatre in Glasgow, happened to be there one night. Michael was already making a name for himself as something of a maverick—he's now the direc-tor of the Royal Shakespeare Company—with his unconventional and daring approach. He eschewed the lumpy, formal style of elitist theater and encouraged the energy and vitality of performance that he felt existed in the spirit of Scottish variety performers. Basically he was a closet vaudevillian with a sparkling, innovative mind and was transforming the Tron into a very popular location, a hot spot for what passed as the glitterati in Glasgow, even though it was in the decidedly untrendy and downright dangerous East End.

Michael watched me work the bar for a while and eventually asked me if I had ever been a performer. I told him about *Telema-chus Clay*, which made him giggle, and I also confessed that in New York I had attempted an open-mike spot at the Comic Strip comedy club but had met with limited, or indeed disastrous, results. The audience of drunken mafiosi didn't understand my accent but hated me anyway.

Michael was interested in my story and told me about an idea he had. There was a large public bar at the Tron Theatre with a raised platform at one end that Michael wanted to turn into a stage every Friday night where amateurs could try their luck in a "gong show." After observing my antics behind the bar and learning of my inter-est in the performing arts, he thought I should do it.

I said I'd think about it.

I snuck in to the first gong show and stood at the back. The room was smoky and packed with a large, hostile, drunken crowd

who delighted in yelling instructions to the gong master, Harry Lennon, who was also the good-natured stage manager of the theater. Harry seemed very reluctant at first in his role as allegorical executioner but soon grew power-crazed with the beater in his hand as act after act came onstage. Housewives with pithy wee morality tales—these days they'd be blogging—were gonged immediately. Singing children fared a little better, until they got too sweet, then the mob would bray "GONG!" until Harry had no choice. One juggler lasted all of six seconds, while a mime who came on fully made up with a stripy shirt and beret was gonged before he even got a chance to move, never mind walk into the wind or pull an invisible rope. He didn't take it well and, breaking the sacred code of his order, yelled, "You're all a bunch o' fucking shites!" at the crowd, which laughed uproariously.

It was an absolute bear pit, where success for a performer was all but impossible. It was also hysterical.

I had to try it at least once.

It took a few weeks for me to come up with an act. I decided I would do a parody of all the uber-patriotic native folksingers who seemed to infect every public performance in Scotland and appeared on local television every New Year in the annual orgy of maudlin, folksy sentimentality that the Scots call Hogmanay. Though everyone I knew thought these guys were annoying as hell, I had never seen anyone publicly go after them. Perhaps it would be seen as treasonous to attack anything homegrown, but I was willing to risk it, so I wrote a little song about how sexually attractive sheep are and prepared a little spiel. I put together a costume made of my wedding suit, which had been shrunk beyond recognition by an incompetent dry cleaner, and a hideous green sweater I had been given as a present one Christmas by a relative who must have hated me. I also wore a pair of ill-fitting glasses with broken black frames

held together by a Band-Aid, and to complete the look a pair of plastic zip-up Chelsea boots, pants tucked inside.

I needed a name for my character, something that might get an immediate laugh so that I wouldn't be gonged off the second I spoke. I remembered Bing Hitler, the name Peter Capaldi had come up with for our little drag act. Peter had by then become a well-respected working actor and I figured he wouldn't be using it again, so I stole it. I could easily have called him for permission, but that's not who I was then.

Not telling anyone what I was up to, not even Anne, I finished work early one night, drank a few beers, and headed to the theater. In my outfit I waited backstage until the real folksinger ahead of me had been gonged off, and then Harry called "Next!" and out I went.

They laughed at my look, an encouraging sign, but then it fell silent. I walked to the microphone. In the most ridiculous provincial Scottish accent I could muster, I bellowed:

"My name is Bing Hitler."

"Gong!" shouted a female voice from the back of the room.

"Thank you, Mother," I shot back.

The crowd laughed again. I'll never forget the power behind that sound. I knew immediately they were with me. I pressed on with my little spiel about how Scotland was great and everywhere else was not, pursuing my point to ludicrous degrees. Why Scottish insects were better than English insects, which were effete dandies. Why the world was lucky there were only five million Scots, because if there were more we'd make everybody eat fucking haggis, which was more tasty than anything those so-called French or Italian bastards had to offer. Why being Scottish was better than having an orgasm, or sex, which never happened for Bing at the same time. For a finale I sang my fake folk tune, which I called "The Sheep Song":

Many years ago,
Oor sheep ganged free,
Roamin throo the glens in groups,
Of two or three.
Fear they did not know-ee-o,
their fleece was white as snow-ee-o,
And it didn't tak verra long-ee-ong,
For their little ones to grow-ee-o. . . .

It wasn't much, but it represented just the kind of inane garbage that most of us Scots had been force-fed from as far back as we could remember. The audience loved it. When I was finished they shouted for more but I had no more, and told them so. They thought that was a joke. Eventually, not knowing what to do I turned to Harry and yelled, "Gong!" He gonged me off, but they were still cheering when I got backstage.

There was a fifty-quid prize for winning, but the audience, quite rightly, gave it to the guy after me, an octogenarian in a tweed cap who played a blistering "Ghost Riders in the Sky" on the harmonica. I, however, took away a couple of bigger prizes.

(1) When I was onstage, I had seen the theater director Michael Boyd standing at the bar, laughing his ass off; and

(2) finally I had discovered what I wanted to do.

The Rise of (Bing) Hitler

Bing was not an instant hit. I had no material to speak of beyond a few lines of shtick and "The Sheep Song." I booked a few gigs in local bars but I would die onstage after a few minutes because I hadn't enough material, and I wasn't yet experienced or confident enough to riff. I had a woeful appearance at the Cul De Sac bar right next door to the Chip, where I still worked full time as bartender.

The place was jammed to the gills with people I knew who had heard about my triumph at the gong show. I choked, I panicked at the awkward silence, clammed up, got sweaty, and even forgot the words to my comedy song. This resulted in the first review I ever received. It ran in an underground magazine, and though I can't recall its name, I'll never forget the headline: "Bing Stinks." You get the gist.

For some reason a bad gig didn't bother me that much. I actually enjoyed the failure in some perverse way, and sometimes through drunken misjudgment of what people would find funny, I actively encouraged it. In one show at the Carnegie Hall in Dunfermline, on Scotland's east coast (nowhere near as prestigious as its New York namesake), I lambasted the locals simply for being east-coasters. I

told them that where I was from, on Scotland's more civilized west coast, east coast men were considered idiots and sheepshaggers, but I told them that I empathized. It was their only option, given that the women of the area were so fucking ugly.

This kind of comment will rarely endear you to an audience, and this one rushed the stage, grabbed my guitar, and smashed it up in front of me. I bolted out the back door and into a waiting taxi that the theater manager had ordered to take me to the local train station. As we sped away with an angry mob in pursuit someone threw a large rock that shattered the back window and showered me with broken glass. I was pretty drunk and a little alarmed, but I loved this. In an odd way I thought it was romantic. But I guess any attention is good attention for a nutcase. I gave the cabdriver the fee I got for the gig (always get the money up front) to cover the repairs.

Michael Boyd persuaded me to do another gong show, and I survived it but felt that was enough, to do any more would be pressing my luck. Around this time, something of an alternative music-hall circuit was springing up around Glasgow and Edinburgh. There always seemed to be benefit shows going on for miners' families crushed under Margaret Thatcher, or to free Nelson Mandela (the caving of the racist right-wing South African government later was of course due to the pressure exerted from obscure Scottish entertainers). I wrote more material and started to play these shows, usually wedged into the bill between the lesbian a cappella folk group and the performance poet. There were very few stand-ups around—actually, I'm the only one that I can recall—but there were plenty of comedy acts.

One, called Victor and Barry, was a comedy duo who wore dressing gowns and sang campy and amusing ditties about genteel Scottishness. I wasn't crazy about them (I was probably jealous)

but most people ate it up. Victor and Barry were played by two young actors getting started in their careers—Forbes Masson, now a very successful and respected actor in Scotland, and Alan Cumming, who you may know as one of the leading ladies of Broadway. Even my sister Lynn was part of a comic double act. After attending the Royal Scottish Academy of Music and Drama, she and a fellow student formed the Alexander Sisters, a hilarious send-up of desperate middle-class Scottish matrons.

Meanwhile the comedy circuit in London was in full swing, and unlike Glasgow or Edinburgh it was producing brilliant stand-ups like Rik Mayall, Eddie Izzard, and Alexei Sayle. I told myself it was almost cooler to be in comedy than in music, but while London was teeming with comedy clubs, Scotland had none. Most of my performances were openers for rock bands, or occurred in nightclubs, where they would expect me to entertain drunken hipsters who were instantly pissed that the music had been turned off for me. In these situations the heckling started before I even made it to the microphone, which forced me to develop a particularly aggressive style. Sometimes I won them over, sometimes I made things worse. Sometimes my aggression, combined with too much alcohol, made for a rather difficult evening for everyone.

One night, while performing at the Rock Garden—the bar where I had met Peter Capaldi and joined the Dreamboys, years before—a drunken heckler approached the stage to take issue with me over a joke in my act he didn't like. I proceeded to make a fool of him, but he was too drunk to sit down and shut up, so he lunged at me, and I, being a drunk Glaswegian first and a comedian second, knocked him cold, necessitating an ambulance for him and a quick getaway for me, out the kitchen door, avoiding his friends and the cops.

Here's a tip for all you aspiring young comics: Don't beat up the customers. It is very difficult to get laughs from an audience when

you've actually drawn blood from one of their number. It kills the mood.

I kept trying, though, gig after crappy gig, until one night at yet another benefit show at the Tron Theatre, a guy by the name of John McCalman, who was something of a big shot at the local radio station, made me an offer. He grew up worshiping BBC radio comedy shows, acts like the Goons and Peter Cook and Dudley Moore. Local Scottish radio was not known for programming comedy (not intentionally, anyway) but John asked me if I fancied trying to write and record some shows. I jumped at it. We recorded a few monologues I had written for Bing Hitler, who had now developed from a folk singer into a misanthropic buffoon who stood onstage, ranting about everything in the world he hated. The list included bees, whales, cats, vampires, scones, and, of course, the English.

These tapes played into the late-night alt-rock show, and they got a pretty warm reception, though the act sounded dry—just a guy in a studio, talking in a funny voice. You need real people in front of you for that type of comedy, or at least I do. I feel more energized and relish the immediate feedback a live audience supplies. Still, I was getting my name, or at least Bing's name, out to more people who seemed happy to watch me live. Now the nightclub patrons actually cheered sometimes when the DJ stopped the music to announce me.

I quit my job and signed up for unemployment benefits, making me a bona fide member of the show-business community.

Anne was very supportive when I gave up bartending. I think she felt it might keep me away from the booze. It didn't work out like that. Anyway, we were circling the drain pretty fast by then.

We had finally gotten a mortgage and were living in a small ground-floor apartment of our own on Maryhill Road. It was a cheap, shitty, modern building on a busy thoroughfare and I hated

it. I found it hard to be around Anne, who was always angry—with justification, I hasten to add—since most nights I was coming home too late and too drunk. Some nights not at all. At one grimy after-hours party in someone else's apartment, as I was sitting on the living room floor, talking to a very attractive girl, Anne turned up with some of her friends. I didn't know she'd be there too, even though we lived in the same house and were supposedly a couple. We were both pretty drunk and Anne soon let me know that I had disrespected her one time too many, and although I have to say she would have been right about that on a thousand other occasions, in this instance I really was just talking to the girl. Anne was a Highland lass, though, and full of good whiskey, mad as hell, and not going to take it anymore. She removed one of her stiletto-heeled shoes and started pounding me over the head with it, causing a spectacular ruckus and no small amount of blood.

I drunkenly told her our marriage was over, which I don't think came as news to anybody, and I left the party with the beautiful girl. We went to her house.

Later Anne and I tried to patch things up; she was contrite and so was I, and, as I said, there was genuine affection between us, but it was impossible. She was a generous soul who wanted a life and marriage and kids, and I was a selfish asshole who wanted booze and sex and drugs and escape and adventure, and I blamed her for our leaving New York. We were hopelessly and terminally incompatible.

For my birthday that year Anne gave me an inflatable atlas globe, along with a birthday card in which she wrote:

> I give you the world.
> Have fun blowing it up.

Edinburgh, 1986

Every year, usually the last three weeks in August, Edinburgh hosts the biggest arts and entertainment festival in the world. The normally sleepy Presbyterian city becomes a riot of color and noise, its dignified old buildings crammed with theater companies and circus troupes and performance artists. Every available venue has some kind of a show running 24/7. There are any number of amazing and unusual acts performing from all over the world. Russian mime artists, Italian jugglers, Belgian comedians, Finnish punk-rock balloon sculptors, and a fucking Peruvian flute band on every street corner. There is opera and ballet, and there is obscure international cinema, and because this is still Scotland, there is drinking.

The festival has given rise to some of the greatest comedic minds in Britain. Most of the Pythons honed their skills in Edinburgh. Peter Cook and Dudley Moore started here in the 1960s. Some of the great American stand-ups of the eighties made it in the U.K. through the festival: Bill Hicks, Denis Leary, Lewis Black, along with groundbreaking improvisers like Ryan Stiles and Colin Mochrie who went on to create *Whose Line Is It Anyway?* for U.K. and U.S. television. Every young hopeful in show business heads to

Edinburgh every year. The rich kids from the Footlights Society of Cambridge University, the grimy sarcastic snaggle-toothed stand-ups from London, and the pompous pretty actors from the Drama schools. All of them. It's a thrilling hybrid of Carnival and St. Patrick's Day. If you've never been, then go.

By August of 1986, Bing Hitler had gained enough notoriety, even if it was mostly because of the shocking name, to secure me my first Edinburgh appearance. The gig was at one a.m. in a function room above the Cafe Royal bar and restaurant. It was not one of the more prestigious venues, and it was a dog of a time slot, but the location was in central Edinburgh and it was every night for three weeks, so there was a remote possibility that I could make some money if a few people turned up. My overhead was low, just my Bing outfit and travel expenses. I couldn't afford lodging in Edinburgh, so after the show I had to wait for the first morning train back to Glasgow: the 6:15. This was fine by me since I was still sharing the house with Anne and it meant I got home after she left for work and I left before she returned. It was kind of perfect.

At the festival I was part of a double bill with a four-piece acoustic guitar band from Dundee that played Django Reinhardt covers and was actually pretty good, but it's the kind of act that has limited appeal. I was scheduled to go onstage after them, and they were following a play—a dark farce called *Grave Plots* by the Scottish writer David Kane, who went on to become a rather successful film director. (Later on he even cast me in a couple of his movies, but they turned out okay anyway.)

The regular traffic jams that resulted from all of these different performers sharing the tiny backstage area made for a sort of repertory company feel, as if I were part of a troupe. It was like being back in the Dreamboys or among the arty people in black from Gunka James's record store, and I loved it.

Because I was on so late I had plenty of time to get drunk beforehand, which was necessary because I suffered horribly from performance anxiety. There was always at least one drunken heckler in the crowd, and although I had learned already that it was unacceptable to hit one of them, it was still essential that I best them verbally. I always thought I would fail at this, though I rarely, if ever, did. Bing Hitler was an angry drunken character played by an angry drunken man, so I had plenty to draw on. I could just shout someone down and it would be true to the performance. Might even have improved it.

I'd built up to about a half hour with rants and routines and had added another song. On the first few nights, the room was pretty empty, it had a capacity of about 150 and as few as twelve or thirteen tickets sold. I was too hammered to notice.

All the festival shows get reviewed in the local papers, but given the sheer volume of performances that have to be covered, hordes of local journalists who don't usually cover the arts are drafted to help. Therefore you may have a review of a serious play written by the fishing correspondent, who will moan about the show having a disappointing lack of trout, etc. The dearth of qualified professionals doing this job might be the only reason for the glowing coverage I got in the *Scotsman* and the *Edinburgh Evening News*.

Whatever the explanation, the reviews had a startling and dramatic effect. I arrived at the show five nights into the run to find a line of people waiting to get in. I asked the ticket-taker girl at the door what had happened, thinking perhaps the fire alarm had gone off during *Grave Plots* or something. I was astonished to hear they were waiting to see me and my acoustic-guitaring buddies, since I assumed them to be jazz aficionados, but I finally felt it when I went onstage—they were there to see *me*, or at least Bing.

I was then, and remain now, bewildered by how funny people find material once a newspaper has given them permission to laugh at it. Jokes that had only got titters before now got guffaws. This is

tremendously encouraging to a performer, leading to more confidence and improvisation as he or she feeds off the positive energy of the crowd, which in turn leads to more laughs. I started to enjoy myself like when I was drumming or tending bar.

The show quickly became the hip, late-night find of that year's festival, drawing an audience that included other performers, as well as people from the media. The Glasgow *Herald* ran a profile of me. The local BBC TV station put me on their news roundup of the festival—my first television appearance—and the independent Scottish Television featured me on a show that they broadcast to the entire U.K. Called *Acropolis Now*, after one of Edinburgh's notable buildings, which mirrors its more famous namesake in Athens, it highlighted the hot shows from the festival and was cohosted by Muriel Gray, the very clever and fashionable Scottish journalist, and by Jimmy Mulville, a superconfident and acerbic Liverpudlian comic who was on the way up.

Bing's five-minute spot on *Acropolis Now* went well, and after that, the Cafe Royal shows got even busier, so that we were turning people away at one a.m. It was an odd first brush with success because none of the attention had translated into money. The Cafe Royal promoter would theoretically write me a check at the end of the run and I was now playing to packed houses. So after my nightly triumph I would be kicked out of the bar after my act ended at 2:30 a.m. and have nearly four hours to kill until I could get on the train home at 6:15.

Usually I'd grab a crappy cheeseburger at the all-night snack bar in Waverly Station and then sleep in the Photo-Me booth next to the closed passenger waiting room. I'd try to make myself comfortable by adjusting the spinning stool, mentally blocking out the smell of pee as much as I could—the booth's or my own, I'm not sure which. I pulled the little curtain over for privacy, but it certainly wasn't the Ritz.

One night toward the end of the festival, waiting in line for my sal-monella burger and fries at three a.m., the drunk guy in front of me recognized me from the show.

"Hey. You're Bing Hitler!"

"Yeah," I said.

"You're doing great, man! It must be fantastic to be the big hit show."

"It is," I said, while casting anxious glances over to the photo booth, hoping that no one would steal my accommodations.

Another night, Jimmy Mulville, whom I'd met at the TV taping for *Acropolis Now*, came along to see my show at the Cafe Royal with his fiancée, Denise O'Donoghue, a very classy woman who was at that time becoming one of the more successful television producers in the country. After the show, I went to their hotel to sit and drink in the all-night bar with them rather than sleep in the train station. Denise gave up at around three and went to bed, and then Jimmy explained his resilience and capacity for alcohol. He reintroduced me to an old friend I hadn't seen since New York City.

Cocaine.

There was no coke in Glasgow that I knew of, but Jimmy as-sured me there was a plentiful supply in London. I made a mental note to get to London more often.

It was almost the last night of the festival when a very sweet, ador-able English girl, blond and bookish, looking about twelve years old, cornered me after my show.

"I'm Rachel Swann," she said in a Mary Poppins voice. "I'd like to be your agent."

"Do I need an agent?" I asked.

"You do if you want to work in London, dear."

I thought about what my new friend Jimmy had told me about London and cocaine. I told her to sign me up.

And so Rachel Swann became my first agent. I was with her for five years, until she left to get married to a minor rock star whose name I can't remember.

24

On the Train

The Edinburgh Festival in 1986 changed my life. I haven't had a real job since. The TV appearances led to me playing bigger venues in Scotland. John McCalman, the man who had first put me on local radio, suggested we record a comedy album for the independent record label he owned. I jumped at the chance. Over two nights I recorded *Bing Hitler—Live at the Tron Theatre*. It became something of a cult hit, which means lots of people heard and liked it. But no one seemed to make any money off of it. Certainly not me.

I wasn't aware then that my career was moving forward, I wasn't actually aware that I had a career, but I realize now that things were happening very quickly, despite my shortcomings offstage as a viable human being.

Michael Boyd asked my old Dreamboys cohort and friend Peter Capaldi, who was now writing as well as acting, to create a Christmas show for the Tron. Michael also wanted me to write on the project, so Peter and I came up with a sort of alternative pantomime we called "Sleeping Beauty," very loosely based on the fairy tale. The script turned out very well (thanks for the most part to Peter's diligent efforts; I just tagged along, clinging lazily to his

coattails once again) and starred me, or rather Bing Hitler, as prime minister of the far-off land of Vulgaria, and the camp comedy duo Victor and Barry, as the ugly stepsisters. Filling out the cast were a host of well-respected Scottish stage actors who had been persuaded to enlist, thanks to the reputation of the director, Michael Boyd himself. The piece was a big success, and I put the final nail in the coffin of my marriage to Anne by having a scandalous affair with the actress who played the part of Beauty.

During the same holiday season, Scottish Television decided they wanted to attempt a Live New Year's Eve show that would, for once, not be the usual tartan-and-bagpipe cheesefest. This year, wanting something younger and hipper, they enlisted Peter Capaldi and me, along with Jimmy Mulville and Muriel Gray, the team that had done well with the *Acropolis Now* program only months before.

Our plan was to put on a live show of music and comedy acts that would be interspersed with some sketches, basically a rip-off of the *Saturday Night Live* format. It is difficult enough to make live television under the best of circumstances, but when you're in Scotland on New Year's Eve (or, as the natives call it, Hogmanay— a time of unbridled drunkenness in a country not renowned for its restraint involving alcohol on any day of the year) it's damn near impossible.

Add to this a nasty trick by the network: at the last minute they drafted my brother Scott to be the show's director. Scott had, in his career as a journalist, climbed the ladder to producing and directing the news shows, and then to an executive position at Scottish Television. He actually ended up running the company for a while before leaving in the early nineties.

Scott was not really interested in directing light entertainment— he's a news guy—but he had been put in this uncomfortable situation by the suits, who believed he would be more effective at bending

us to their will, a ridiculous notion, as anyone who has or is a little brother will tell you. The bosses were desperate, though, because my fellow castmates and I were getting very upset and were shouting about it to anyone who'd listen.

This was because the network had gotten cold feet with their "edgy" and "hip" stance when there were rumbles of disapproval in the Scottish press that this new show would betray the tradition of Hogmanay.

The network compromise was, basically: "To hell with any initiative of a different show. Let's not bother with any *ideas*. We'll do the same we always do, but with younger people." This put me in a very awkward position, because I would end up performing the type of stuff I was making my name lampooning.

I have seen this a million times since in show business. In TV, movies, and the music business you get executives who start out with a radical notion, but as the moment of truth approaches they lose their nerve and go back to what they are familiar with.

Scott and I butted heads, it was just like when we were kids. He wanted me to do as I was told, and I wanted him to fuck off. We didn't speak for a while afterward, but not for too long. There was beer to be drunk, and we both support the same pathetic soccer team, Partick Thistle. We were back to our regular bullshitting within six months.

The New Year's Eve show was a miserable experience, but not without its moments. During rehearsals Jimmy Mulville and I became friendly; we would sit in his hotel room, doing lines of coke and drinking beer and talking rubbish for hours. On one memorable night, an eager, tubby, and rather gauche network executive called Sandy McDougal decided to join us. He claimed he had "done tons of coke" in his "extensive world traveling," but that seemed a little doubtful to Jimmy and me seeing that when it was his turn to snort a line off the mirror with a rolled-up banknote he exhaled instead of inhaling, blowing the precious white powder all

over the carpet. Even now, when I bump into Jimmy, who has been clean and sober for a million years and about as far removed from that world as anyone can be, he still seems a little annoyed at Sandy for this. I am, too.

After the Tron Christmas show and the New Year's Eve debacle, my professional commitments in Scotland were over. It had been almost five months since the Edinburgh Festival, and Rachel Swann insisted that I come to London to meet the rest of the staff at the unfortunately named Noel Gay Organization, which was, as it turned out, a large and hugely prestigious theatrical agency in the heart of the city's West End. I had, it seemed, landed on my feet.

Rachel started booking me some club dates in London. Ten minutes at the Comedy Store in Leicester Square, fifteen at the Hackney Empire. I had heard of these places and I was impressed. Real people in real show business had played there.

But I still wasn't making real money, so I would travel the four hundred miles from Glasgow to London by "luxury" coach, "luxury" meaning that the vehicle had a little bathroom at the back. It was a horribly uncomfortable trip, like taking a Greyhound, only slower and damper, and once I got there I would crash on Peter Capaldi's couch.

Peter and I had stayed close since the Dreamboys and by now he had moved to a little house next to Kensal Green Cemetery in Northwest London, a stone's throw from the site of the gruesome Dennis Nilsen serial killings. The strange, creepy environment suited him to a tee and we spent some smashing-cold winter afternoons together, wearing big black coats and smoking cigarettes while walking round the preposterously overdone Victorian tombs of that colossal graveyard. Our own little *Withnail and I* period.

Peter was unfailingly kind and supportive to me, and I repaid him by taking advantage of our friendship, turning up at his place

unannounced and leaving a terrible mess in my drunken wake. I thought that because I could make him laugh we were good and was genuinely mystified when he told me that unless I treated him and his life with a little more respect I was no longer welcome. Only years later did I finally find the sense to apologize to him, an apology which he took with his usual generosity and class. Of all the truly remarkable and impressive people I have been lucky enough to know, Peter is surely one of them.

Rachel Swann teamed me up with another comedian she represented, an English chap named Harry Enfield. Harry was chubby and schoolboyish and astonishingly talented. He had invented the character Stavros, a send-up of a typical Greek kebab-shop owner in London, and performed it to great success every week on Channel Four Television's *Saturday Live*, Britain's version of *Saturday Night Live*. Harry and I met for the first time when I appeared on that show. We got along well and started playing on the same bill around the country at university and college gigs. It was like touring with a band except we got our own car and a driver and had no cumbersome equipment to schlep around, though we did stay in the same shitty B and B's. Harry was a quiet, introspective guy and I was a loud, boorish inebriate, and we were never very close, but we were comfortable with each other.

Rachel was very excited when she called me on the road one day and asked if I had a passport. Harry and I had both been invited to the Just for Laughs comedy festival in Montreal, and while it wasn't America, at least it was on the right side of the Atlantic.

Harry brought along two of his buddies, Paul Whitehouse and Charlie Higson. Charlie had been the singer of the Higsons, an indie rock band. I had heard them, and they were pretty good, but Charlie had no love for the music world so he had left for writing, which was his real passion. He wrote science-fiction stories, along

with jokes for Harry. He was a taciturn fellow but once his natural reservation ebbed away and he got to know you, Charlie turned into a convivial and witty comrade in arms.

Paul was a plasterer from Harry's neighborhood and not really in show business at that point since there was more money to be made in London just then working construction, but he loved the comedy scene and would write the occasional gag or come up with character ideas for Harry. Without doubt, Paul was the most comedically talented of any of us on the Montreal trip and it seemed inevitable he would end up performing by himself.

Early one July morning we left London—Harry, Paul, Charlie, and myself, along with Rachel Swann, the Truly Scrumptious of London agents—and with a few entertainment journalists and managers in tow. It felt like a school trip.

These were the early days of the Montreal festival, long before it became an institution. No one had even heard of it yet. We were the pioneers, canaries in the coal mine for the British comedy world. We had a blast, boating on the rapids of the St. Lawrence River and hanging out with the gregarious and hilarious American comics, not to mention the festival's staff of beautiful, young French-Canadian girls.

I struck up a friendship with Rick Siegel, a talent manager from New York City who at six-five and two-forty was one of the biggest humans I had ever met. Steve Kravitz, the San Francisco comedian, calls him "the mutant Jew."

Rick was a little worried when he heard that I worked under the name Bing Hitler but was placated when he saw there was nothing anti-Semitic about the act. At one time Rick had been a comic himself and won the annual "Mr. Peanut" new comedian competition, whatever that was. He told me it was quite something. He also told me that if I wanted to succeed in the U.S. it might be a good idea to drop the whole "Hitler" thing. I said I'd think about it.

Because New York was just an hour away by plane I made a detour to my old East Village neighborhood before returning to London, but it turned out to be an awful, cold bucket of water after the high jinks of Montreal. I met Jamesy on the plastic chairs in front of the Vintage Furniture Store on Avenue A. He expressed some surprise at the forty or so pounds I had gained since I had last seen him. That made me feel fucking great, but it was just the beginning.

He told me the neighborhood was changing beyond recognition because the property developers had moved in and all the old characters—along with most of the street crime—were moving out. That wasn't such a bad thing, he said, but there seemed to be a great loss that went along with it. Something was dying, Jamesy said. It just wasn't the same. And he was right, it wasn't.

He also told me why I hadn't been able to find my old actor buddy Roswell, the guy who suggested I go to my first acting audition and who was my doorman partner at Save the Robots.

Ros was dead.

He had loved heroin more than it loved him. I was shocked beyond imagining; he was the first of my friends to fall.

I went to O'Tooles uptown but no one I knew was there. It was all manicured hedge-fund pricks in those shirts that have different-colored collars.

I went to the Last Resort Bar to look for my old theater buddies. The bar was deserted and half of the clientele and staff were gone. The AIDS epidemic was scorching its path through the world. In fact, the entire town of New York seemed consumed and obsessed with it. All anyone would talk about in that town in the late eighties was their HIV tests or how frightened they were of contracting AIDS or already having it. By the time I got on the plane to leave I was terrified and depressed. I have never been so happy, before or since, to leave New York City.

Those unexpected morality lessons provided by the trip had jolted me into some kind of action. It was time to jettison the past before the present jettisoned me. This was my first veiled attempt at recovery. Although perhaps I was just running away again. I returned to Glasgow, planning to say a final goodbye to Anne and get out of her life, but ended up drinking with buddies in the Chip Bar and never seeing her. I called her instead to say I was moving to London and told her she could have the house and everything else we owned, which wasn't much. I think she was as relieved as I was that I was leaving town for good.

I took the sleeper out of Glasgow, and as the smelly old train bumped out of Central Station and across the Jamaica Street Bridge, I stared out at the orange halogen streetlamps reflected in the black water of the river Clyde. I gazed at the crumbling Victorian buildings that would soon be sandblasted and renovated into yuppie hutches. I watched the revelers and rascals traverse the shiny wet streets. I thought of the thrill and danger of my youth and the fear and frustration of my adult life thus far. I thought of the failure of my marriage and my failures as a man. I saw all this through my reflection in the nighttime window.

Down the tracks I went, hardly aware that I was going further south with every passing second.

Jimmy's Wedding

My relationship with Helen was my first clue that love really could be the answer. At the very least, it was sufficient to arrest for some time the more glaring symptoms of my alcoholism.

We met during the production of a TV show that Jimmy Mulville, who was now working behind the camera as well as in front of it, had hired me for.

It was a sitcom called *Chelmsford 123*. Set in the time when the Roman Empire occupied Britain, it was a little on the high-concept side, but still very funny. I was to play a Roman actor who was masquerading as a Scottish barbarian, while Helen had been cast as an ancient British hag. The part required her to wear a wretched wig with (fake) dead mice in it and some of her teeth to be blacked out. Although I thought she was funny and interesting when I chatted with her at the craft services table, I can't say that I overcame my aesthetic fascism and fell for her on the spot. But it wouldn't be long.

After the episode we were filming wrapped, there was a party for the cast and crew and she came over to talk to me. It took a few

seconds for me to grasp who this very, very beautiful woman was. I had never seen her out of her costume.

Helen is short, around five six, but looks taller because she always wears heels. She has curly blond hair and piercing cobalt-blue eyes. Her mouth is big and sexy and when she smiles at you it feels like you've won something. Her giggle is so deep and throaty, so downright *filthy*, that when I made her laugh it felt sexual. Really, I'm not kidding about this; I had never been so physically attracted to a human in my entire life, and since I'd already had a beer or twelve I told her so. She dismissed my attentions as Celtic charm, but she gave me her phone number before she left.

Soon afterward, Harry and I went on tour once more, roistering around the smaller theaters and student unions of England and Wales, so it was a while before Helen and I met again, but I called her often from the road and we talked for hours. I found out all about her.

Her full name was Helen Atkinson-Wood. She was eight years older than me and was an actress from Cheshire, in the north of England. She was from a wealthy family—her father owned a textile mill—and she had gone to an all-girls school where she had been very horsey and bossy and popular and then went on to study fine arts at Oxford. She adored her two brothers, Chris and Pete, and went home often to spend time with her parents. She never took drugs but liked to drink good wine with dinner and would take a glass of sherry with the vicar after church if he insisted. Helen owned the apartment she lived in, located in the wildly fashionable borough of Islington, north-central London. She made me laugh more than anyone I had ever met, and her conversation was peppered with thrilling, clever, and uproarious innuendo.

In short, she was way out of my league.

The tour that Harry and I were on was scheduled for a two-week run at the 1987 Edinburgh Festival, where we'd be appearing at the Assembly Room, a much more prestigious venue than I had been in the year before. One day when I was drinking in the Artists Bar, a hangout for the performers and their friends, Helen came in wearing some kind of flamingo-colored summer dress. I saw her standing in the doorway, she was backlit by the cold Edinburgh sun, and for a moment I literally lost the ability to breathe. As soon as I recovered, I called her over, and though we hugged a little too long for a friendly greeting, it wasn't long enough for me. I could have stayed there all day.

She had another impossibly glamorous creature named Sue with her, the two English ladies having decided on the spur of the moment to come to the city for one day of culture. Helen and I talked for as long as we could but eventually I had to go onstage and she had to go for her return train to London. We'd be seeing each other the following week, though, at the wedding of Jimmy Mulville and Denise O'Donoghue, slated to be a terribly grand affair at the Chelsea Barracks in London.

I still hadn't bothered to learn to drive, and I would have felt conspicuous riding on public transport in full Highland dress—kilt, sporran, sgian dubh (the ceremonial dagger worn with the kilt)—so I took a taxi from my tiny rented North London flat to Chelsea.

I had promised to wear the complete rig because Denise asked me to. She and Jimmy had been so kind to me, even letting me crash in their spare room until I found a place of my own. It seemed the least I could do was give her the total Brigadoon if she wanted it.

I don't know if the bride and groom had a good time at their wedding, but Helen and I had a blast. We danced and danced and

danced, and she didn't seem to notice when I snuck off to the lavatories to do lines of coke with the boys. Of course I drank and drank and drank, too, but the coke, together with the dancing, kept me appearing sober enough to be allowed to go home with Helen at the end of that wonderful evening.

I have heard women talking about having to take the "ride of shame" the morning after, when you travel home on the subway in what you wore the night before and everyone knows what you have been up to. I know exactly what they mean. I didn't have enough money (coke is expensive) for a taxi home from Helen's the following day, so in my Highland battle dress I had to cross London on the underground, not a little conspicuously.

I was hungover and embarrassed and shaky and profoundly in love for the first time in my life.

26

The Aspirations of a Phony Englishman

can't explain Helen and me. How do you explain love? We were just in it, that's all. Soon after the wedding, she asked me to move in with her and I did, although I kept the little flat across town for the first few months just in case she kicked me out.

We stayed together for five years, and by the time it was over, she had, with my blessing, changed my life beyond recognition. I wanted her to, and I was and still am happy and grateful that she did.

She insisted I learn to drive and made me get a license as well as a car. Right away she told me that she didn't want to have a boyfriend who was a lush. So for a while when I was around her, quite a lot since we lived together, I didn't get drunk.

She changed the way I ate, introduced me to fresh fruit and, saints preserve us, muesli. We slept during the nighttime and got up in the morning—this was a staggering concept for someone who hadn't lived like this since his early years of high school. We went to movies and the theater and restaurants and had friends whom we *hadn't met in bars!* We even took vacations to the Seychelles and

Barcelona and Sri Lanka and France. In short, Helen was a grown-up, and in order to be with her I had to at least try to be one myself. She taught me how to live, and while doing so, she was the sexiest, funniest person I'd ever met. She also smelled great.

Helen had done Ibsen and Shakespeare and Chekhov at very classy and impressive joints from Stratford to the West End. She played crazy Mrs. Miggins on U.K. television's most popular comedy show, *Blackadder*, alongside Rowan Atkinson, Hugh Laurie, and Stephen Fry.

Helen was a serious actress who believed in preparation and rehearsal, and thought that I could use a bit of both. She told me that although I undoubtedly had some kind of innate talent as a performer, I had some real work to do.

I listened to her. I worked harder on the act, I began writing material, both for myself and, through my ever-eager agent, Rachel Swann, for other, more successful, comedians. Because of Helen I got a lot better at my job. I looked better, too—she made me go swimming with her every morning at the public pool.

The only people I knew in London were the newlyweds Jimmy and Den, while Helen knew everybody. Her actor buddies were familiar to me and easy to be with, but sometimes I had a terrible feeling of inferiority when we had dinner with her older (and, actually, her closer) friends.

They were alumni of Oxford and Cambridge who "came up to London" after university and tended to stick together. Helen's gang of ineffably talented souls included Helen Fielding, Richard Curtis, Douglas Adams, Hugh Laurie, Stephen Fry, Rowan Atkinson, Emma Thompson, Angus Deaton (Helen's ex—I distrusted him until I actually met him), and Geoffrey Perkins, who would eventually become controller of the BBC. All of these individuals were hugely influential in British comedy, and I felt tremendously un-

comfortable around them, assuming that they looked down on me for not attending a swanky school or being from the "right" family, but I see now that that was hogwash. If anyone was unfairly prejudiced it was me—I had a chip on my shoulder because of my background. I didn't want anybody's fucking help or influence. I was better than them because I was, I don't know, Scottish, or angry, or something. Also, I didn't know how to behave around these rather brilliant people who treated me with tact and charm and sympathy, not because they feared me, which is what I told myself at the time, but because they loved Helen and knew she loved me.

These people came from the privileged English middle and upper classes, they were the very people I'd grown up believing were the enemy, yet here I was among them, even living with one of them. And they had no problem with it. I was the one in conflict.

Loving Helen split me in two. It was agony. If I drank I'd lose her; if I didn't I'd lose my mind. The longer we were together, the harder it was for me to contain my drinking. I would look for jobs that took me away from her so that she couldn't see me get fucked up. I toured Australia with an all-girl Jewish singing group called the Hot Bagels, and of course ended up having an affair with the Everything Bagel. More accursed secrets. More shame brought on by behavior instigated by alcohol, which only fueled the need for more alcohol, and on and on and fucking on.

I made a film for Channel Four at the bull-running festival in Pamplona, Spain, and stayed drunk for a week. One night I struck up a conversation with some American film-crew members in town shooting second-unit footage for a Billy Crystal movie that was to be called *City Slickers*. I told them I wanted to go to Hollywood and be in the film business and they said forget it. They told me they already had enough assholes like me.

Once again I toured the U.K. with Harry Enfield, but this time it wasn't as a double bill. As "Loadsamoney," the character he and Paul had come up with—a vulgar *nouveau riche* London plasterer—Harry had become a huge star. On this tour, Harry got top billing, Paul and Charlie played secondary roles in his skits, and I was the opening act.

I was grateful for the work, but also bitter and resentful, even though Harry, Paul, and Charlie were always gentlemen and not one ever once gave me cause to feel like that. I just felt like that anyway.

We spent two months on the road, this time in a real luxury coach with not just a bathroom and real beds but with a TV, on which we watched the movie *Spinal Tap* every day. We were living the dream—big hotels, big theaters, big partying, big money, big fun—but underneath all that partying I was just another miserable drunk.

I got shitfaced every single night; sometimes I couldn't even remember being onstage, but somehow I did okay in front of the audience. On tour, pretty much everybody was living like an alcoholic, anyway, so for a while it seemed I was just part of the team.

Eventually I got a stand-up special of my own for Channel Four that would be filmed at Glasgow's Pavilion Theatre and produced by Rowan Atkinson's company. I wrote a little wraparound story for the show, containing flashbacks to my fictional family life, and sent the script to the legendary Peter Cook, offering him the part of my character's father. To my astonishment, Peter invited me to come discuss the project with him at his house in Hampstead.

I was extremely nervous when I arrived there for an eleven-a.m. meeting one Monday because Peter Cook has always been a comedy god to me, and to countless others. The idea of meeting and perhaps even working with him was almost beyond belief, but

I managed to ring the doorbell intercom, and after a moment a very familiar, if somewhat sleepy, voice answered.

"Hello?"

"Peter. It's Craig Ferguson. I've come to talk about the Channel Four thing."

"Ah yes, Craig," he said, perking up a bit. "Come on in. I've got a little breakfast for us, it's in the fridge, in the kitchen, just on the right. I'm upstairs, I'll be down in a trice."

The door buzzed and I pushed it open.

The kitchen was indeed on the right. The fridge was empty except for two large cans of Strongbow hard cider. I yelled up the staircase.

"Peter, I can't see anything. There's only two cans of Strongbow here."

"I repeat. Breakfast is in the fridge," he yelled back.

Peter came downstairs in an alarmingly short terrycloth robe and we proceeded to have breakfast. He was a beautiful and gregarious man, very generous about comedy and his own life, and a hysterical, deeply interesting conversationalist.

We talked a little about the project, and after he agreed to do it, we then blabbed on for hours about the comedy scene, past and present. He was aware of the Bing Hitler stuff and knew many of the guys I had been working with. He was fascinated by comics in general and stayed very current on who was doing what. We talked some about my life, and a lot more about his, which was fascinating. He talked very warmly about his old partner, Dudley Moore, who had gone on to a huge film career in America with *Ten* and the *Arthur* movies. He clearly adored Dudley but felt that his success in America had failed to make him happy.

During our conversation, Peter told me about an incident that

occurred very early on in his career. He had received a telephone call from the office of Prince Charles, which was amazing because everyone knew Peter was no fan of the monarchy. The conversation, he said, went like this:

EQUERRY: Hello, Mr. Cook. I am Sir Rodney Bumblington-Trousers and I am the equerry to His Royal Highness the Prince of Wales.

PETER: Oh. Congratulations.

EQUERRY: Er . . . thank you. His Royal Highness is a great admirer of your work and was wondering if you would be free to have dinner with him on the seventeenth.

PETER: Oh. Well. Let me see. Would that be the seventeenth of March or the seventeenth of April.

EQUERRY: The seventeenth of March, Mr. Cook.

At that point Peter picked up a telephone directory and rustled it next to the phone.

PETER: Hold on. Just consulting the old diary. Won't be a minute.

More rustling.

PETER: Oh, dear. I'm sorry. I have consulted my schedule and I find I am watching television that evening. Do give His Highness my apologies.

I don't know if Peter's story was true or not, and I don't care. I loved that man.

So Peter and I worked together on the comedy special, and I don't think any human being has made me laugh so much before or

since. We did some drinking together, too, but Peter was trying to be careful, the booze really had a hold of him. I was, needless to say, having the same trouble.

No one can live a double life forever, and mine was falling apart at the seams. My love for Helen, or, more accurately, the power that it held against the rising tide of my alcoholism, was beginning to wane.

In the early years together I rarely got drunk in front of Helen, but whenever either of us was out of town I'd pour booze down my neck like a man possessed, which I suppose in a way I was.

Now, though, I was getting drunk all the time. It wasn't that I didn't care; I simply couldn't stop. I was out of control, and whenever I needed to make a good impression at a party, a dinner, or while performing—I'd get so bombed I'd fuck it up.

I was cast in *The Rocky Horror Show* in the West End, playing the role of Brad Majors. It was a year's commitment and I thought it would have a stabilizing influence on my life, but the opposite was true. Whenever Helen was away—and, as a working actress, this was not a rare occurrence—I could be found at the notorious Groucho Club, London's plush but seedy mecca for dipsomaniac showbiz types, immersing myself in whatever debaucheries presented themselves.

I was arrested for a DUI one night while driving in a boozy, coked-up haze from the Groucho to pick up Helen at Heathrow Airport. She'd been working in Africa for the British Comic Relief Charity and arrived home exhausted, and somehow had to figure out what had happened (though by this time she knew it would be safe to assume I'd gotten drunk and screwed up) and get herself and her luggage home.

Meanwhile, I was in jail and her car was impounded. (My own rattly old bus was in the shop for a change.)

I still wonder what was in it for Helen all that time. Why did she put up with me? I suppose she knew that I loved her as much as I was then capable of loving anyone. And, inexplicably, she loved me. Thank heavens at least she had the sense not to marry me.

We had tried our best to make a life together. As soon as I was earning enough money to inspire the bank to give us a mortgage, we bought the most adorable house in a tiny Suffolk village named Dunwich—its population then jumping from twenty-three to twenty-five when we moved in. There, in the desolate beauty of the East Anglian coast, we hid from everything. We decorated the place and bought a washing machine and a fridge, I chopped firewood out in the garden, Helen made jam, and for a while it was heaven. Then inevitably it all came crashing down.

One Monday morning I set off for London to do a little business. Helen dropped me at the station; it was a two-hour train ride, and I told her I'd be back around four in the afternoon.

I got there in time for whatever bullshit meeting I had scheduled and then went to the Groucho. I had a beer with someone, and that led to a beer with someone else, which led to a line of coke with someone, which led to a conversation with a girl. The upshot was I didn't make it back home until Thursday. I was too busy tearing around London with my cokehead compadres, passing out on people's floors or hotel rooms. I know it's crazy, I can't really explain it either, but this is what happens when I drink alcohol.

I was a very sorry soldier when I walked the long country lanes back to the house in Dunwich three days late. I expected rage and grim ultimatums from Helen but found instead that she had packed her

bags—indeed most of her stuff was already gone—and was very sad. We went into the little kitchen with its view of the North Sea. She made me some tea and sat in my lap. We held on to each other as tightly as we could. We cried and cried and cried. I haven't come apart like that at any other time in my life, and it was very rough on her, too, but when she had enough breath she told me what we both knew was coming.

"I love you, but I won't watch you kill yourself. I have to leave you."

I totally understood. I would have left me if I could.

After she had gone, I went for a walk on the lonely Walberswick marshes outside the village. Out there I did something I hadn't done since I was a farty wee schoolboy in the miserable damp town church. I prayed. I asked the God I still don't really understand and have trouble believing in to help me—either to kill me or change me.

I had become something I despised, and I couldn't break free of whatever spell had been cast. I was an inmate in a prison of my own construction. I told Him I was willing to go to any length to get out.

I don't know if my prayers were answered, I'm not an Evangelical, or even a very religious person.

But things sure started moving quickly after that.

The End of Daze

After a few days alone curled inside a whiskey bottle in the big empty country house, it occurred to me that as I was no longer with Helen I could return to America. Helen would never have left Britain—she loved it there—and I had wanted to be wherever she was, but all of that was over now.

It was time for the States. A fresh start.

Unfortunately, I was flat broke and couldn't conceivably make the trip without at least some money. Borrowing it from the bank was not an option—I'd already had the last of my credit cards cut up in front of me by an embarrassed liquor-store clerk who had called Amex to see why I'd been declined.

I got a few gigs and made some money, but I couldn't hang on to it, because with Helen gone, the brakes were off and I was getting fucked up all the time, which wasn't cheap.

Finally I caught a break when the BBC cast me in a movie to be filmed in Glasgow called *The Bogie Man*. It starred Robbie Coltrane (he plays Hagrid in the Harry Potter movies) as a nutter convinced he is Humphrey Bogart who winds up solving a real murder. The

stunning English actress Fiona Fullerton, already internationally famous for playing a Bond girl in *A View to a Kill*—she takes a Jacuzzi with Roger Moore and is murdered while wearing a sexy scuba outfit—was cast as an investigative journalist who has an affair with my character, a detective. I didn't know why they cast me, unless it was because all Glasgow cops are senseless drunks. Actually, now that I think about it I know exactly why they cast me.

After the first day of rehearsal, Fiona and I went out for dinner, got drunk, and ended up in bed together, beginning an affair that became a fascination for the British tabloid press. No one could understand what this beautiful famous English rose was doing with the little-known, overweight, drunken vaudevillian. I didn't really understand it, either. Fiona is a kind, intelligent woman who really should have known better. I suppose she fell for whatever baloney I was spouting then and, like many women who found themselves with men like I was at the time, she hoped that she could change me, that whatever good she saw in me could be nurtured with affection, sex, and home cooking. But I was too far gone for that. I was well out to sea.

After the film wrapped I returned to London, essentially homeless. I still had the little place in Dunwich but could never bear to go there, it was a mausoleum for an old dream. The money I made on the movie was spent before I earned it.

I stayed with Fiona a lot of the time in her Chelsea flat, and when I was too full of the wildness I'd lie on the floor of someone's house or spend the night in one of the rooms available for rent above the Groucho Club.

At Christmas, Fiona asked me to her parents' place in the country but I declined, saying that I really should get to Scotland and

see my own family. That's what I meant to do, but first I went for a wee drink.

During my year of performing in *The Rocky Horror Show* I had naturally become friendly with the staff of the Grouch Club, the bar right next to the theater. I would get our half-hour calls there and would dash in for a quick refresher during intermission, after throwing a large overcoat over my costume.

The landlord, Tommy, was an Irish fella and a terrific story-teller. We would often jaw for hours after closing time. Tommy had since changed pubs and was now running the White Horse, in London's Soho, and I thought I'd go see him in his new place and have a pint before heading home on the last flight to Glasgow on Christmas Eve. I needed a drink to get on the plane—I had developed a terrible fear of flying, which I tried to combat with alcohol. It didn't work, it would only render me both drunk *and* terrified.

I got to the bar around four p.m. and shared a pint with Tommy, and another with an actor I knew, and one thing led to another blah blah and I woke up on a mattress in the storage room above the bar at seven the following morning covered in vomit and pee. I hoped at least it was my own vomit and pee.

I felt worse than I ever had. Worse than when I first blacked out on the sickly sweet Eldorado. Worse than when I felt the first stab of chronic alcoholism and panic in Mrs. Henderson's car. Worse than when I fled the ferocious and partially imaginary killer ducks of Kelvingrove Park. Worse than I hope I will ever feel again.

Worse than when Helen left.

But there were no tears this time. I was done with that.

I was a drunk, a loser, and a disaster of a human being. I was almost thirty, divorced, and broke. I'd lost the only woman I ever loved, and I couldn't even make it to Scotland to be with my parents at Christmas.

The shame was immense. It pushed down on me like a terrible weight. And the pressure of that weight began to forge an idea as hard and as clear as any diamond.

It was time for me to die.

There would be no grandstanding; this was a rational, sensible thought, not a cry for help. I was checking out, and that would be the end of it. Goodbye, cruel world, and fuck you. The suicide idea felt good. It felt great. I meant it; this time I would not mess up.

I felt sober and encouraged. I knew what I would do: walk down to Tower Bridge and swan-dive into the dark and murky Thames. The river would take me out to sea with all the other garbage that London had produced. And that would show *them*. Even though I had no idea who *they* were.

With the decision made, I got up and shook off my dizziness. At the little sink in the storeroom I washed off my face and clothes as best I could, trying to make myself presentable for the Reaper, and headed downstairs. I could escape it all without ever having to face Tommy or any of his family, who lived in the same building.

Except I hadn't figured on one thing. Tommy loved to drink nearly as much as I did, and, after all, it was Christmas.

Tommy had actually slept *in* the bar. He was already awake and

messing about with bottles and crates when I was trying to exit the building, and my life.

"Mornin'," he croaked.

Clearly I wasn't the only one who was suffering.

"Aye, Tommy," I said. "Sorry about last night."

"Hey, I don't remember anything after about ten. You're good with me."

He really was a decent sort.

"I'm away, then. See you soon," I told him, heading for the door.

"Where you goin'?" he said.

I didn't want to tell him about my suicide plan. It was private. Plus, I knew that if I mentioned it to anyone the spell would be broken, and I didn't want that. I wanted to die. So I said, "I'm going to Scotland."

"How?" he asked. "All the planes and trains and buses are stopped for Christmas, and I know for sure your car will be at the feckin' mechanic's again."

He was right, of course.

"I'll figure something out."

"Suit yourself," he said, "but surely you'll have a glass of sherry for Our Savior's birthday."

I turned and saw that he had poured us both glasses of sherry and was holding them out. Not little glasses, either. These were half-pints.

I didn't want to be rude; Tommy was a nice guy. Anyway, I could have a sherry and still be dead by nine o'clock.

I walked back to the bar and he handed me a glass. I raised it, clinking mine against his.

"The Baby Jesus!" I said.

"The Infant Christ!" he said.

And we both took long draughts.

God help me but I can still taste how wondrous that sherry felt going down. Bitter and sweet and harsh and smooth all at the same time. The heavenly tonic soothed the palpitations of my erratic and troubled heart and restored my breath from shallow panic to even calm, as though the Lord himself had taken his cool hand to my furrowed brow. As the warmth spread through me as if from a thousand loving suns, I completely forgot about killing myself.

And I don't even like sherry.

Like many before me, I found salvation in liquor and Jesus.

People who have never gotten drunk in the morning have no idea just how therapeutic it can be for alcoholics.

In fact, it saved my life.

28

Rehab

Throughout all of my drinking and all of my failures, all the disappointing performances and no-shows, Jimmy Mulville had always thrown me little pieces of work. As he became something of a force as a producer, he'd get me a part in a sitcom here or a stand-up appearance there, although we no longer socialized. I never saw him out and about and had heard dark rumors swirling that he'd been in rehab.

In 1991, Jimmy threw me another bone and gave me a spot on his highly successful Saturday-night panel show *Have I Got News for You*. I repaid him by being terrible. The show was basically a few smug guys cracking wise about that week's news stories, and I was too uncomfortable to speak. Afterward, I saw Jimmy in the green room. He seemed all shiny and religious or something, so I knew the rumors must be true, although I didn't dare ask. He saved me the trouble and told me. He said he'd gone to some place in the country and sobered up, and, inexplicably, I felt sorry for him. I got the hell away from him as soon as I could because he scared me.

Meanwhile, I kept getting worse. On New Year's Eve 1991, Fiona and I joined the other drunken revelers in Parliament Square in London to watch the hands of Big Ben chime at midnight. As the

crowd counted down the last few seconds of the year, I felt a wind spring up and I turned to Fiona.

"Can you feel it?" I asked.

"What?" she said.

"I don't know." But I think I did. I knew that I had been partially right in the storeroom above the bar on Christmas Day.

Whoever I had become had to die.

I drank until February. Then I called Jimmy from another room above another pub.

"I give up," I said. "I can't drink and I can't not drink. I'm too sick to live and too chickenshit to die."

"Oh that's great, Craig," he said with genuine warmth, which made me even more uncomfortable. Jimmy doesn't normally do warmth; he does sarcastic, glib, or cranky. Sometimes, impressively, he does all three at the same time.

"I've been waiting for this call," he said, which didn't make me feel any better, either, but he calmed me down and just, well, took over and rescued me as if I'd been drowning and he'd pulled me ashore. He flat out saved my life. He hates it when I say this, and reading about it will make him squirm, but I don't care. I know it's true, and so does he.

Jimmy used his new influence in the alcoholic rehab world and finagled me a bed in Farm Place, one of the finest rehab centers for addiction in the U.K., if not the world. It was terribly expensive and I couldn't afford it, as my personal debt, including the money I owed on the house in Dunwich, approached a quarter of a million dollars and I had no health insurance, but Farm Place took me on credit, something they rarely do. Apparently Jimmy put in a word and told them that if I made it, I wouldn't be able to live with myself without paying them back. That I'd sooner die than owe anyone money for helping me.

Apparently Jimmy knew more about me at that point than I knew about myself.

On the bleak and bland daybreak of February 18th, 1992, I had a glass of warm white wine poured by my younger sister, Lynn, who had since moved to London and lived near the flat I'd once shared with Helen. The wine was to steady my nerves before I went for the cure. At nine a.m., Jimmy picked me up in his big, warm, expensive car.

And that is how my drinking ended. A tepid liebfraumilch on a Tuesday morning.

Farm Place is in Surrey, about an hour outside London. On the way there I told Jimmy that not only was I going to stop drinking and get myself right, I was going to quit smoking and lose weight, too.

He pulled into a gas station and bought me a carton of Marlboro lights and some candy.

"In case you change your mind," he said as he tossed them to me.

Farm Place is a gorgeous old English country house, all wooden beams and brick and slate and ivy, reached by a long winding tree-lined drive that runs from the gates to the front door. When Jimmy stopped the car there, a portly, cheerful-looking middle-aged woman stood waiting. She had gray hair and kind eyes and was wearing a plaid dress.

"You must be Craig," she said as I got out of the car. "Welcome to Farm Place. I'm Kirsty."

I felt a lump in my throat like I was five years old and in Mrs. Sherman's office. I wanted to run, just take off across the green fields and never stop.

Jimmy saw the terror on my face.

"Don't worry, buddy," he said. "The war's over."

I nodded.

"And you lost," he added reassuringly.

He smiled and got back in his car and drove off, waving through the sunroof.

Kirsty checked me in. She got me to fill in the requisite forms, and explained the medical and blood tests they would do once the doctor arrived. Then she showed me around the old building. It looked more like a country hotel than a mental hospital, and I suppose it was a combination of the two.

Kirsty told me that there were both male and female patients here who were treated for all forms of addiction; alcohol, drugs, sex, food, gambling, whatever. Meals were served at set times every day and no one could skip them. (I think this was more for the benefit of the anorexics than for the alkies, since we very rarely skip a meal). Therapy sessions were held every weekday, group and individual two-hour sessions in the morning and another in the afternoon. I would be assigned a counselor later. No visitors or phone calls in or out were allowed for the first ten days. All patients slept on the premises and had at least one roommate. Absolutely NO fraternizing with (as in fucking) the other patients. And no drugs, ever.

Patients were expected to help with maintenance chores, and anyone the counselors believed was adversely affecting the health or treatment of other patients or disrespected the staff could and probably would be asked to leave.

I told her I understood, and then she introduced me to a nurse named Rachel. She was another kind-looking middle-aged lady, with brown eyes and brown hair and pale skin. She had the air of a supportive Labrador, benign and solid.

Rachel ushered me into her office and took some blood. She also checked my blood pressure and pulse and poked around at my liver and lymph nodes.

"Seen worse," she said, softly.

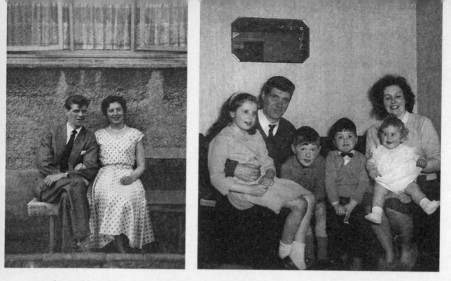

Left: Bob and Netta Ferguson, my ridiculously attractive parents in 1952.
Right: The Fergusons of Trobrex Road, circa 1965. Which of these children
will grow up to become a vulgar lounge entertainer? *Left to right:* Janice,
Bob, Scott, me, Lynn, and Netta.

Muirfield Primary School, 1969ish—me, top row, third from left. The kid
to my left was a rotten bastard.

All photographs courtesy of the author unless otherwise noted.

Left: With my dad and my uncle James on my first trip to the U.S. in 1975. My mouth is still healing from the fight at school.

Above right: Peter Capaldi, the charismatic singer, on stage with The Dreamboys, my first (and best) real band. *(Simon Clegg)*

Tricia Reid (in the plaid scarf): the punk rock goddess who ditched me for cheating. *(Simon Clegg)*

Left: My brother, Scott, and me in 1981, as Evelyn Waugh would have written us.

Above right: Robbie, my "not gay" gay roommate in 1982. He is even cuter today.

Below: Me drumming with a band in 1983. I can't remember which one. This is photographic proof of alcoholism.

Above: With my first wife, Anne, in Long Island in 1984. Given my behavior, it's a wonder she didn't throw me overboard.

The cover of my first stand-up comedy album under the name "Bing Hitler."

My only academic achievement.

1990—Helen, the English actress whom I adored enough to try and stay sober, with my grandmother Jean in 1990. Two tough women who loved me despite themselves.

Above: Mum and Dad and me backstage with Tom Jones in 2000. A few moments after this photo was taken, Tom's sexiness set the room on fire.

My second wife, Sascha, and me at the premiere of *Saving Grace,* the movie I am proudest of. (*Getty Images Entertainment*)

My parents with their first American grandchild, Milo, in 2002.

Below: I owe my talk-show career to Peter Lassally, the legendary producer of *The Tonight Show Starring Johnny Carson*. (John P. Filo)

The Ferguson brood (my parents, Robert and Netta, are in the second row) in 2005.

With Megan in Washington for the White House Correspondents' Association Dinner in 2008. We were not yet married, but there can be no greater declaration of love than attending this affair with the host. (*Joshua Lebowitz*)

Megan and me standing too close to an airplane.

Vice President Cheney appraises Megan's diamonds. (Look at the size of those hands!)

Left to right: John Naismith, me, Philip McGrade, and Alan Darby at my wedding to Megan in 2008. I am actually happy in this picture, which was unusual for me when getting married. *(Shari McBride)*

My uncle Gunka James in 2009—still crazy after all these years.

"You're overweight but you are malnourished. Your blood pressure is high and your liver is enlarged. Your pulse is racing a little, but everybody is like that when they get here. When did you have your last drink?"

I told her about my glass of wine with my sister and she nodded. She asked about my drinking for the previous few weeks.

"Yeah, you're the real deal," she said after I told her. "Take these."

She handed me a few pills in a little plastic container.

"What are they?" I asked.

"One is an anticonvulsant. Guys who drink as much as you did will often go into fits when they stop abruptly. The other is hemineverin. It's a mild tranc, it'll stop you going into delirium tremens. You had them yet?"

I had lived in fear of the fabled terrifying visions that assail chronic drinkers, but which had not yet attacked me. I told her that, too.

"Lucky. Days away, I'd say. That's how a lot of alkies die. Heart failure during the DTs. Hallucinations just scare the poor bastards to death."

I told her that I didn't want to take any drugs. That I had come here *not* to take drugs.

"Listen," she said, not unkindly, "up until now I would say that ninety-nine percent of all the narcotics you have taken in your life you bought from guys you didn't know, in bathrooms or on street corners, something like that. Correct?"

I nodded.

"Well, these guys could have been selling you salt or strychnine. They didn't care. They wanted your money. I don't care about your money, and, unlike your previous suppliers, I went to college to study just the right drugs to give to people like you in order to help you get better. So, bearing all that in mind . . . take the fucking drugs!"

I took the drugs.

A little later, I sat alone in the TV room, waiting for the other patients to come out of therapy. My nose was itching terribly from the hemineverin. I turned on the TV but kept the sound very low, not wanting to cause trouble. There was a commercial for Gillette razors on the screen; lots of square-jawed guys playing sports and hugging their dads or kids or wives, all of them with the healthy sheen and perfect teeth I identified with Americans. The advertising jingle trilled enthusiastically:

"Gillette—the best a man can get."

I stared at the screen. What had happened to me? I was meant to be one of those guys, vigorous and athletic and successful and, most of all, *American*. I was going to walk on the moon, be a movie star or a rock god or a comedian. I was going to have an amazing life and kids with Helen and die like Chaplin a thousand years from now in my Beverly Hills mansion surrounded by my adoring family, with the grieving world media standing by. Instead, I was just another show-business mediocrity. A drunk who shat his pants and ran for help.

My life had been careless and selfish. Pleasure in the moment was my only thought, my solitary motivation. I had disappointed whoever had been foolish enough to love me, and left them scarred.

I was a very long way from being the best a man can get.

29

Reboot

My rehab counselor, Brian, explained that I had been suffering from a disease, that alcoholism was not just the expression of a morally incompetent mind but rather an unavoidable malady for those afflicted. It was a spiel I'd heard before and I thought it was a cop-out, an excuse for my behavior. Brian, a mega-tanned, mega-handsome ski-instructor type who looked unnervingly like the dudes in the Gillette commercial, said he didn't give a shit about what I thought or how I felt, whether I or anyone else accepted the concept of alcoholism as a disease didn't matter; what mattered was that when treated as a disease, those who suffered from it were most likely to recover. Therefore why debate it?

That made some sense, I had to admit. Brian also assured me that I would not be excused from making amends to everyone I had harmed. In order to get and stay sober I was going to have to clean up the wreckage of my past. I found the prospect daunting, but somehow comforting, too, because the counselors insisted it could be done, and, after all, many of them were recovering alcoholics themselves.

I had two roommates, let's call them Matthew and Lucerne. Matthew, a Church of England vicar, was sixty years old and in

treatment for the first time. After one of his parishioners came to him complaining about some drunk he'd seen sleeping on top of the tombs in the churchyard, Matthew decided he'd better get help before anyone figured out it was him.

Lucerne was a rail-thin hope-to-die junkie in his twenties whose father, a rich Swiss banker, had thrown him into Farm Place in a last-gasp attempt to save his son's life. It worked.

It worked for all three of us, actually. We all made it through those grueling weeks of harsh self-examination and evaluation. There are a million books about recovery and rehab, some written by charlatans and some by people far more qualified than I to discuss the subject, and if you want to stop drinking you could do worse than read a few, but you could save yourself a good deal of money and time by just looking up an organization very near the front of the telephone directory.

When Jimmy came to pick me up two months later, I was, in the words of Raymond Chandler, "clean and sober and didn't care who knew it." My confidence didn't last long; it was already waning on the drive back into London. We passed what seemed like a million pubs and I felt terribly vulnerable. How was I going to stay out of pubs after spending my life in them? Jimmy said he thought I'd figure it out.

"I don't know how I can ever repay you for what you did for me," I told him.

"Just do it for someone else one day. Pass it on," he said.

And so I have, many times.

I believe it's the only way I can retain the right to remain sober.

I stayed with Jimmy in London for the first few nights but then headed back to Glasgow because I actually had a job there. Philip Differ, the BBC producer who'd worked on a Bing Hitler special a few years before, had offered me a series of my own. It would be broadcast on BBC Scotland, not throughout the U.K., but it was a great offer, and one that Philip didn't take back even when he

heard I was in Show-Business Hospital; he just delayed the start of production till I got out. As a prominent TV producer, Philip had encountered plenty of alcoholics, but I think I was the first he knew who'd sobered up, and it fascinated him. When the suits wanted to shitcan the production because of my adventures in rehab, Philip defended me, and we went on to make a couple of series together. Philip's kindness and steadfast loyalty were hugely helpful in putting my life together.

The first series Philip and I did was a half-hour sketch-comedy show called *2000 Not Out*, and I wouldn't call it a high point in either of our careers. The persona I created was meant to be a mysterious yet comic Rod Serling sort of character, but I was still rusty and tweaked from being newly sober. The makeup people got overly enthusiastic and turned me into what looked like an anxiety-ridden Pakistani maître d'.

The good thing was that I'd be spending the first few months of my sobriety writing and filming the show in Glasgow, where I would be less likely to fall into old patterns. By this time I had not actually lived in the city for five years and didn't even know where the cool bars were anymore. Thank God.

Through Jimmy I met John Naismith, a Scottish businessman and former drunk who lived in London and who would become a kind of guardian angel to me.

Some people turn to a priest or minister or other clergyman for spiritual guidance, or, if they live in L.A., perhaps to their Pilates instructor or publicist, but I turn to my friend John.

He grew up just outside of Glasgow and had lived a very similar life to my own, but was fifteen years ahead of me, both chronologically and in terms of giving up drinking. John had shown great

promise as a young man but was constantly being dragged down by his alcohol intake. Having managed to stop drinking long before I did, he agreed to help me along on the path to something more closely resembling normalcy. Given the remarkable parallels in our backgrounds and life stories, it seemed a convenient symbiosis. John would look out for me and help me through those first few difficult months of abstinence, while I would serve as a reminder of what it was like to be crazy, and of how foolish it would be ever to try drinking again. What started out as just one ex-drunk helping another became a deep and valued mutual friendship that survives to this day.

Some people, I suppose, are restored to sanity the minute they get sober. That was not true in any way for me. I think I got even more peculiar after rehab but was just a little more effective than most at hiding it. My mind rumbled like a bad neighborhood. To be stuck in there alone felt dangerous, particularly at night. Plagued by terrible fears, I had nightmares almost every time I closed my eyes, making sleep very difficult, and for a while I experienced frightening bouts of rage that I had difficulty understanding, let alone controlling.

I was still looking long and hard at my life thus far—where I had fallen down, where I had tripped, where decisions I'd made could at best be described as unwise. John helped me through this painful process without ever making me feel that he was judging me. Many times, as I talked through some difficult or embarrassing incident in my past, he would bring one up from his own that matched or even bested mine in some way. It was hard not to be impressed by how crazy he had been. My moods became a little more even. I felt less afraid, and a lot less angry.

I was ready to begin trudging through the amends process, getting in touch with many people I knew I'd treated badly, telling them that I was sorry and if there was any way to put things right I would. Some people I didn't call: John said that the best way I could

put things right with them was simply never to bother them again. But my ex-wife wasn't in this group.

The most difficult move I had to make, the one that I dreaded more than any other, was contacting Anne. I just felt so rotten about how I had treated her, I didn't know where I would find the nerve to call her, and couldn't begin to guess how she'd react. Fate forced my hand in the end. Walking home from the BBC one day, I turned a corner and there she was. I asked if she had time for a coffee and she said of course. We went to a nearby café and I laid it all out, told her how I felt about having been such a prick and how badly I wanted to make it up to her, to make it right between us. She started crying. Then she told me she was happy I had found a better way to live and didn't feel I was totally to blame for the failure of our marriage—a staggering notion that I, in my self-obsession, had not considered. Anne said that she had been so wrapped up in her own desire to settle down and build a family that she couldn't or wouldn't see how crazy I was, how incapable of giving her what she wanted. She still cared for me, and the best way I could make amends to her was to be happy.

I do have a knack for finding great women.

Helen and I tried and failed to repair our relationship. She visited me in rehab, and once I was sober and working in Glasgow she came there, too. But something had ended, something had died between us, and we couldn't resurrect it. Maybe we had both become too sad to find a way back. I realized that the best thing I could do for Helen was to let her get on with her life.

Eventually I sold the cottage in Dunwich, at a horrible loss that racked up even more debt, but first I had to make the miserable eight-hour trip down there from Scotland to remove the last of my

belongings, which was no simple affair, as I had been banned from driving after my DUI.

By now I'd learned that when things are really tricky it's best to rely on the people you know you can trust in a tight spot. I called and asked Gunka James for help, and he drove me in his beat-up Volvo. I was very glad to have him there because loading up the car and leaving that house was enormously sad, and I was filled with sorrow. Gunka is the right sort of guy to be around when something troubling is going on, as I had discovered when I was eight years old.

On the way back I reminded him about the time he took me to that record store and how deeply it had affected me, and how he got the driver to stop the bus in Moodiesburn so that I could take a wee boy dump in the old lady's magic lavatory.

He of course had no recollection of it but made sure we took plenty of bathroom breaks on the drive home.

30

Buying a Knife

After six months of the sober life I began to feel a little better. I was in good physical shape because I was working out every day; I was more confident, and happier, and, frankly, horny. My work in Glasgow was finished and I didn't feel that I belonged there, but as I was still too raw to try America, I went back to London.

I don't know what happened to the city of London when I was away for those six months but something had changed. It didn't seem as dark and gloomy, it didn't seem as frightening or dangerous. And, by George, the girls were beautiful. That town was vastly improved by me getting sober.

I stayed in my friend John's spare room for a few nights while looking for an apartment. I didn't have much money to spend on a place to live and I was still paying off debts. Though I had considered declaring bankruptcy, John told me I had to pay everyone back, with interest. By the time I was clear of all the money I owed, I'd been sober for seven years.

I found an attic flat in central London just off St. John's Wood High Street, near Regent's Park. Through John I met two more expat Scots, Philip McGrade and Alan Darby. Neither of them drank, for reasons of their own, but they still knew how to have a good time and set about teaching me that skill.

Philip, a giant, ginger man with an astonishingly quick and profane mind, taught English to Pakistani kids during the day and did stand-up comedy on the London circuit at night. Alan was blond and pretty and a very successful musician who was playing guitar in Eric Clapton's band when we met.

With John, we formed a little Caledonian mafia, a wee Scotia Nostra. These men are like brothers to me and to this day are my closest friends. Philip, who later emigrated to America, now works alongside my sister Lynn as a writer on *The Late Late Show*.

In London we'd meet in coffee shops and restaurants, see movies or bands or comedians, and, most of all, chase girls. Not that they ran too fast.

English girls, especially those in London, are friendly and saucy and confident and funny and fun and want to have a good time. They also really seem to like boys with Scottish accents who aren't falling-down drunk. The affable women of Chelsea lit up my first two years of sobriety and I shall always remain grateful for that.

The first woman I dated in London was a striking redhead who worked as a counselor in a treatment center during the day and as a drummer in a band called the Lower Companions at night. She introduced herself to me at a party, telling me to call her Rock and Roll Susie, which I was happy to do. She was older than me and lots of fun, a woman who really sucked the marrow out of life. Susie knew I was newish to sobriety and in no way a good bet for

anything long term. This was fine by her since she didn't want a real relationship anyway. A win-win, I suppose.

While dating Susie, I was hired to play a small part in a BBC-TV Christmas special called *One Foot in the Grave*. It was shot in southern Portugal and they flew me out there for two weeks. I was delighted to get the job, not only because I needed it but because it reunited me with Peter Cook, whom I hadn't seen for some time. Our filming schedules were a little different, so I arrived before him, shot a scene, and had a few days off before I was slated to return to the set. Susie flew out from London during the hiatus and I picked her up at the airport in the very battered and smelly Renault 5 I had rented.

"Nice ride," she said. "Hey, I was looking at a map on the plane. It's not that far to Africa. Just a few hundred miles. Let's drive there."

I told her that would be a little scary.

"Really?" she said. "I had no idea you were such a girly-man. I sometimes wonder if fear isn't just God's way of saying, 'Pay attention, this could be fun.'"

I thought about that for a moment. Then I hung an illegal U-turn, much to the beeping consternation of the Portuguese commuters, and headed east across the Portuguese border into Spain. We drove down the southern coast, on the hot, dusty, and deserted roads lined with orange and cork trees until we reached the seedy port town of Algeciras. We crossed the Straits of Gibraltar on the car ferry that night, the Renault stowed away in the hold. There was no wind and the sea was glassy and calm and a low crescent moon hung above the dark silhouette of the Atlas Mountains. As we neared the Moroccan coast I could hear the call to prayer coming from the minarets, signaling the final devotion of the day.

When the boat docked, we rolled the Renault out past the noisy and intimidating hordes gathered on the quayside and started driving along a bumpy unlit road until a broken-down fleabag hotel

loomed ahead. We checked into a room and reunited enthusiastically.

The next morning we walked around the town of Tangier, Susie bought some beads and dangly earrings, and I bought a big curly scimitar with fake jewels encrusted on the decorative handle. We had a glass of mint tea with a Bedouin tribesman who tried to sell me whatever he thought I might buy—a carpet, hashish—and then we got back in the car, returning to Portugal in time for me to get back to work. We made the whole strange and wonderful trip in three days. It occurred to me that had I still been drinking I would have lain by the hotel pool, getting smashed the whole time. I felt I was really starting to get the hang of the sober thing. I felt good.

Peter Cook arrived just as Susie returned to London and seemed as happy to see me as I was to see him. After the day's filming we went out for dinner, just the two of us. I didn't bring up my not drinking and if Peter noticed he didn't say anything, though he happily drank wine all through dinner. Some of the other actors and crew members came into the restaurant as we were having dessert and an impromptu party got going. From there, we all went to a local nightclub and after dancing to bad house music for two hours we moved on to the beach, where those so inclined could smoke their wacky tabacky and drink their duty-free brandies. It was dawn before everyone staggered back to their hotel rooms, many of us hooking up with people we shouldn't have.

Later that day, having finished filming my role, I was packing my bag to go back to London when there was a knock at the door. It was Peter, looking ever so serious and uncomfortable. I had never seen him like this before.

"Can I talk to you for a minute?" he asked.

"Of course," I said, ushering him in. "What is it?"

He told me that he'd been watching me closely the night before

in the restaurant, at the nightclub, on the beach, and had not seen me take a single sip of wine or hit from a joint. I told him he was right, I had not.

"Yet you seemed to have a great time."

"I did," I told him, my cheeks flushing at the thought of the conversation I had to have with Susie when I got back to London.

Peter considered this for a long moment, and then, in a quieter voice than I had ever heard him use, he asked, "How do you do that?"

I told him it took a little getting used to but I could introduce him to some people in London who could help him out if he wanted me to. He said he did and agreed to call me when he got back to town.

It was a while before I heard from him, months and months, but then he called and said he was about ready to get sober. He caught me at a terrible time—I was literally walking out the door with my bags packed to start a two-month tour of Britain playing Oscar Madison in *The Odd Couple*. I gave him a few telephone numbers and told him we'd meet up when I returned.

Peter was dead before that could happen. His body finally gave out against the constant onslaught of alcohol. To this day I wish I had done more to help him.

Providence

In 1994, I returned to the Edinburgh Festival. *The Odd Couple* revival was a big hit and it was packed every day for its afternoon show. At night, in the same theater, I performed a stand-up show I had written called *Love, Sex, Death, and the Weather*. This also proved to be a hit. It seemed that I performed better sober than drunk. Who knew?

I was riding high and feeling pretty good about things when, one night after my stand-up show, I walked into the artists' bar, the same place I had seen Helen wearing that orange dress years before, and ordered my (now) usual club soda and lime. When I turned around I stood face-to-face, better make that face-to-chest, with Rick Siegel, the giant-sized American talent manager I had met in Montreal in '87, the guy who first told me Bing Hitler wasn't such a great name for a long run in showbiz. He'd flown in from L.A. to work with a client of his, the comedian Robert Schimmel.

"What the fuck happened to you?" he said.

"What do you mean?" I said.

"You're all thin and healthy-looking and sober, and I just saw your show and it was great."

I thanked him but he brushed my gratitude away like it was a bad smell.

"No, I'm not blowing smoke up your ass. You need to get back to America. And you need representation."

I pretended to be skeptical, but like most skeptics I was really just afraid. I had made a couple of failed attempts at an American career when I was drinking. In 1987 after Montreal, I had auditioned for a spot as a VJ for MTV in New York but they had decided a drunk, incoherent, vaguely enraged Scotsman with an indecipherable accent wasn't exactly what they needed at that point.

Two years later I played the Montreal festival again and fared somewhat better. CBS talent scouts were there and I was cast in a pilot for an hour-long teen drama called *High,* in which I would play a high school teacher who was hip and foreign and really understood the kids.

That show hadn't worked either, and though this wasn't entirely my fault, I played a part by being out of shape and drunk during filming. Two of the kids involved in *High* went on to bigger things. Gwyneth Paltrow played one of the kids (her father, Bruce, was the show's producer), and Zach Braff had the role of the school's troubled nerd. I was too hammered on the set to remember either of them. Many years later, when Zach and I were both backstage at some Hollywood awards broadcast, he told me he'd been in the show too, and he probably thought I was being an asshole when I said I couldn't recall him—but I really couldn't.

I could blame my previous disappointments on alcohol, but what if I returned to America sober and failed again? Then I could only blame myself. Maybe it was safer to dream of being a success in America than to actually attempt it. Rick made a deal with me. If I came to L.A. for two weeks in November he would set up some meetings with studio casting executives and get me some stand-up showcase spots at the Improv comedy club. I could save money on a hotel (a good thing, as I was still quite broke) by

sleeping on his couch. The trip would only cost me airfare, and Rick said he was confident that in those two weeks he'd be able to get me some kind of a deal somewhere. But if not, I'd just go home. The worst thing that would happen was I'd have a vacation and get a tan.

"What's in it for you?" I asked.

"Fifteen percent of everything you earn, if you earn anything. I'll be your manager."

When I spoke to John about it he reminded me that I was always bleating about how I wanted to go to America and now that I had received an invitation I should go.

My parents told me the same thing one afternoon during a visit to their house, and then my mother told me something else.

She had cancer.

I decided right there that I wasn't going, I wasn't about to leave Scotland while my mother was literally fighting for her life, but my mother said I was being melodramatic. She had non-Hodgkin's lymphoma, with a decent chance of making a full recovery, and her chemo treatments weren't scheduled to begin for a while. I could leave for two weeks and come back and nothing would be different. I would be going for work (and remember: work = love), and Dad agreed with her. So in November of 1994 I went to L.A. on Rick's invitation for what I assumed would be a short, fun, but ultimately futile trip, professionally speaking.

Right from the beginning, Rick delivered more than he had promised. I turned up expecting to sleep on his couch but he had made arrangements with a friend of his, the actress Brenda Bakke, for me to house-sit her place in Santa Monica while she was in New York City doing a play. It was a sweet little yellow house on Sixth Street, and from the front porch you could see the Pacific. I splashed out and rented a blue Jeep Wrangler convertible, thinking I was the fucking cat's pajamas as I drove round L.A., feeling like a

movie star but looking for all the world like a moderately successful hairdresser.

Rick and I met with casting agents and executives at all the big studios. I will never forget the thrill of walking onto the Warner Brothers lot for the first time, seeing the giant soundstages, and witnessing the casual hum of the entertainment industry. Actors in costume chatting with irritated agents, chubby teamsters moving with aggressive sloth, fake New York and fake Wild West—this was real showbiz. This was Hollywoodland, the place I'd been dreaming about since I was a child. Sometimes I still feel that thrill, even today. On the way to or from a meeting at one of the studios I'll see an actor or a set or an empty soundstage—and I will stop dead, in wonder that I finally got here.

The casting people Rick set me up with were nearly all women or gay men, which seemed to work well for me in the meetings, but no one followed up with any kind of a deal. It was always that old showbiz standard rejection line "We love you, but . . ."

I did do a ten-minute stand-up spot at the Improv and it seemed to go pretty well. Lots of people laughed, anyway, and industry types in the room said to Rick that they loved me, but . . .

My last meeting was at Disney Television, then being headed by Dean Valentine, who was supposedly one of the toughest guys in show business and legendary for his crankiness. I wasn't hugely hopeful about this meeting. Neither was Rick. It had been set up by Disney's head of TV casting, who had seen me in Montreal years before and agreed with Rick that I had changed sufficiently to be of potential interest to the company.

The Disney meeting was held in a giant air-conditioned oak boardroom with lots of fussy executives hovering around Valentine himself, who bore a worrying resemblance to the Satan of my imagining—slightly balding, with thin dark hair, thin lips, a thin trimmed beard, and cold angry eyes. As everyone sat around the

table, Rick began his flowery sales pitch about how sexy and great and marketable and brilliant I was. The junior execs nodded enthusiastically while glancing every so often at Dean, who looked as if he might fall asleep, or vomit, or both.

When it was my turn to talk I poked fun at Rick for overdoing it. This, wonder of wonders, seemed to crack something resembling a smile from Mr. Valentine. Encouraged, I pressed on. I told a few ribald drinking stories that seemed to make the nodding executives very uncomfortable. I yakked a bit about the old country and how I had made such a train wreck of my life there. I gave them my impressions of Los Angeles, which were by and large favorable, if somewhat condescending.

To my amazement, Mr. Valentine opened up. He laughed at the right places, asked a few questions, and after about twenty minutes he said:

"Well . . ."

That meant the meeting was over. So we all stood up. He shook my hand and said, "What do you want to do if you come here?"

"Take my shirt off and kill aliens," I said.

He smiled and said that was more for the movies than for television. I told him I was prepared to slum it for a while.

The head of casting walked us out to Rick's car. "I've never seen him like that," he said, beaming. "I think you boys might have a deal." But of course it's never that simple.

32

Scottish Women

Rick and I waited for some news from Disney but all we could get out of them was that they were thinking about it. I delayed my return home in the hope that something would happen and as luck would have it, my friend John turned up in L.A. on business. He was headed to Las Vegas for a convention and, as I had never been there I said I'd drive him. It didn't take long before we realized that traveling by car across the high desert in winter is not the sort of trip you want to make in a convertible, and like bickering wee girls we fought all the way there over who was sitting too close to the heater.

I dropped John off at the convention and before I turned back to L.A. I had myself a look around Sin City. I was intrigued and captivated by the sleaze and desperation, and thanked my lucky stars I had never been here drunk; I don't think it would have ended well. The town itself made me uneasy, so I got out of there pretty quickly, savoring my solo access to the Jeep's pitiful heater all the way across the Mojave Desert.

The desert is magical at night, and, with the instincts of a bikini model in a slasher movie, I turned off of the interstate and headed out into the wilderness for about five miles. Then I stopped the

Jeep on the lonely dirt road and listened to the silence. I got out and walked away from the car and looked up at the immense blackness of the night sky, and the tininess of myself against the enormity of the universe had never been more obvious, even on acid.

An inexplicable bolt of terror shot through my system. Then I remembered what Rock and Roll Susie had said, that fear might be God's way of saying, "Pay attention, this could be fun," and I said aloud to whoever was out there, even if it was only me:

"Between safety and adventure, I choose adventure."

I stood for a bit longer until I started to feel a little foolish. Then I got back in the Jeep and drove to L.A.

There was still no news from Disney when I returned, and after talking on the phone to my sister Janice, who said that our mother seemed to be getting very ill very quickly, I decided I had to get home. The only affordable flight to Scotland I could find required a one-night layover in New York, and I took advantage of it by reacquainting myself with the old neighborhood. I strolled up from the East Village to Union Square and went into Coffee Shop, one of my old haunts, to get some milky caffeine and check in with Rick to see if anything had happened. It was 1994, and though some people were using cell phones by then, I was certainly not one of them.

I dropped the required quarters for a long-distance call into the pay-phone slot and plugged a finger in my ear to try and block the busy diner noise.

Rick, once I reached him, was in an excellent mood.

"They'll give you a hold deal for pilot season. Congratulations."

I asked him to translate.

"They'll give you fifty grand to live in L.A. for the first three months of next year and audition for TV producers they're developing shows with. They'll also pay for your visa and immigration bills and will sponsor you for a work visa."

I said that sounded very generous, and Rick agreed.

"Welcome to America," he added.

I thanked him. Then I headed back to the airport for the second leg of my trip home.

The plan was to go to London first, pack up my apartment and put anything that I couldn't or wouldn't ship in storage. Then I'd join my family in Scotland for Christmas, returning to Los Angeles, as required, around the first of the year. Unfortunately by the time my plane touched down at Heathrow my mother had taken a turn for the worse and was now in intensive care, so I went directly to the hospital in Glasgow.

There I learned that my mother had accidentally been poisoned. She'd been receiving injections of gold for a few years to help alleviate the symptoms of her crippling arthritis but no one had figured out that these treatments had already so compromised her immune system that she wouldn't be able to tolerate the cancer drugs. Essentially it was like giving chemotherapy to someone in the latter stages of AIDS.

My mother was still in the ICU when I reached the hospital, where I found my father and brother and sisters. They tried to prepare me but I couldn't help being deeply shocked when I saw her. Ma was unconscious and hooked up to what seemed like dozens of machines. She seemed small and helpless in a way I had never imagined, with a plastic ventilator tube stuck down her throat and the other end of it taped to the side of her mouth. I remember being struck by how invasive that seemed, even though the apparatus was keeping her alive, literally breathing for her.

While the rest of my family came and went, I sat by the bed and told my unconscious mother all my news about America and droned on about the trip to Las Vegas, even though there was no response. It seemed she might die at any moment.

I asked to speak to a doctor about her condition but it took a long time before anyone was available. This made me furious, until

I found out why. There had been a terrible pileup on the local motorway and the medical staff was overwhelmed. Eventually a young and blond and beautiful woman doctor came.

"I'm sorry for keeping you," she said in a clean and clear Edinburgh accent.

I glanced at her OR greens, which were spattered with little flecks of blood. Her eyes were bright and she seemed a little hyper, which was understandable enough, given that she had been engaged in hand-to-hand combat with death. I felt ashamed and uncomfortable that she'd be apologizing to me.

"It's okay. I heard you were busy."

She gave a sad little smile, and I swear that for a moment I felt I was in the presence of a genuine angel.

She told me that my mother was very ill, which I could see for myself, but that upon arriving at the ICU her life expectancy was estimated to be about fifteen minutes, and that was twenty-four hours ago.

I asked if she was close to death now.

"I don't know," said the doctor.

"What treatments can you give her?"

"We can keep her comfortable and hydrated. The ventilator will keep her going. Other than that, I don't know what we can do."

I wanted to be angry, at the doctor, at someone, anyone, but there was no point. Everybody was doing their best.

They took Netta off all the meds she was on, everything, and for some reason that no one could explain, her vital signs started to improve. The ICU staff was amazed at how she clung to life, but of course they had no idea just how tough my mother was, and after a few days she regained consciousness. She was still on the ventilator and couldn't talk, so she communicated with us by scribbling notes on scrap paper at the side of her bed. It took a lot of effort, so she kept it to a minimum.

I told her again about my adventures in L.A., only this time she could hear me and even tried to smile when I told her about driving to Vegas with John. She had always wanted to see the place, so I lied and told her Vegas was spectacular.

I also told her that I'd been invited to move to America but was going to wait until she got better before I did any such thing. This agitated her enough to indicate that she wanted some paper. I placed some in her hand, along with a stubby pencil, and after a struggle she wrote:

Still go.

Then she closed her eyes, exhausted.

I wasn't sure how to react to this so I went to visit Jean Ingram, my mother's mother, on the way home from the hospital. Jean was in her eighties by then and was living in an old folks' home nearby. She suffered from terrible arthritis but her mental faculties were still very sharp. I gave her the latest from the ICU and then asked Jean what she thought about Ma's note. Jean said, "She's right. Still go. This is your life, son, not your mother's. All you can do here is be another greetin' face at the bedside."

"She's my mother, Nana," I said. "She'll want me here. She's just saying I should go 'cause she knows I've always wanted to live in America, but America's not going anywhere. It can wait."

Jean argued that Netta wasn't "just saying it." She really meant it because she wanted what all good parents want for their kids, for them to be happy.

To which I said I couldn't be happy running off to America if it meant leaving my mother to die in Scotland without me.

Jean clucked and shook her head like I was being an idiot.

"And what if you lose this opportunity you've been given and your mother dies anyway. What will you have achieved?"

It's difficult to explain the resiliency of Scottish women without romanticizing them, which wouldn't play very well with Scottish

women. Being one of them herself, Jean might seem callous, especially as she was talking about the death of her own daughter, but women of her generation had seen their fathers killed in the First World War, and their husbands and brothers in the Second. These daughters and wives and sisters had themselves been shot at and bombed and starved and had not faltered. To them, practicality took precedence over all. "Whatever it took you" expressed their attitude. In other words, make a living or die.

For all its macho posturing, Scotland is not a patriarchy but a matriarchy. The women run things. Certainly that's how it was in my family. So I told Jean I'd think about it, kissed her cheek, and went home to help my dad put up the Christmas tree.

The deal I made with myself, and then with Netta, was that if and when she recovered sufficiently to breathe on her own and have the hated plastic tube removed, *then* I would go to the States. If she didn't, I wouldn't. Netta loved a challenge, so with the doctors scratching their heads, she continued to improve. She was moved out of the ICU and into a room of her own, complete with TV, and within a few days she was breathing unassisted. Her mouth and throat were still sore from the ventilator that had been in place, so she spoke quietly but she was sitting up in bed and drinking tea and even had some color in her cheeks. As soon as she could, she was ordering everyone around and telling them what needed to be done. My job was to go to America.

I said I would delay for a bit because after all she wasn't out of the woods yet, she still had cancer and needed treatment—now radiation instead of chemo—but she said no. And that was that.

So on January 25, 1995, I arrived at LAX with two suitcases full of clothes. I had left a mountain of debt and a sick mother back home and I was in no way convinced I was doing the right thing, but a

deal was a deal, and I had made one with my mother, and another with Disney.

If I wanted to get paid I had to be here—and, to be honest, every time I get off a plane from another country and realize I'm back in the U.S., I get a charge of excitement.

It feels like anything is possible, that the adventure of my life is finally unfolding as it was meant to. It feels like I'm where I should be, at last.

33

Dudley and Jadis

I thought the fifty grand I got from Disney would last a long time and even allow me to pay down a bit of the massive debt I still owed from my drinking days to various banks and credit card companies, and the Farm Place as well. I clearly hadn't thought this through very well. After Rick took his commission and taxes were deducted, I still had to put down the first and last months' rent, and of course I had to buy a car, because no one could exist in L.A. without one, and it would be nice to own a TV, etc., etc. I was burning through the money at a scary pace, but Rick stayed calm and confident. He told me not to worry, he had every confidence that I would be making plenty very soon and that I would be rich in no time.

With that vision in mind, he had arranged lodgings for me that I obviously could not afford. He got me a sublet in the swanky Pacific Palisades area of L.A. A small white clapboard house on Amalfi Drive owned by an elderly Australian lady who wanted to return to her homeland for six months. I could stay there for a reasonable price if I took care of her ancient grumpy golden retriever, Dudley, and a pissy cat called Jadis who reminded me a lot of the dreaded Ken.

It was a great deal for the money, but since I didn't have any,

it didn't matter how great the deal was. Still, Rick told me not to worry, and, wonder of wonders, he was right. Again.

Rick sent me out on auditions to meet TV producers who were casting pilot shows for the next season, all of them aligned with Disney in some way, as per my deal. On my third audition, after being in the country less than a month, I struck pay dirt.

Michael Jacobs, fresh off his hit show *Boy Meets World*, was in preproduction for a half-hour sitcom starring Marie Osmond and the great comic actress Betty White. Marie was to play a café owner and Betty the crazy mother who helped Marie's character run the place. They were looking to cast someone as the café's baker and Marie's eventual love interest, a character named Logan. Although it was in no one's head that Logan should be Scottish, after a few meetings I managed to persuade the producers that this was the way to go, and the network, ABC, agreed. In March we shot the pilot of the would-be series, to be called *Maybe This Time*, on a soundstage in the San Fernando Valley.

The first day of rehearsals was nerve-wracking because I couldn't believe I was actually going to meet a real live Osmond. Until then I didn't believe that real live Osmonds actually existed; to me they were as credible as, say, Scooby Doo, or Santa. Marie was definitely real—a great person right from the beginning. She was funny and charming and warm and kind of sexy, too, although at the time she was happily married, with what looked to be about seventeen children but probably was only five. She and I got along just fine, which was a surprise as I had half-expected some kind of a puritan diva. There were a lot of other Mormons around, too, and I was all ready to be oppressed by them, but it never happened. From what I know about that faith, it's not for me, but I have to say I never met a Mormon I didn't like. On the set they were all so darned friendly and upbeat and secretly kinky—or so I told myself.

Although Marie and I worked well together, it was with Betty that I really clicked. I'd been a fan of hers since I was a tubby schoolboy and she was the sexy Sue Ann Nivens on *The Mary Tyler Moore Show*. Now she was coming off of her hugely successful run on *The Golden Girls*. Betty has been on TV as long as the medium has existed, and she possesses, without doubt, the finest comedic timing of any human being I have ever seen—in movies, TV, or real life. I found her simply astonishing, and there was instant chemistry between us. I think if we had been born a little closer together we would have ended up marrying, or at least spending a weekend together in Tijuana. Actually, I still wouldn't rule out either of those things since I continue to be in love with Betty. She is the most frequent guest on my show, averaging one appearance a month. Probably she's the reason I'm still on the air.

My first experience of making a TV show in the U.S. was a bit unnerving. For a start, there were so many writers, about ten of them, while in the old country there was usually only one writer, and he was me.

All these writers would come to rehearsals every day and laugh uproariously at their own jokes over and over again. I was baffled by this until my new best friend Betty took me aside and explained that they were laughing at the jokes they had written in the hope that the producers wouldn't cut them.

Everyone working on the pilot was very tense during shooting, and that was understandable with so much at stake. A successful sitcom can provide millions of dollars to the production company, the studio (in this case Disney), and the network (ABC), so there are always a lot of management types on the set, and it seemed to me that with all these suits buzzing around it would be a miracle if anything worked. It's difficult to do comedy by committee, because there's always going to be someone who thinks the material isn't funny, and I have concluded that, unfortunately, everyone is an expert on comedy. Really. If you think something's not funny, then

it's not—to you, but it might be to me. I judge whether comedy is good or not by its ability to make me laugh, just like you do. It takes a very single-minded individual to keep his vision in the fog of studio and network pressure, and I fear Michael Jacobs wasn't able to do this during the making of *Maybe This Time*.

He desperately wanted the show to work, to get and keep it on the air, and I think he was a little too willing to accept the input of executives on what was funny instead of trusting himself. But what the fuck do I know?

Once the pilot was shot, I had to sit on my thumbs for a bit, waiting to see if it would be picked up for a series, because under the terms of my deal I couldn't try out for any other TV work—movies were okay, but I couldn't get a sniff from Hollywood. At one point I auditioned to read the audiobook of Mel Gibson's current hit, *Braveheart*, which of course was all about the legendary Scottish warrior William Wallace, but the casting director turned me down. She said she didn't find my accent sufficiently authentic.

The Disney deal did allow me to audition for guest spots on existing series, so I tried out for TV shows like *Diagnosis Murder* and *Murder She Wrote*—just about anything with "murder" in the title, I guess—but I was rejected again and again and again. This produced in me a funky kind of bitterness that I didn't like but couldn't help since I was failing to get parts in shows that I thought were crap in the first place. When I told Rick I wasn't going to audition anymore, he laughed and said it was just a phase I was going through.

To pass the time I read film scripts, even though I had no chance of getting a part in any movies. I was surprised by how awful many of these scripts were (given that they actually were on the verge of being produced). There were thousands more just sitting on shelves that the studios had already paid a fortune for. I didn't know if I

could do any better than these writers had, but I was convinced I couldn't do worse, so I started writing a movie script on spec—what the hell, I had nothing else to do—something called *All American Man*, a romantic comedy about a Scottish shipyard worker and his American girlfriend. Though it was never made into a movie, the script served as a writing sample that would eventually serve me well. I shared the standard immigrant belief that hard work would be rewarded in America. I still believe it, although now I realize it doesn't hurt to have a bit of luck, too.

I also used my downtime to explore my new surroundings. I hung out with Rick a lot—he was the only person I knew in town, after all—and we went to some Hollywood parties, where I met several great friendly girls. I was having a high old time, living the bachelor life in L.A., driving around in my used white Ford Bronco. It was 1995, OJ was awaiting trial, and used white Broncos were going cheap. I got on pretty well with Dudley, the old dog I shared the house with. One of us was very farty but we were both too polite to complain. I even got along with the cat, Jadis. The deal was I would put food and water out for her every day, which suited her, and she would completely ignore the fact that I existed, which suited me.

I was in regular contact with everyone at home, where my mother seemed to be making huge improvements: the radiation therapy was working, and the doctors felt she would make a full recovery, although it wasn't lost on me that they had been wrong before. Things were rolling along pretty well in general.

Then came Sascha.

34

The Aspirations of a Phony Frenchman

Rick decided to throw a little party at Oscar time. His management business was taking off: I had done a pilot that might become a series, and he represented several others in the same position. Rick felt this was the right time for his clients and friends—synonymous, he hoped, with the up-and-comers of Hollywood—to experience the delights of his reasonably priced condo in West L.A. He couldn't afford to have the party catered, so he got a girl he had known in New York and her roommate to help pour drinks and serve the delivery pizza.

It was a Saturday-afternoon affair held the day before the Oscars themselves, and by the time I arrived it was in full swing. Ever since I got sober I've felt pretty awkward at parties—as opposed to my drinking days, when I was fine but everyone else felt awkward—and have developed the tactic of heading straight to the kitchen if one is available. In my experience that's where the most interesting people will always end up, plus there's very little chance of anyone dragging you onto a dance floor.

I talked to Rick for a while, and he introduced me to a few of

his other clients, including a grumpy actress who later went on to become very successful in a TV sitcom and an outspoken Scientologist. Rick told her that I was foreign and she was completely underwhelmed. "Where you from, France?" she asked in her annoying nasal twang.

"*Oui*," I said, and since she kept talking, I pretended I couldn't understand her so she would go away and leave me alone.

Just then the girl from New York who was helping Rick came in wearing a striped T-shirt which clung tightly to her spectacular breasts and a pair of jeans with so many novelty patches on them that there seemed to be little actual denim left. The patch that caught my eye was round and red with "Sex Has No Calories" spelled out on it in white letters. She heard me dismiss the actress in French and asked if I was from Europe.

"*Oui*," I said again.

She rattled off a whole load of French that I had no hope of understanding. I didn't mind, though. I liked looking at her big brown eyes and her shiny American teeth, and I was happy just to be this close to her breasts. When she stopped talking, I just grinned and nodded.

"You have no idea what I just said, do you?"

"Not a word," I told her.

Then she smiled her great big smile and we got down to some real talking.

And that's how I met Sascha.

With her parents she had moved to Paris as a child and attended school there until she returned to her native Connecticut when she was sixteen. She went to Syracuse University and lived in N.Y.C. for a while after college, but the endless bickering of her parents, who'd split up ten years earlier, soon after returning to America from Paris, had since driven her to L.A. Sascha's parents have the worst divorce I have ever seen. They're still bitching and snapping

at each other today. Now that I have been divorced twice myself, I can tell you that it seems to me that the greatest danger is to get so stuck in the resentment stage that you never get out of it.

Sascha and I were full on right from the beginning—we are both pretty impetuous people. At that time she was only twenty-four and just a ball of energy. Rick said "she's crazy" and told me to be careful, and I told him I'd never been all that attracted to women who weren't at least a little crazy. I guessed, but of course didn't say, that he might have had advances rejected by her and was annoyed or jealous that I was having better luck. I found out later that I'd guessed right.

Sascha was working in the music department of MGM and knew a lot more about the film business than I did. She was also more fun than a barrel of monkeys, always had a scheme or a road trip or an adventure planned, and was deeply into physical fitness— a quality I admire in others but don't possess myself. Exercising is prudent for health, but otherwise I'm not much taken with it. Luckily we could shove our differences to the side and just enjoy being together.

On one trip to San Francisco we took one of those little cable cars that climb halfway to the stars. It was a clear day, rare for that city, and I don't know what made the idea explode in my head, maybe it was the blue of the sky or the romance of the tram or the soft breeze coming off the bay. Maybe it was just the view of the notorious island prison Alcatraz, but before I knew what I was saying, I asked Sascha to marry me.

She looked shocked, and then said, "What you mean is that you're happy and you wish you could feel like this forever."

"Yes! Exactly!" I agreed gratefully.

We dropped the subject, but it would return.

My house-sitting deal on Amalfi Drive ended just as I found out that *Maybe This Time* had indeed been picked up as a series. ABC ordered an initial thirteen episodes and I rented a groovy bachelor pad on Sunset Plaza Drive, where the rich(-ish) trash of L.A. gather every lunchtime to watch each other pick at overpriced chicken salads, the men in Armani and aftershave and hair dye and the women in silicone and leopard skin. I really wanted to be part of all that sleazy glamour, but Sascha wouldn't have it and she hated my new apartment on sight. I only lasted six months there before Sascha and I moved in together, renting a little house in Laurel Canyon. In a typical spasm of spectacular inaccuracy, the Scottish *Daily Record* back home reported in its gossip column that I had become engaged to an American woman called Laurel Canyon. The item had an alleged "insider's" assessment: "Craig and Laurel are very happy, said a source close to the couple."

I was pretty happy with Sascha then, at home anyway, but work was a pain in the ass. *Maybe This Time* was killing me. Much as I loved working with Marie and Betty and the other lead actors, Amy Hill and Dane Cook, I was horrified by the writing. I just couldn't keep my mouth shut about how awful I thought it was, nor could I stop making suggestions to improve it. None of this endeared me to the writing or producing staff, but where I came from an actor is treated as a collaborative artist rather than a hired gun, so I approached the work in a way that is anything but normal in U.S. television production. Eventually, after much discussion with Sascha, I decided I had to quit. I'd made enough TV garbage in the U.K. and didn't want to continue the practice in America. I told Betty about my decision before I officially quit and she thought it brave, if maybe a little rash. Marie was astonished. Some of the Mormons even came to my trailer to try to talk me out of it. I thanked them

for their input and then waited quietly, knowing they'd become uncomfortable enough to leave. They really were such nice people. It's not so easy getting out of a TV contract just because you're unhappy with the writing. I would have to get permission from the head of the studio, the Dark One, the Earl of Hell himself, Dean Valentine.

Rick called him and said I wanted out. To my own astonishment, not to mention Rick's and the producers', Valentine let me go. More than that, he said the studio would continue to pay me to the end of my contract. Even though Rick negotiated this, he still can't believe it actually happened. When I saw Dean a few months later at some Hollywood event and thanked him personally for his kindness, I couldn't help telling him that his reputation as a ruthless Machiavellian hardass was unfair.

"Oh no," he insisted, "it's fair. I don't think I was being nice. I made a perfectly sound business decision. The way I see it is you may have a future in this town whereas the sitcom you were on clearly doesn't. If you become a big star I don't need to be remembered as the asshole who fucked you over."

I still think he's softer than he lets on.

After the thrill of quitting, though, comes the cold, harsh reality of unemployment. I kept writing and rewriting my screenplay. I let a producer friend of mine in L.A. from London read the script; and while the story wasn't really to her taste, she liked my writing enough to recommend me to another producer who was looking for a writer to collaborate with him on a project.

Mark Crowdy had found a local news story in his native Cornwall, in England, about a respectable woman who had been convicted of growing marijuana in her greenhouse to escape financial difficulties. He thought it might be a TV show. I said it sounded more like a film. He liked that.

After a genial lunch at Café Med on Sunset, the affable and

charming Mr. Crowdy asked me to collaborate with him on the script. There was no money in it right now, but if the film was made I would get paid, and maybe I could even be in it.

I didn't have anything else to do so I agreed and we started working on a movie we would call *Saving Grace*.

35

The Fat Man, the Gay Man, Vampires, and Marriage

Mark and I worked Monday through Friday and in about six weeks we came up with a first draft. Then he went off to London to begin the long and arduous task of raising the money for production. He felt that since the movie was set in Britain he'd have a better chance of getting it financed there, which made sense to me, but in the meantime I was left with nothing to do. Sascha and I took some trips, and because we were burning through money pretty fast, I revised my "no auditions" policy and tried out for anyone who would look at me, but I couldn't get a bite. The only paid work I had for almost a year was a one-episode guest spot on a faltering sitcom called *Almost Perfect* as the ex-boyfriend of the show's star, Nancy Travis.

Soon we were living on Sascha's savings and some money we borrowed from Rick. During this very difficult and tense time, I finally decided to quit smoking, which I found much harder than giving up drinking. When you stop boozing you lose weight and

start to feel better but when you stop smoking, at least initially, the opposite happens. I suppose I must have been a little fractious because after I'd evened out a bit, Sascha told me that for three days she had her bags packed and in her car.

Through a friend of a friend I met another writer from Britain, the prodigiously talented Sacha Gervasi, whose sense of humor reminded me of Peter Cook. He was an ex-drummer like me who had drifted into more literary pursuits and was now pursuing a career in the film business, after winning a scholarship to UCLA's screenwriting program. It confused a lot of people when he and I became great chums since he had the same name as my girlfriend, although I never once got the two of them mixed up. For purposes of clarity I shall henceforth refer to him as Gervasi, but this must not be taken as a sign of animosity on my part.

Gervasi and I got to talking one day about my old life back in Glasgow. I told him about my gay roommate Robbie, who he thought sounded hilarious and so interesting that Gervasi proposed we write a movie script around a character just like him. Again, since I had nothing but time, I agreed, on the condition that if we ever made the movie, I'd play Robbie. So I began another time-consuming project that didn't help me pay the rent.

We changed Robbie's name to Crawford Mackenzie, made him a hairdresser instead of a waiter, and spun a story about Crawford coming to Los Angeles to seek fame and fortune. It was a kind of hairdresser sports story, or, as we pitched it, "Rocky in curlers."

Fun though it was writing comic screenplays on spec with my friends, I was earning nothing at all, we had spent all of Sascha's savings on rent and car payments, and the largesse of the generous Rick Siegel was wearing thin—he wasn't making much himself. I was getting desperate. That's probably why I agreed to try out

for the part of the Hispanic photographer on a sitcom pilot that Warner Brothers Television was making for NBC called *Suddenly Susan*, with Brooke Shields in the title role.

Rick delivered the script to my house so I could prepare for the audition, and I read with dismay the dialogue that I was supposed to speak. I tried my Latino accent out on Sascha, who looked like she might burst from the attempt to contain her laughter. I tried again with my buddy John, who happened to be visiting us on one of his many business trips to California. John agreed with Sascha that my accent was indeed woeful.

"But . . ." he said, "you should go and audition anyway. What the fuck else do you have to do except sit around here and complain? Plus, you never know what'll turn up."

There's no arguing with John sometimes. So even though I knew I was destined for major humiliation and embarrassment, I got in the rattly old white Bronco and made the low-speed chase to the audition on the Warner lot.

I wasn't mistaken about how it was going to play. The whole thing was inordinately awkward, and I couldn't believe the producers had even let me read for the part. I have since learned that casting directors will sometimes intentionally include actors who are completely wrong for a role into the audition process to make their other choices seem better. Perverse, but it's standard practice.

I ignored the curious stares of the other actors, genuine Latinos all of them, waiting with me outside the room. When my turn came I went through the scene a couple of times with an intern reading Brooke Shields's lines. The producers watched and listened with awe as I tried hard to seem Hispanic, openly giggling at my Speedy-Gonzales-meets-Braveheart accent. On the second pass I decided to play along, hamming it up and being ridiculously over the top on purpose, which I think relieved everyone's embarrassment to some degree. Afterwards they thanked me for coming, and

on my way out a cheerful-looking, dark-haired man got up from the desk where he had been sitting next to the bemused producers and approached me.

"I'm Tony Sepulveda. I do casting for Warner Brothers Television."

"Well, thanks for seeing me today, Tony," I said, deciding not to berate him for dragging me into a situation where I clearly didn't stand a chance. No point in being an asshole about it now that it was over.

"Do you, by any chance, do an English accent?" he asked.

"I think I just did," I said. "Although I was trying to sound Mexican."

He smiled and told me that although I was clearly not right for the role of the Hispanic photographer, they were currently casting for *The Drew Carey Show*, going into its second season, and needed someone to play Drew's snooty English boss. It was only for three episodes but was I interested?

I said I was.

There was a quick meeting with the show's producer and co-creator, Bruce Helford—a Tolkienesque character who was small and dark and busy, like some kind of super-intelligent alien hamster from a world more advanced than our own.

The meeting was a formality—the character wouldn't be on the air long enough to need an enormous amount of attention—and when Bruce also asked if I could do an English accent, I said, "*Sí, señor*," in my best Latino. I was in.

And that is how I ended up playing an Englishman on American television not for three episodes but for eight years. My debut episode went pretty well, the cast and crew were relaxed and friendly, and after a week the producers asked Rick if I wanted to become a full-time cast member. I think he almost cried, either because he was overwhelmed with happiness for me or because he realized that I would now be able to pay back all the money I owed him.

The Drew Carey Show changed my life. Not only did it allow me to pay Rick back, but I started reducing my debts from the U.K. I was seven years sober before I managed to get clear everything I owed—over 250 grand, plus interest. It was one hell of a bar tab. On hiatus after my first season on *Drew*, I got a part in a groovy comedic vampire movie called *The Revenant*. (It went straight to video under the name *Modern Vampires*.) I had the time of my life, camping it up with corn-syrup blood and busty actresses playing victims.

Although Mark Crowdy had not yet managed to raise the money for *Saving Grace*, he had come frustratingly close a number of times. For a while it looked like the movie might well get made, especially when the Oscar nominee Brenda Blethyn expressed a desire to play the lead. However, another screenplay I had cowritten, with Gervasi, about the hairdressing version of Robbie, which we had called *Je m'appelle Crawford!* had fared a lot better. It sparked a bidding war, and the winner, Warner Brothers Films, agreed to let me play the lead. We shot it in and around L.A. after my second season of *Drew* and in the end it was released as *The Big Tease* because Warner felt Americans wouldn't go to see a movie with French words in the title. I'm not kidding.

One day we shot a scene in which my character checks into a seedy motel on Sunset Boulevard. This involved hiring local cops to stop traffic whenever cameras were rolling, and while waiting for the director to call "action," I heard one of the cops over the radio say, "Okay, we've shut down Sunset, you guys can go ahead and shoot."

It struck me as astonishing that I had been in America a little over two years and I had already managed to close Sunset Boulevard, even if it was only for a few minutes. I was very pleased with myself.

I was making enough money for Sascha and me to move out of our rented cottage and buy an old Spanish house in the Hollywood Hills. We even rescued a couple of dogs from outside a coffee shop, and although the dogs were free, the vet bills would have scared Trump.

For me, it was domestic bliss, but Sascha was uncomfortable about our living together without being married. I wasn't sure if that was a good idea, but I liked her a lot. I was also a little bit scared of her, and I really hate confrontation, so I agreed to tie the knot.

The wedding was a massive affair in a big downtown L.A. hotel where Sascha's Jewish New York family partied hard with the Scottish hordes till the wee hours of the morning. Drew and my other castmates were there, along with the show's producers. It was a raucous affair—the two cultures meshing together on the dance floor in a riot of yarmulkes and kilts. A fine time was had by all, but a word of caution for anyone thinking of making a similar match: the Jewish tradition of dancing the hora with the bride and groom hoisted high on chairs is liable to clash, spectacularly, with the Scottish tradition of wearing kilts with no underwear, so be prepared for fainting relatives.

36

America the Beautiful

Actors on prime-time sitcoms make good money. And so, I was not only paying large and regular sums to my astonished creditors in the U.K., but taking care of my finances as never before. I invested in a few things here, bought a few things there, and was on my way to getting on my feet. Like millions before me, I came to America seeking my fortune, and—lo and behold—I seemed to find it. This had less to do with my own business acumen and more with the sage counsel of my friend, CPA, and business manager David Leventhal, whom I met through Rick. I have always worked hard, and I like money, and have been able to earn a little, but taking care of it has always been beyond me. Left to my own devices, I'll spend it all on candy and airplane rides.

Luckily I have David. He is an observant Jew whose business decisions and transactions have to align with his conservative religious beliefs. That's just the kind of financial wizard I need—one who respects money as a useful tool and believes it should be cared for and attended to prudently but never worshiped.

I believe the correct quote, often mangled, is: "*Love of* money is the root of all evil."

I'm not evil enough to love money, but I am naughty enough to

fuck around with it, spank it, pull its hair a little bit. David stops me from doing so, from throwing it all away, although he encourages me to spend it when called for.

One of our adorable rescue dogs, Nala, had gotten some kind of horrible intestinal infection, and I was picking weird-looking creepy little white maggots from her ass with a pair of tweezers when I received a call from David. He was in a chipper mood.

"How you doing?"

He had that musical lilt in his voice that means he's excited about giving out good news. I described to him the grisly (for me) and humiliating (for Nala) nature of the task I was performing.

"Oh, that's perfect!" he said. "Just as it should be."

"What are you talking about?" I asked, a little annoyed at his manic glee. It really was a disgusting job.

"Well," he told me, "I've been looking at some numbers, and if we put aside the mortgage that you owe on your house you could technically be called a millionaire."

"Fuck my old boots!" I blurted, then instantly regretted it.

I am always uncomfortable when I cuss around David, although he never lets on he hears me. He was right, though. There is no better time to hear news like this than when you're cleaning parasites from your dog's bum.

David went on to remind me in his usual way that the best way to enjoy good fortune is to share it, and between us we came up with the idea of bringing my parents over for an all-expenses-paid vacation. They could see the house and meet the folks at the *Carey* show and see L.A. and get a better look around California. Though they'd been here for the wedding, along with the rest of my family, I had been too preoccupied then to spend much time with them. Also, it was getting toward the end of the year, and the winters in Scotland can be very grim. It would do them good to escape all that sleet and dampness for a while. My mother was in remission and still pretty weak from her bout with cancer; and her arthritis was

severe and she had difficulty walking, so most of the time she used a wheelchair, hating every minute of it. My father, however, enjoyed pushing her around—he said it was the first time since they were married that he had any kind of control over her.

When I met them at the airport they were exhausted from the grueling flight from Glasgow, which requires changing planes at the awful, noisy labyrinthine Heathrow Airport in London. They soon perked up when they got into my car, cooing in wonder over the SUV that recently replaced my trusty, old, white Bronco, and the fact that their son had a swimming pool in his backyard simply astonished them. My father swam in that pool for an hour every day during his visit, more than anyone else has ever used it, with the possible exception of my son, Milo, and his buddies, who won't leave the water until threatened with dire recriminations.

I had some time off work, so Sascha and I drove them up to San Francisco. We did all the tourist nonsense, Fisherman's Wharf and Alcatraz and Chinatown. My mother was tickled and I think kind of proud when my father got hit on by an attractive middle-aged Asian lady who hadn't noticed he was with his family. He was certainly very pleased about it.

Netta announced that she had always had a particular ambition—news not only to me but to my father, who had known her a lot longer—and that was to be driven across the Golden Gate Bridge, waving a silk scarf out the car window. Even though neither of us had ever heard her mention this burning desire before, we dutifully fulfilled it by getting her a scarf and driving her across the bridge. It was a peculiarly poetic impulse coming from my normally stoic mother that she never could explain other than to say it was "romantic."

We went to a groovy café called Spaghetti Western in the Haight district for brunch with some of Sascha's longhaired super-

hip music-biz friends who lived in the neighborhood. They made a terrific fuss over my parents, which made them even hipper. As we waited outside the busy restaurant for a table with my mother parked on the sidewalk in her wheelchair, she struck up a conversation with a large Rastafarian gentleman originally from Jamaica who was enjoying a herbal cigarette. He and Netta hit it off, yakking away to each other about God knows what. My mother could have easily hosted a talk show, actually. She had questions for everybody.

As they chatted, fumes from the Rasta's joint kept wafting into my mother's face. She'd just wave them away, apparently to little effect because I'd never seen my mother put away more food at one sitting than she did at that brunch. Also, she was very giggly and kept talking about how much she loved California, until she went very quiet; that afternoon we drove back to L.A. and she slept most of the way.

Sascha had to get some work done so I took my folks on another road trip, this time to the Grand Canyon. On the way we stopped at an exclusive spa near Palm Springs where they got massages for the first time in their lives. As the sensual rubbing of emollient oils into the skin was not something routinely experienced by Scottish Protestants of my parents' generation, they both seemed a little uncomfortable and guilty afterward.

This was my first visit to the Grand Canyon too, and, like everyone else, I found myself speechless at the scale and majesty of the place. It was cold, so my mother stayed in the car but my dad and I got out to stare at the view.

As we watched the low winter sun reflecting on the rock below, changing its colors, I remembered the time he and I had stood in much the same mood of wonder, gazing from the crown of Liberty across New York Harbor all those years ago.

"I told you I was going to come to America," I said.

He smiled.

"Aye, son, so ye did." He ruffled my hair like I was eight years old.

Then we drove to Las Vegas, and they loved it. My mother clucked at the moral turpitude of people who would put good money into slot machines, before putting some in herself. She won fifty bucks, which she quickly stuffed in her purse, sure it was about to be grabbed by the mafia. Because my manager, Rick, was friendly with a comedian named Max Alexander who at the time was the opening act for Tom Jones, Max got us tickets to see them both. Netta loved Tom Jones, and I have to admit it, that old Welsh ham puts on one hell of a show.

Afterward, Max arranged for us to go backstage and meet Tom. I thought my mother would faint—we didn't know about this until it happened, Max kept it a surprise for us—and she appeared for all the world like an overexcited bobby-soxer. Tom was very nice and chatted with them both about his visits to Scotland before he took off. To get up to something sexy, no doubt.

I escorted my parents back to the big suite I'd booked for them at the top of the MGM Grand, and as I left them to enjoy their luxurious surroundings so I could go and collapse in my own room, they seemed tanned and relaxed and very much at ease with the gaudy opulence all around them.

In fact, they looked and acted as if they were a couple of old movie stars. Like he was Frank Sinatra and she was Elizabeth Taylor.

Success and Failure

On the third hiatus from *Drew* in 1999, thanks to the Herculean fund-raising efforts of Mark Crowdy, we shot *Saving Grace* in Cornwall. I played the pothead gardener alongside the remarkable Brenda Blethyn, who makes any film good just by being in it.

It would seem to the outside world that I was on something of a roll; newly married with a couple of films in production and steady work as a cast member on a prime-time network sitcom, but I couldn't be happy.

If you have made it this far you will no doubt have surmised that I am something of a malcontent, although perhaps "ungrateful wretch" is more precise. Sometimes the word "driven" is used to describe me, but I think that's inaccurate, too. I rarely allow myself to be driven anywhere. I am a restless alcoholic/workaholic control freak.

The producers of *The Drew Carey Show* were kind and respectful. I loved my castmates, particularly Kathy Kinney, who played Drew's multicolored nemesis, Mimi. She and I became—and we remain—close friends, but the work itself was intensely frustrating for me. It was Drew's show, all I had to do was run onto the set

from time to time and say something naughty or outrageous in my bad English accent. It bored my ass off and I hated it.

Hated the work, loved the money.

I was a hooker.

In some peculiar way I felt like I was copping out of the deal I had made with the universe in the Mojave Desert.

Between safety and adventure I was supposed to choose adventure.

I shared my frustrations with Sascha, who kept telling me to quit, but I didn't have the nuts. The last time I quit a job we got into real financial trouble, and I didn't want to go through that again, although I think that was just an excuse. Things were getting a little difficult between Sascha and me, but I was reluctant to confront it.

I was away all the time, shooting or trying to set up movies, and I should have made her my partner and taken her with me, but I didn't, so she found something of her own to be enthusiastic about. She started getting involved in Pilates, then the new physical fitness craze sweeping L.A. She used some of our money to open a studio in the middle of West Hollywood, filled with all the strange medieval-looking equipment that Pilates requires. When I told her I didn't want to be married to the CEO of a company because then I would never see her, she said I never saw her anyway so what the hell was the difference—and she had me there.

In the late summer of 2000, having papered over the cracks in our marriage, we went for a bike ride in Griffith Park, near our home in Hollywood. After a while we took a break and sat on one of the green wooden benches that pepper the area. Sascha drank water from a blue plastic bottle and then smiled her big happy smile and told me she was pregnant.

I can't remember what I said, but according to Sascha I just giggled like an idiot and wouldn't let her ride her bike home.

We had only just decided to try for a baby and it happened so fast that I think we were both thunderstruck; delighted, but thunderstruck. I suppose that's why you're given nine months to get used to the idea.

This was the best time of our marriage, we were both so thrilled and happy about becoming parents. We walked every day for five miles because Sascha had read that it was good for the baby. We went to one of L.A.'s ridiculous "Kum Ba Ya"–ish birthing classes, where we did prenatal yoga together and watched badly shot videos from the 1970s of actual births. These videos were so awful and the people in them were so weird and hairy that during one of them Sascha started to giggle. I was trying very hard to hold in my laughter, making it a thousand times worse, while also trying to avoid stern looks from the spiritually advanced yet paradoxically humorless teacher. Sascha was shaking with suppressed hysterics just as I was, but then it all got too much for her tired pregnant body. It released the pressure by squeaking out a tiny fart that, I'm not kidding, went:

"Boing!"

We almost had to be stretchered out of there, and for the next two weeks it was hard to stop laughing.

Sascha was still pregnant when *Saving Grace* came out. The studio, Fine Line, gave us premieres in both New York and Los Angeles. It was the first film I'd ever been involved with that had good advance buzz and turned out to be something of a hit; it even won the audience award at Sundance. When that happens, lots of people you don't know start kissing your ass. The dishonesty is unnerving. You have to be careful who you listen to, so I listened to Sascha.

On the way to the L.A. premiere at the Egyptian Theatre I sat quietly with my wife in the back of a ridiculously oversized limo.

"You taking this in?" she asked.

"What?" I said.

"You're going to the big premiere of a movie that you wrote and starred in. This is what you came here to do—anything from here on in will just be variations of this."

She was wrong, though. I loved *Saving Grace* and I'm still proud of it so I wanted to promote it and wanted it to succeed. I was to find out just how rare that is in the next few years.

Sascha's predictions, however, can be spookily accurate. Like the time we were leaving David Letterman's New York studio after my first-ever visit to his show, to promote *Saving Grace*.

"You're going to be asked to take over for him one day," she said.

I told her she was nuts, that I was an actor and a writer, not a late-night TV host.

"I'm telling you," she insisted.

No one has remotely suggested to me, as I write this, that I should take over for David Letterman when he retires, but I would say it's a little more likely than it was when I first visited the show, and I certainly would be more interested in the idea now than I was then. We'll see.

No matter the box-office track record of the actual films, the scripts of *The Big Tease* and *Saving Grace* were very highly thought of in Hollywood, leading to a call from Victoria Pearman, the bookish Englishwoman who runs Mick Jagger's production company. She read my work and wondered if I was interested in collaborating with Mick, who had an idea for a movie. As you might expect, I said yes.

I was flown to Istanbul to take a meeting with Mick. He was then on the Bridges to Babylon tour and Victoria explained that it was easier for me to go to him than the other way around. I could see how that might make sense, given that Mick seemed just a bit busier than I was.

Our first discussion took place in the penthouse suite of the Istanbul Hilton, and I don't think I have ever been so nervous about meeting someone in my life, seeing as this particular someone had been a world-famous rock star—*the* rock star—as long as I'd been alive.

Luckily Mick was used to people being nervous and bumbling around him and quickly put me at ease with his easy laugh and generous nature. He picked up the phone himself to order us lunch—I could hear the excited yelling of the room-service operator clear across the room—and as we waited for it to be delivered he told me about his idea.

It was a story, much like Twain's *The Prince and the Pauper*, about a rock star and a roadie who change places for a few days, and though it seemed pretty thin as a premise, what the hell was I going to do, turn the gig down? It was Mick Jagger, for Christ's sake!

Plus, Mick's producing partner, Paramount Studios, was offering me a three-picture development deal, just to keep me happy.

I took the job, of course, and spent a lot of time on the phone with Mick over the following six months, but try as I might I couldn't spin the story into a movie Mick wanted to make, even though Paramount was happy with the script.

Mick kept asking if it could be "more edgy," until eventually I asked in exasperation, "Mick, what exactly do you mean by 'edgy'?"

He said, "Well, you know that film *As Good As It Gets*, with Jack Nicholson?"

"Yes," I said.

"Well, could it be more like that?"

I told Victoria I had no fucking idea what Mick was on about. She seemed sympathetic but fired me a week after I delivered the second draft.

Father

The *Big Tease* was made before *Saving Grace* but didn't get released until a year afterwards because of the antiquated and monolithic studio distribution system. When the big hairdressing movie finally came out, though, Warner Brothers did it proud with a lavish premiere for the U.K. opening, a mammoth party during the Edinburgh Film Festival. My commitments on *The Drew Carey Show* made it difficult for me to get from L.A. to Britain in time, so they flew Sascha and me out on the Concorde.

On the morning of the premiere we arrived in our luxurious hotel feeling terribly glamorous. While Sascha unpacked I went for a pee in one of our suite's four bathrooms. We were on the top floor, and, looking down through the open window, I could see the glass roof of Waverly Railway Station far below. Through the cracked panes in the ceiling I could see the same Photo-Me booth that I had slept in during the 1986 festival, years before.

Our flight on the Concorde didn't turn out to be round-trip. Once Warner saw the first weekend's box-office returns they decided we could travel back like regular folks. *The Big Tease* was ignored by the Brits, prompting Warner to drastically reduce their sales campaign in America.

Saving Grace had also received terrible reviews and failed at the box office in the U.K., but Fine Line, in particular its CEO, Mark Ordesky, who later went on to champion the *Lord of the Rings* trilogy, believed in the film and wouldn't let the negativity of the British press sway their decision.

In large part thanks to this supportive attitude of the American distributor, *Saving Grace* went on to be a hit in the U.S., but *The Big Tease* was doomed. I hated what happened to it, because I think it was a funny and touching film, but when the studio involved loses faith in your project, for whatever reason, it's over. They don't care what's on the screen, they will promote two hours of pigs fucking in black and white as long as they believe it will pay off.

The Big Tease was a very disappointing experience. In the space of a few months I'd gone from being a big success to an equally big failure in the movies, but I soon stopped caring because Milo was born.

On the afternoon of May 14, 2001, I had just left my doctor's office in West L.A. after my annual physical. I was starving from the fast that started the night before and fantasizing about IHOP's Colorado omelet when my cell phone rang.

"I'm at Cedars. It's on," Sascha said.

I ditched the omelet idea and drove straight to the hospital and in the early morning of the following day Milo came into the world, a sticky, angry, and slightly confused mess, just like his dad.

Anyone who has been present at a birth knows how weirdly adrenal the whole event is. As a first-time father, I found myself terrified in a whole new way, not afraid for myself but for my child, who until that moment had been an abstraction. All of a sudden he was real and the world had changed beyond recognition. Now there was someone I would unthinkingly lay down my life for, and I felt a massive, uncontrollable, powerful, feral love.

As I cut the umbilical cord, Milo started to cry and shiver. One of the nurses, a dour Russian woman who had bossed Sascha around a little too much for my liking, said, not unkindly, "Oh, baby, life is hard."

"Shut up," I snapped. She looked at me with astonishment.

"He just got here. He doesn't need that shit yet," I told her.

She looked at me like I was insane, but I didn't give a toss. I think when you become a parent you go from being a star in the movie of your own life to a supporting player in the movie of someone else's.

I placed Milo on his mother's chest and the two of them cuddled and got their breath back. I watched them until they both fell asleep, exhausted.

California law states that newborns have to receive a vitamin K supplement after delivery and the hospital staff wanted to take Milo away and clean him up and give him his shot, but I wouldn't let them unless I could go, too. They had seen me snarl at the Russian nurse and must have decided it wasn't worth a fight, so they let me carry my son to a little room where a much nicer, mumsier nurse gave him a little bath, weighed him, injected the vitamin, and wrapped him up in a blanket.

Milo was pissed at all the fussing. He yelled at the nurse at the top of his lungs, protesting at a decibel level that made me feel immense pride.

It was past four a.m. when the mumsy nurse finally placed him in a clear plastic crib, swaddled in his blankie and wearing a tiny white wool cap. When she left us alone, Milo's eyes were wide open and as deep and dark and blue as the sea on the Scottish coast.

For the first time it was just the two of us. He stared at me for a few minutes and I stared back at him. My American son.

After a few moments he let out a long tired sigh, like the whole thing had been such an ordeal.

"I know," I told him, "but don't worry. I got your back."

Soon enough we were home and in the middle of the massive chaos that any newborn baby brings. For the first six weeks I don't think I changed out of my pajamas once, but eventually the three of us got into some kind of routine, and I started to look around for work.

By then it was evident that *The Drew Carey Show* was beginning to creak and show its age and I was being used less and less. Sometimes they would just pay me to stay home and not do anything else, which sounds fantastic but doesn't do much for your ego. It's probably a little like getting alimony—the money is nice but has a nasty aftertaste.

I got a leave of absence from *Drew* to shoot a movie in Russia for six weeks, thinking I'd be able to come home once or twice during that time, but a few weeks before filming started, those murdering ratbag motherfuckers crashed those planes into the World Trade Center and international travel became a whole lot harder. Once I got to Moscow, I was stuck.

During my six weeks away, Milo developed croup, and Sascha had to deal with it alone. We talked every day but she didn't tell me how scary it got with his illness, figuring there was nothing I could do. I still feel like a prick for being away at that time.

Once I returned I was grumpy and unused to family life. It was a tough transitional time for both of us. Sascha's business was beginning to take off and she needed to spend more time at the Pilates studio—which I could hardly bitch about, given how long I'd been gone, but I bitched about it anyway.

Things were getting pretty snippy between us. It was odd that when I was in Moscow our phone conversations were fun and warm, but in person we were irritable and cold with each other. Clearly our marriage was in trouble, but because we both adored Milo we tried to ignore this, hoping that things would somehow work out.

Crash

With Philip McGrade, a good friend since we first met in London when I was newly sober, I wrote a spec screenplay called *The Family Business*, about a has-been rock star who finds out he has a daughter he never knew existed. It was quite a dark story but ultimately uplifting, so when I shopped it around the studios, I got a bit of interest. Eventually we made a deal with Morgan Creek Films, which was prepared to let me direct the movie as well as play the lead. I thought that as director instead of producer I would have more control over the outcome of the film, but in this I was hugely mistaken, especially with Morgan Creek involved.

It's an indie studio owned and run by James "Jim" G. Robinson, a Baltimore businessman who at the time had a distribution deal with Warner Brothers. You will no doubt remember that Warner fucked my last movie, but that's showbiz; you can't bear a grudge too long or you'll never get anything else made. Jim is a forceful, bullish man who likes things done his way, and so am I, so it was a difficult relationship. Jim is a businessman, a good one, but he is no filmmaker, and he has about as much taste as a carny with a head

cold. Though if you want your film made by Morgan Creek, you'd better not tell him that.

The Family Business was shot in and around London in 2002, and I made all the classic mistakes early on. Like allowing the studio to insist I use an actor I really didn't want in the role of the rock star's daughter. In the script she is also a singer, and the studio wanted the Welsh teenage soprano Charlotte Church, already a big star in Britain, for the part, on the assumption that she'd be a box-office draw over there. My problem was that:

(A) Charlotte was a tabloid magnet with a pushy alcoholic showbiz mother and no credibility as an actor, having never done anything but sing.

Plus:

(B) I never have *any* success in Britain. For the movie to have a chance, it had to be aimed at a U.S. audience. Shot in Britain but made for America, like *Saving Grace*.

I was overruled, yet the casting of Charlotte, who actually isn't that bad in the movie, might not have been catastrophic if the yes-men at Morgan Creek who called themselves "development executives" hadn't shit all over my script. Changing music choices, changing lines, changing the title of the movie from *The Family Business* to the loathsome and insipid *I'll Be There*. Generally just sweetening the whole thing beyond recognition until it became an expensive Hallmark Hall of Fame movie.

Much as I would like to blame those guys, it was really my fault. I should have been stronger from the start, should have said "Fuck it, no way!" and pulled the project. I was ambitious and desperate to direct my first film, so I capitulated and blew it. Never again. Never fucking again.

I found out it is just as hard to make a movie that you are not proud of as it is to make one you love. The shoot was arduous enough, but to cap it all I was in a motorcycle crash halfway

through production, which meant I had to act and direct with a broken collarbone and three cracked ribs. Plus, it was summer in the U.K., triggering my hay fever, and every time I sneezed, a white-hot bolt of pain shot through my battered skeletal structure.

Sascha and Milo came to London for a visit, but I was such rotten company, my wife took our son off to Paris with her friends.

Somehow I finished the movie, which opened in May 2003 to resounding failure in the U.K. Predictably, Warner declined to release it in the U.S., so it went straight to video. I had spent a year of my life on a project that had damaged my marriage beyond repair, ruined me as a filmmaker, and had been no fucking fun at all. I didn't even make much money after all the taxes and commissions and travel.

Also in May of 2003 I went to the Cannes Film Festival, hoping to raise money for another project and salvage the doomed *I'll Be There*, but I came away deeply discouraged and empty-handed.

It was time to clean house. I felt that no one had protected me from the disaster, that the agents had been lazy, and that Rick, my friend and manager for eight years, had been outmaneuvered. I fired them all, and I wished I could have fired myself, too. On the way back from Cannes I stopped in Paris. As I walked around the city, trying to figure out my next move, it seemed to me that I had hit some kind of a wall. I determined that if I ever had another story to tell I would do it in the form of a book, not a film, so that I wouldn't have to collaborate with a bunch of people I wouldn't trust with a fork.

As it turned out, I did have an idea for a story. It was about a Scotsman who experiences a lot of setbacks but ultimately triumphs, albeit in a very obscure way.

It would take the form of a novel, and although I didn't yet know how it ended, I would start writing, as an act of faith.

I returned to my hotel and on a leaf of embossed Georges Cinq notepaper I wrote:

"Fraser had a problem. His problem was that he wanted people who didn't know him to like him."

And with that sentence I began to build a bridge to a new freedom. I had found a medium that required no collaboration or approval. No equipment, other than the computer I already owned. It had no union rules and no producers. I could do whatever the fuck I wanted.

After all this time I found that the novel is in fact punk rock.

Every day I ran to that book like it was a bottle of whiskey and crawled inside because it was a world that I had at least some control over, and slowly, in time, it began to take shape.

Between the Bridge
and the River

By March of 2004, Sascha and I concluded that we could no longer live under the same roof without fighting, and we wanted to protect Milo, so I moved into a rented apartment near our house. The split was utterly heartbreaking, although I credit us both for keeping the worst of it, the pain and resentment and bitterness, away from our son. Sascha is Milo's mother and she is and always will be family to me. We loved each other and we had a child together and though the love changed its shape, it did not go away.

Divorce lawyers stoke anger and fear in their clients, knowing that as long as the conflicts remain unresolved the revenue stream will keep flowing. I like to believe that there is an extra warm corner of hell for these fuckers who traffic in emotional misery. We fell prey to them for a while, but thankfully not too long.

We avoided going to court, we did the whole thing through mediation. Eventually I moved back into the house in the Hollywood Hills and Sascha got the one that was two doors down. The proximity has been a challenge for us at times, but the advantages for

Milo outweigh the disadvantages for us. Our family has "suffer[ed] a sea-change / Into something rich and strange."

For a year after Sascha and I split up, I lived in a cheesy rented apartment that Milo dubbed "Daddy's Funny Home." Funny, as in the lamest bachelor pad ever; as soon as I moved in I had the place completely baby-proofed, and Milo and I agreed that girls weren't allowed. (After a decent interval, I broke that rule from time to time when he was staying over at Sascha's.)

Through the trauma and heartbreak and surges of rage produced by the divorce process, I kept plugging away at the novel I had begun in Paris. Whenever I was feeling trapped or like I couldn't cope, I would escape into the world of the book, where my characters were taking on a life of their own. In that world there was justice for the just and punishment for the wicked and for me it was all extremely therapeutic.

After the Morgan Creek fiasco I spent time with my friend Philip as we nursed our bruised egos slowly back to health. One day we went out for a walk and the subject of suicide came up. I think I may have been talking about my transcendental sherry experience, or the pain of divorce, or both, and Philip told me about once asking a Jesuit priest if he believed that if someone kills himself he will go to hell. The priest thought for a moment and then answered no, not all suicides went to hell. For example, if a fellow were to jump from a high bridge and *genuinely repent* his actions before he hit the river and died, he would yet enter the Kingdom of Heaven.

As soon as Philip told me this I knew I had the title for my book. I'd call it *Between the Bridge and the River*—unexpected redemption brought about by authentic atonement for a regrettable life. Around this time I started seeing a beautiful dark-haired girl, Andi

O'Reilly, and she and I became very close for a while. Andi was fascinated by the novel; she kept pushing me to keep writing because she wanted to find out what happened to the characters, and if not for her enthusiasm and energy maybe I wouldn't have finished it. But I did. By then I'd become a client of the giant ICM corporation, which had offices in New York and Los Angeles, so that's where I took my manuscript, to their literary department in N.Y.C., hoping that the agency would help me find a publisher. Unfortunately the woman I met with was a snooty *Sex and the City* type who told me, "We get a lot of 'L.A. celebrities' here," pronouncing "celebrity" like it meant "leper" (although given the state of my career at that point, "leper" was a more accurate description). "They come here trying to sell their little books and I just tell them—go home."

When I asked if she read the book she said yes, but I could see in her eyes that she was lying. Still, I was crushed and walked out of her expensively furnished office and wandered in Central Park, trying to collect my thoughts. I had poured my heart and soul into that book and I couldn't even get it read *by my own agency*!

I felt sick and sad, so I sat down on a park bench. For some reason I happened to turn and look behind me, and there was Mr. Big Shot himself, albeit in bronze. My countryman, Sir Walter Scott.

He stared down at me patronizingly, even though his head was covered in pigeon shit.

I read the inscription at the base of the statue:
Erected by the New York friends of the great Scottish novelist.

I don't know why but this chance encounter made me feel better and I decided to keep trying with the book. Sooner or later, someone other than Andi would read it, and, who knows, maybe even like it.

I did eventually find a publisher for *Between the Bridge and the River.* It received terrific reviews and sold a lot more copies than I thought it ever would. I even had the satisfaction of the ICM liter-

ary division apologizing to me for the way I was treated. I still left, of course, and I am ashamed to admit that I enjoyed listening to their apology a lot more than would be considered seemly.

Back in Los Angeles, I was offered a part in a dark independent film being shot in Winnipeg. Although I was less inclined to leave town now that I was a father, I still had to earn money because, as anyone who's gone through it will tell you, divorce ain't cheap.

The character I played in the movie, eerily enough, was a man who tried to commit suicide by jumping into Niagara Falls but inexplicably survived. I seemed to be surrounded by thwarted suicide attempts, which I suppose is infinitely preferable to being surrounded by successful ones.

A few weeks into the shoot I got a call from my new agent.

"Do you know Craig Kilborn?" she asked.

I said I didn't know him, though we'd met. He was the host of *The Late Late Show* and I'd been on it a few times to promote movies. I didn't care for him much. He seemed arrogant and distant and I preferred the company of his competitor, Conan O'Brien.

"He's quit his job," she said.

"Oh," I said.

Then she told me that to find a replacement for him the network (CBS) and the production company (David Letterman's Worldwide Pants) were inviting a whole bunch of people to guest-host the show. Would I be interested?

I said I would love to guest-host but couldn't see myself doing it on a permanent basis, it wasn't really my thing. Although by then I wasn't sure what my thing actually was anymore. I was bored with acting. I hated producing. Writing for other people was too hard and too annoying, and I hadn't done stand-up comedy in ten years. I was thinking maybe I should go back to drumming or delivering milk.

They were only offering two nights, but my agent warned me that if I agreed I'd have to sign a six-year contract with the studio and the network just in case the job became permanent. I accepted their terms. As I said, no one seemed close to offering me *The Late Late Show* itself, that was unthinkable. So I would enjoy myself for a couple of nights—who knows, it might be fun. At the very least I'd get a little bit of exposure, which is always helpful when you're trying to raise money for something, and I always seemed to be trying to raise money for something. In September of 2004 I walked into the CBS studios in West Hollywood for what I was convinced would be the first of a two-night run.

41

Latecomer

A late-night talk-show host is supposed to be cool. I am not for a second suggesting that I am cool. I am a middle-aged white man with graying hair, a thickening waist, and a creepy laugh. That is not cool.

Nor am I suggesting that I am a late-night talk-show host any more than I was a stand-up comedian or writer or actor or drummer or milk delivery boy. Late night is just what I do now—it's only my job. It's the job itself that is cool.

A little bit of cool goes a long way; it lands on you if you are a late-night talk-show host. Consider the other guys: if Dave wasn't the king of late night he'd just be a cranky old man who drives too fast. Jay would be a weirdly needy mechanic, and Conan would have kids following him down the street calling him names. Without his show, Jimmy Fallon is just a thirty-five-year-old giggly adolescent; and Jimmy Kimmel is a good guy, but he'd be the first to admit he's not cool—in another life he'd be a genial maître d'.

None of us are cool, but if we appear cool it's because of one man.

Johnny Carson.

Johnny was cool. Jeez, even his name was cool . . . *Johnny.*

Johnny did not invent the late-night format but he branded it. He's Babe Ruth or Tiger Woods. The game belongs to him anyway.

Johnny Carson fronted *The Tonight Show* for an astounding thirty years, and no one has ever done it better. He was smart and quick and flawed and warm. He made men want to be him and women want to be with him. Johnny could take a lame gag that clearly didn't work and turn it into the funniest part of the show. I never knew this stuff until I drifted into late night myself; up until then I'd seen *The Tonight Show* maybe three or four times, but I was probably too drunk to pay attention.

Before I got into the late-night game, the only person I ever watched was Dave, because Dave was funny and bitter and I got the feeling he secretly (or maybe not so secretly) despised showbiz. I felt I could relate.

When I agreed to guest-host *The Late Late Show*, I prepared for it as if for an acting gig. I did a little research into the character I'd be playing, into the people who really did what I would only be pretending to do.

If Dave was the best of the current crop, and I believe he is, then I wanted to know who he considered the gold standard and how they work. I'd read that he greatly admired Regis Philbin as a broadcaster and downright revered Johnny, so I plowed through a ton of old tapes of *The Tonight Show*, and I watched *Live with Regis and Kelly* every morning.

Dave was right. Johnny was great, you just loved the guy. Like he was your best pal and uncle and dad all rolled into one, and Regis was astonishing in a different way. Here was a kind of TV Proust, a man who could take the most mundane moment of his existence and spin it into five, sometimes even ten minutes of entertaining talk. I studied these three guys, Dave and Johnny and Regis, for hours, not to try and impersonate them but to get a few pointers. I don't know if I learned anything, but I laughed a lot.

I turned up at CBS Television City in L.A. the night before my scheduled slot to get a feel for the place, and, of course, to see what kind of act I'd have to follow. That night's guest host was a young chap by the name of Damien Fahey, and so I stood in the green room and watched him work. He seemed pretty good to me, good enough to take over permanently. I was approached by Michael Naidus, the segment producer who had shepherded my guest appearances on the show when Kilborn was the host. Michael is an affable fellow, so I felt comfortable talking to him. He asked if I was looking forward to giving it a shot the next night and I said of course.

Then he said, "There's someone I'd like you to meet," and he led me out to the corridor.

"This is Peter Lassally," Michael said, introducing me to an elegant and genial older man. I knew the name. Lassally had been a producer on *The Tonight Show* for thirty years when Johnny was the host. He'd set Dave up at CBS after the late-night wars of the nineties and still held a senior position at Worldwide Pants, Letterman's production company, which also owned *The Late Late Show*. This was the man who had mentored Jon Stewart and Garry Shandling and Steven Wright. He is a legend in the business.

I told Peter that I was honored to meet him, and after we chatted a bit, I thanked him for letting me guest-host for a couple of nights.

"This should be a lark," I said.

"This is not a lark," he said. "I want you to take this seriously. I have few discernible talents, but one of them is finding guys like you. I watched you as a guest on Letterman and Kilborn and Conan, and if I'm right about you, you are lightning in a bottle. I think you may be the one we're looking for."

I nodded somberly and promised to take it seriously and said

that I was looking forward to seeing him the next day, too. As I walked out to my car I thought, "Poor old coot. He's lost his marbles."

I was wrong, though, and Peter was right, and so began a pattern that continues to this day at *The Late Late Show*. He is still executive producer of the show and nearly every day I am wrong and he is right.

Back in the green room at five o'clock the following afternoon, I heard Richard Malmos, the show's announcer, call my name, and I walked out onto the floor of tiny Studio 56 to bask in the riotous applause of a paid audience who had no earthly idea who I was.

I loved it anyway.

For a second you get to feel like Johnny. I'm convinced that's why we all do it, Dave and Jay and Conan and the Jimmys and me, because every now and again you get to feel like Johnny.

I also felt comfortable being in front of a television camera— eight years on *The Drew Carey Show* had immunized me against any nasty rushes of adrenaline. I rattled off the gags from cue cards, but the guys responsible for writing the gags had worked as a team to create Kilborn's TV voice and had about as much in common with me as I have with Dakota Fanning.

The material was generic and mostly lame, but having seen Johnny on tape, and how he coped with bad jokes, I became convinced that somewhere in there, fucking around between written gags—the glue between inanities—lay the key to me winning the job that I wanted so badly about five seconds into my first night as guest host.

I yakked it up with the guests in a satisfactory way apparently, something I didn't find difficult at all. I was genuinely interested in what they had to say; plus, I had been given a very important acting lesson by Brenda Blethyn on the set of *Saving Grace*.

"If you truly listen to what the other actors are saying, everyone will think you're a fucking genius, dear."

God bless her, the mad old trout. But she's right. Everyone picked up on it right away.

"I loved the way you actually had a conversation with the guests," said Peter after the first show.

"I thought that was the job?" I said.

"It used to be," he said, smiling his lovely big sad clowny smile.

So I was in love again. I wanted very badly to host the show on a permanent basis. The trouble was, so did a whole lot of other people more famous or more qualified than me. But I had a secret weapon, and I knew it: Peter liked me, and I liked him, and I believed he would champion me if I did my best, so that's exactly what I did.

"Gimme a week of shows and I'll nail this," I told him after that first night.

"We'll see," Peter said.

All together about fifty or so people had guest-hosted the show, some of them very big stars just doing it for fun and some of them very big stars who wanted to appear like they were just doing it for fun lest they not be chosen.

The field was finally narrowed down to four contenders. They were: D. L. Hughley, the only real name of the lineup; Damien Fahey, the kid who had gone on the night before I did; Michael Ian Black, the popular trendy comedian; and me.

We'd each get a week of shows to prove what we could do and then Worldwide Pants and CBS would pick one of us. I was pretty sure that D.L. had nailed it because he was experienced as well as funny. Rumor had it that Dave favored Damien Fahey, which seemed to be confirmed when Damien appeared as a guest on *Letterman* during the tryouts. I was frantic about this until I watched the show and quickly guessed that if Dave had been hot for this guy, he cooled considerably once they began conversing.

Michael Ian Black was definitely the hippest choice, and it was no secret that he was the friend and favorite of Rob Burnett, the CEO of Worldwide Pants—a considerable ally, to say the least.

The entertainment press speculated that of all four candidates I was the longest shot, and although it pained me to admit it, I had to agree. I went first, and I like to think I threw down a pretty strong challenge to the others, except for a huge misstep on my fifth and last show, Friday night, when I decided to introduce "Formal Friday." The whole thing was shot in black and white, I wore a tuxedo, and the guests dressed appropriately, and it stunk. Peter said that was okay, because it showed I was willing to stick my neck out and try things. He very kindly neglected to point out that he had advised against my doing it in the first place.

I didn't watch what the other guys did, it would have been like watching someone else kiss your girlfriend, which was bad enough, and maybe doing it better than you, which was worse.

During the big late-night bake-off, I was lucky enough to book a guest spot on a struggling ABC show called *Life As We Know It* that starred Kelly Osbourne. I was to play another rock star, the father of Kelly's character (where do they get their ideas?), and although I wasn't crazy about the script, they were filming in Vancouver, which would get me out of L.A. and away from all the noise about who was going to win *The Late Late Show* job. I also thought the work would distract me enough to relieve some of the antsiness I was feeling.

I drove my car from L.A. to Vancouver; a road trip always provides distraction for me and at that time I would only get on a plane if I absolutely had to.

Michael Ian Black was last up, and when he finished his Friday-night show I spoke to the other Michael (Naidus—*The Late Late Show* producer) by telephone. Mr. Naidus had by then become my mole on the inside; he told me whatever he knew, and although he stopped short of actually saying so, I could tell he was rooting for me. He said that the head of CBS, Les Moonves, would be having

a conference call with David Letterman, Rob Burnett, and Peter Lassally on the following Monday morning and the final decision would be made then. These were the four horsemen I had to worry about over that weekend.

Speculation was running wild as to who it would be. I felt instinctively that Peter was for me. We had just clicked as soon as we met. The others were a different matter.

Like the three other candidates, I had sat down with Les Moonves, and I thought it had gone well. Les, as anyone who's dealt with him will tell you, is a straight shooter. He'll shoot you, but it'll be straight; he comes across as a guy who is just too busy for bullshit, and I liked him. I looked him in the eye and told him I wanted the job and that if he gave it to me I wouldn't let him down. He had nodded.

"I know you wouldn't," he said but gave nothing away about his selection.

I knew I was not Rob Burnett's first choice, and whatever Dave was thinking was anyone's guess, although he later confessed he didn't pay much attention to the whole thing, leaving the pick to the others.

The tension was unbearable. My work was finished in Vancouver, and since I couldn't sit still, I bit the bullet and flew to New York, where my girlfriend, Andi, was visiting relatives. I was very gloomy and convinced that terrible disappointment was headed my way. I must have been miserable company because Andi suggested we go and see something on Broadway, it would take my mind off things.

As it turned out, Brenda Blethyn was performing in a show, a two-character piece with Edie Falco called 'Night, Mother, so we went to see it, but it didn't do much to lighten my mood, given that it's a play in which the lead character announces at the top of the show that she is about to commit suicide, argues with her daughter about her decision for two hours, then finally (spoiler alert!) does

herself in. I love Brenda, and she is without doubt one of the best actresses on the planet, but that is a fucking awful play.

Afterward we had dinner with Brenda at Joe Allen's. Andi and I kept the conversation focused on how much we'd enjoyed her performance while tactfully not mentioning the material itself.

Come Monday morning there was still no news—which I took to be bad news. I flew back to Vancouver, where I was going to spend the night, have dinner with some friends, and then drive my car back to L.A. to lick my wounds.

I had just gotten into my hotel room when Peter Lassally and Rob Burnett called.

"It's you," said Peter.

I then did something that surprised me.

I dropped the phone, fell to my knees, and said, "Thank You."

42

Riding the Pass

Peter told me that he wanted me back in Los Angeles the following evening to have dinner with him and Bill Carter, a *New York Times* reporter who had written a bestselling book on the late-night war between Jay and Dave. Bill had agreed to write a story for the *Times* about my taking over if he could meet me, and since he happened to be in L.A. on other business, Peter thought this was a great opportunity and I should not miss it. I told him I wouldn't.

The only problem was that it was already noon in Vancouver and I had to get my car back to L.A., which meant driving all day, catching a few hours' sleep in a motel, and driving all the next day, too, if I wanted to make the dinner date. I didn't dare leave my car in Canada and fly because I was still rattled and nervous from the bumpy six-hour flight I'd taken from New York that morning, plus I was convinced that the gods of irony would kill me in a horrible plane crash just after I had scored the biggest professional coup of my life. I was in my car and pulling out of the hotel parking lot within fifteen minutes.

My cell phone started ringing almost immediately. First it was the CBS press department scheduling interviews for me to do on

the long drive south. I talked to radio stations and journalists from local newspapers, and magazine writers and TV critics, and we all agreed on one thing. None of us could believe I got the job. That's when I began to catch a whiff of the notion that they all seemed to share: that I would fail. Even the ones who liked me seemed skeptical that someone with an accent would be accepted as the host of a late-night talk show in America. I countered by saying that the present governor of California had an accent so thick that he couldn't correctly pronounce the name of the state, so I didn't think people would have a problem with me rolling a few *r*'s here and there.

Between interviews, I gave the news to family and friends. I called my mother in Scotland, even though it was very late in the evening there; my mother was used to getting the occasional late-night call from me ever since the time in Kelvingrove Park during my last acid trip, when I had been stalked by the killer ducks. Then a few years after that I had called her from Bangkok airport, where I was waiting to change planes on a long trip to Australia. I had partaken liberally of the free booze on the flight from London and was staggering around the airport when I spotted a Tie Rack store. For some reason I decided to buy a yellow tie with little black skulls on it. Because my drunken brain believed that buying a tie in Thailand was somehow significant, I had to tell someone.

"Ma, I just bought *a tie . . . in Thailand.* Isn't that amazing?" I told her when she answered the phone, fuzzy with sleep.

"That's nice, son, but what will you do with him when you get him home?"

I was too drunk to explain and hung up.

This time was different; I was sober and had genuine good news.

"Ma, I just got *The Late Late Show.* The job I was trying out for."

She was very happy for me, although I was a little nonplussed

when I heard her wake my dad and tell him that I had become a newsreader in America. I let it pass and let them go back to sleep.

I called Business John, my Scottish guru, who said he thought I was doing pretty good for a hopeless drunk.

My girlfriend, Andi, was delighted but seemed to sense that this was somehow a threat to us.

I spoke to Sascha and she reminded me of her prediction outside the Letterman studio years before.

I didn't have hands-free in my car and my head was beginning to feel cooked from all the cell-phone chat. Luckily the road started to climb and twist through mountain passes where reception was impossible. The weather began to get pretty ugly—a blizzard was coming in fast from the northeast. Traffic got slower and slower and slower.

By the time I got to Grants Pass, in Oregon, night had fallen. Cars and trucks were crawling along the slippery highway, and visibility was practically zero.

Eventually I got to a police barrier where a cop in a parka with padding three feet thick told me that the pass was too dangerous for traffic and had been closed. He thought it might open up in the morning.

There was nothing else to do so, I turned around and went to look for a crib for the night. I drove to a large Indian casino I remembered passing earlier, but the cheerful, morbidly obese receptionist in bottle-thick spectacles told me nothing was available.

"They closed the pass," she said.

"I know," I said.

"When they close the pass everything gets full up. There won't be a bed for you for fifty miles."

"I'll die of exposure," I said.

"The Keno and Blackjack is twenty-four hours. You can sit in here."

"I need sleep," I whined.

"Well, you're not allowed to park your car in the lot and sleep in it, I can tell you that," she said and gave me a wink.

So I trudged back through the snow to my farty potato-chip-and-coffee-smelling car, where I spent my first night as Mr. Bigtime Talkshow Dude curled in the backseat, wearing two hoodies and two pairs of pants.

I watched the snow fall through the halogen lights in the parking lot of the Four Feathers Casino, and I felt great. It was perfect. Like the time I found out I was technically a millionaire just as I was extracting maggots from my dog's bahookie.

I slept like a baby for three hours, then turned on the radio. The pass was indeed open, so I drove all that day, talking to more skeptical reporters on the telephone, and made it to the restaurant just as Peter, his wife, Alice, and Bill Carter were finishing their soup.

Feeding the Beast

Guest-hosting a late-night talk show for a couple of nights is exciting and fun. Doing it for a week is still fun, but challenging, and leaves you feeling exhausted. If anyone offers you the chance to do this job on a permanent basis I urge you to think long and hard, because it will change your life—in bad ways as well as good ones. And it just keeps coming at you, day in and day out, that forty-four minutes of time you have to fill between commercials every weeknight.

Then there's the press and certain sections of the public who either can't sleep or who are fascinated by late night—again only really because of Johnny's legacy and perhaps because Dave's enigmatic persona off-camera intrigues them.

The entertainment press considers it their duty to haze any newcomer to late night. Conan was trashed in the reviews when he started, as were Jay and Jimmy (both of them), and even Johnny back in the day. I was not spared, either. The best reason I have ever heard to explain this is from Bill Carter, who said to me, "First they have to forgive you for trying to make them laugh."

That's it exactly. People actually seemed to be angry when I first took over. Not just disappointed, or skeptical, but angry. The *San*

Francisco Chronicle said that for me to get a show was proof that the genre was itself redundant. *Daily Variety* hated me and said I served as useful reminder to watch Conan. And the *New York Post* guy wrote that not only wasn't I funny but I was unintelligible and looked like I was wearing a wig!

I was stung by the reviews. I went on the Internet to see what the reaction was there, although I should have known better than to do that (I do now). People writing about you under the cloak of anonymity can be even more vicious, and in my case they sure were. I sucked, I should go back to Ireland(!), I was a traitor to Scotland (never could quite figure that one out), and someone deduced because of my accent that I must be a deviant homosexual.

But for all the naysayers, there were the supporters, too. The late-night hosts are something of a fraternity, at least they are a support group. I got a friendly call from Jay Leno, wishing me luck. Jimmy Kimmel sent me flowers and a lovely note which ended, "I hope you know what the fuck you're getting into." Even the great and powerful Dave sent me a welcoming telegram. That particularly amazed me—I didn't know you could still send them.

My predecessor, Craig Kilborn, also called me and was very gracious to me on my first day at work; and Regis Philbin, who turned out to be a great friend of Peter Lassally, took me to lunch. When I say took me to lunch, I mean he had lunch with me. I paid.

Regis gave me the same advice I got from our mutual friend Peter, as well as from Dave and even from Howard Stern: "Be yourself. Make it your own."

They all said it, and certainly they are all giants in their respective fields, but what the fuck does "be yourself and make it your own" mean in practical terms?

I felt lost and out of my depth.

After every show, Peter Lassally and Michael Naidus were there, as they are to this day, with little tips about how to relax and improve. Tips about how to get through the show without looking

too desperate or needy. They went from being mentors and allies to becoming true and valued friends, Michael eventually rising to being the head producer of the show under Peter's tutelage as executive producer. I could not do the job without them, nor would I want to.

Peter is an immigrant himself who understands my zeal for the U.S.A. He is a Holocaust survivor who made his way to the States after being liberated at the end of the war by the Russian Communists, who, he says, were almost as frightening as the Nazis.

I don't complain to Peter about the difficulties of my own childhood. He has something that is not seen so often in show business—class. He is a man who speaks his mind clearly and (for the most part) calmly. He keeps his word, he's respectful of those who work under him, and he firmly but politely doesn't take any shit from me.

"Remember," he's told me over and over again, "it's after midnight. They don't want you yelling at them. Calm down."

Tips about not scaring the kids.

"You've got a creepy laugh. Knock it off."

I didn't know I had a creepy laugh, but now I keep a lookout. It seems to be dormant for the moment, although Lassally stands ever vigilant, protecting America's insomniacs from a flare-up of sinister chuckling.

If Peter is alarmingly direct, Michael, on the other hand, is a born poker player. He can tell what I'm thinking by the way I walk into the office, and he can manipulate me shamelessly with the old bait-and-switch and passive-aggressive tactics. He does it regularly to get me to do what he wants without a fight. It's very clever.

"Hey—feel free to say no to this, but . . ."

Over time, and with their help, I lost the tics that were getting in my way and weeded out most of the staff members who I felt weren't on my side. I used to think I wasn't a very competitive person, so I was surprised to hear myself tell the entire staff on my

first day as host: "This show is number two in its time slot. Anyone who doesn't have a problem with that should quit now."

You must forgive me, I was just excited about scoring the big gig and was getting in touch with my inner douche bag. For the first few months I followed the cookie-cutter format of these shows. A few quick gags, an overwritten comedy bit, then interviews with two guests who were usually plugging some of their own work, then a band or a comic. That was the format that had worked for years, and I sure as shit had nothing better. The guest segments seemed fine, but the comedy was pretty poor, and, as the TV producer Gary Considine, who worked on the show for a while, told me, "Lame comedy will kill ya."

I don't know if that is entirely true—I'm still doing lame comedy now and the show is doing great. Maybe that's because it's *my* lame comedy. I am *my* lame self and make the lame comedy *my own*.

About three weeks after I took over, Johnny Carson died after a long illness. I didn't know how to deal with this on the air, but Peter helped me.

"Don't fake anything. Just be honest about what you feel."

So I told the truth and I said I had only a few memories of Johnny. I told the audience about my father laughing at *The Tonight Show* during our first visit to America, and that if you could make a Scottish Protestant laugh, you had to be really funny. I talked about my recent marathon watching all of those DVDs of Johnny, trying to learn whatever I could from the king of late night.

After my little eulogy we went to commercial and Peter came out onto the stage (which is unheard of—he usually watches from a chair in the safety of the control booth) to thank me for what I said about his old friend, and then he said excitedly, "This is it. Whatever you did just there, that's how you do this show."

I understood. Just talking off the cuff rather than reading cue cards seemed much more comfortable to me, so over the next few weeks I told fewer and fewer gags and ad-libbed more until even-

tually the writers and I did away with the conventional method of constructing a monologue—a team of writers composing individual gags, then handing them to a chief who correlates them into sequence. We developed a new system that involved all of us talking for a while and making notes, then assembling these notes into a list of bullet points that I would try out on the studio floor in front of the live audience. Essentially the monologue would be sketched out but not finished until I'd performed it on camera. That's still how we do it today, although the process has been refined and streamlined by Ted Mulkerin and Jonathan Morano, the show's head writers and my most valued creative partners.

Some nights it works, and some it doesn't, whether I stick to prepared material or ad-lib almost the whole thing. It all depends on where the moon is in Aquarius, or on my biorhythms, or something. I like to think that no matter what night it is, there is an honesty about the show.

I experimented in rebelling against the rule of the mighty Lassally by not wearing a tie, which made him very grumpy; but, like a patient parent, he correctly figured I would grow out of it.

When I did start wearing a tie again, it was, sadly, a black one, and it would have been inappropriate not to wear it.

In January of 2006, my father died after a rough fight with cancer. During his illness I had been pretaping shows and flying back to Scotland to see him, but when he finally passed away I was in L.A. I had a show that night and I didn't know what to do, so, of course, I called my mother. She told me to do what my father would have wanted. My father would have said to go to work.

Remember, work is how my people express love.

I knew I couldn't do a regular show, there was no comedy in me, so instead we turned the whole thing into a wake for my father. I talked about him, rambling from a few notes I had made earlier

in the day. I wanted the guests that night to be grown-ups capable of talking about grief, so we booked Amy Yasbeck—who is, sadly, an expert on the subject since the sudden death of her husband, John Ritter—and Dr. Drew Pinsky, because he is not only smart and empathetic but knows a lot about alcoholics, which meant he'd have a handle on how I was trying to cope. The brilliant Scottish-American trio Wicked Tinkers came on as the musical guests and I joined them in raising a wee bit of thunder, banging a drum loudly for the soul of my father.

I barely remember this show and haven't watched the tape, but I heard it worked out okay. My mother said he would have liked it. That's enough for me.

The Latin motto on the Ferguson clan's official crest is *Dulcius ex asperis*. It means "Sweeter after difficulty." I had the crest and the phrase tattooed on my right shoulder in memory of my father, who hated tattoos. The Celtic Paradox is alive and flourishing in the twenty-first century.

Settling Down

Not long after I got the show, Andi and I split up, as she had foreseen, and since then I'd been dogging around Hollywood, enjoying my newfound micro-celebrity. I was dating some well-known actresses, and getting mentioned in gossip columns for dating other well-known actresses that I hardly knew at all.

I suppose I was having a good time, but this kind of thing can get a little lonely and I had a fear of turning into one of those louche old twerps with dyed hair and a brow lift who hang around the Playboy mansion. I thought that was what the future had in store for me until I went to a party in New York City that I didn't want to go to.

A wealthy and well-connected Scottish émigré who lives in Manhattan named Jeffrey Scott Carroll had invited me, and because I like Jeffrey I went. I couldn't get there until it was almost over, and by then I was already very tired and grumpy from attending an earlier event that I also didn't want to go to, but when you're in New York on a promotional trip, the TV folks like to trot you around a bit.

Jeffrey and I were chatting when the most incandescently shim-

mering vision of a woman I had ever set eyes on came over. She said hi to him and he said, "This is Megan Wallace Cunningham."

I think I actually took a step back. Her long blond hair and her clear green eyes and her dress and her earrings and her smile and I don't know, everything. I mumbled something like "Hello, you're lovely, I love you, you have nice hair, let's get married" or words to that effect. I'm not usually nervous around beautiful women, but I totally lost my cool with this one. I probably drooled or spat or twitched or farted or something. Whatever I did, it made her laugh, and when I saw her laugh I was a goner.

Then we got to talking. She had no idea what I did for a living, although one of her friends staggered over at one point and said, in an upper-class English accent, "Be careful, Megan. He's on *television!*"

She said "television" like it meant "serial killer."

Luckily Megan didn't pay any attention because she had recognized my accent, and her own family was Scottish. She told me that her grandfather had emigrated from Edinburgh, dirt poor as a young man, and had gone on to make his fortune in America. She had been to Scotland many times and knew every obscure cultural reference I threw at her.

I was deeply impressed.

Nothing happened that night between us but we stayed in touch on the telephone, though with her in New York and me in L.A. it seemed we were never likely to meet up, same as when I started dating Helen. After months of long-distance calls I finally persuaded her to come and visit for a weekend. She did and we fell in love, or, perhaps more accurately, we admitted we already had, the moment we met. Then came a year of bicoastal-relationship bullshit, involving too much phone sex and too many air miles. Finally Megan upped sticks and moved to my house in Los Angeles. Our house, I should say, because by the time you read this, we'll be married. I swore I'd never do it again, and I wouldn't have for anyone

else but her, which I suppose tells you that it's the right thing to do. Megan is strong and patient and kind and nurturing and funny and knows about art. She's sexy and clever and sweet and, well, I love her, and Milo does, too, so we became family. She makes me feel like I'm lucky, and I know because I have her that I am. I'm happy to be her husband, and I can absolutely positively categorically swear that this marriage is definitely-and-without-doubt-I'm-not-kidding-you-I-really-mean-it the last one for me. Megs is fine with that.

45

American on Purpose

The late-night game has opened my world up and sent me in directions that continue to surprise me. After years of lying fallow, performing a monologue for the camera every night reawakened in me a desire to do stand-up comedy again.

I cobbled together some old material and started writing some new stuff and got out there and hit the sweaty, low-ceilinged comedy clubs to relearn what I had forgotten. I bounced all over the country, from Birmingham, Alabama, to Bowler, Wisconsin. From Boston to Fort Lauderdale and San Diego to Seattle and all points in between. I returned to my old craft in front of small crowds that pack into these tiny venues every weekend for the chicken fingers and the sarcasm. Some nights I was good, some nights I wasn't, some nights it was like I was back at the fucking gong show in the Tron Theatre in Glasgow.

Slowly I gained confidence and started to enjoy myself, and with all the traveling I met hundreds of regular Americans I would never have encountered had I stayed in the showbiz confines of L.A. and New York.

The clubs soon got too small to fit everyone in, and I am too damn old to do three shows a night anymore, so I started playing

bigger theaters and reached a level that I had tried and failed to achieve back in the Bing Hitler days.

I also believe it was the act of traveling around the country that cemented in my head the notion that I must finally become a citizen.

It's not that I hadn't considered it before. My son, because he was born here, is an American—shit, I'm an American too, I just never really thought about the paperwork. But as more and more people asked me if I was a citizen, I found that I was embarrassed to tell them I wasn't.

I was eligible for consideration because I'd had a green card for more than five years, so I applied for naturalization, and while I waited for the paperwork to be processed I had some fun with it on the show.

I had mentioned on the air that I'd first tasted catfish in the small town of Ozark, Arkansas, and that the mayor of the town, in gratitude for a national TV plug, had made me an honorary citizen of Ozark. I thought if I could be an honorary citizen of Ozark, then maybe some other towns would also bestow that honor and I could rack up some pressure on the government to look favorably on my application.

I talked about this on the show, and it seemed to touch a nerve. The response to my request was overwhelming, so much so that we started keeping a tally of how we were doing, like an election campaign. There was a big map on which we placed pins where I had been accepted, and poked fun at any city that refused to participate. (There was only one—that's right, mayor of Portland, Oregon, whatever your name is. I'm calling you out, you pompous oaf!)

The offices of the show were flooded with proclamations and letters welcoming me as an honorary citizen of literally thousands of towns across the U.S. of A.

The tone of the missives was lighthearted—I was made an Admiral of the Nebraska Navy, for God's sake—and although everyone seemed to be in on the joke, I also got a very strong sense from the sackloads of mail that arrived on my desk that Americans understood and appreciated the emotion involved and the decision process I went through on the way to becoming a citizen. What started as a bit on the show became a way for me to express my gratitude to the welcoming nature of the American people. Everyone was ready for some bipartisan and upbeat patriotism at the tail end of the Bush-Cheney administration.

It seemed to me that American patriotism had been hijacked by politicians who used it for their own jingoistic ends, and I wanted to use my television show to get away from that. I wanted to get back to the image of the gum-chewing GIs who brought swing dancing, fruit, and hope to Scotland when my parents were kids. I wanted to share the feeling I got when I received my big color poster from NASA in the mail. I wanted as many native-born Americans to understand the thrill and exhilaration that comes from joining the land of the free.

If this sounds trite I don't give a rat's ass. I believe in it. America truly is the best idea for a country that anyone has ever come up with so far. Not only because we value democracy and the rights of the individual but because we are always our own most effective voice of dissent. The French may love Barack Obama but they didn't fucking elect him. We did.

We must never mistake disagreement between Americans on political or moral issues to be an indication of their level of patriotism. If you don't like what I say or don't agree with where I stand on certain issues, then good. I'm glad we're in America and don't have to oppress each other over it.

We're not just a nation. We're not an ethnicity. We are a dream of justice that people have had for thousands of years.

I proudly took the Oath of Allegiance and received my citizen-

ship at Pomona Fairgrounds in Los Angeles in January 2008 along with three thousand other new Americans from Mexico, and no others from Scotland.

With a week's hiatus from *The Late Late Show* I traveled to Scotland just before Christmas 2008 to see my mother. She had been in failing health for a long time; it seemed to me that she never fully recovered from her bout with cancer more than a decade earlier, and since my father died she was never the same. How could she be? They had been together for over fifty years.

I arrived at Glasgow Airport on a Saturday night in freezing fog and drove straight to my mother's bedside, probably foolish after such a long trip and so long without sleep. The streets were icy and I was out of practice driving on the left side of the road.

When I finally saw her I was shocked. Her condition had gotten worse even as I flew over, she was barely conscious and I could hear the awful sound of pneumonia rattling her bronchi as she tried to get comfortable.

For the last two years she'd been in an assisted-living facility, and while the staff was kind and attentive, it was clear to everyone that this was, at last, the endgame.

I talked to my sleeping mother that night and all day Sunday and on Monday morning, still badly jet-lagged. I kissed her forehead and said I loved her. Then I left her to take a nap, thinking I'd see her later but she died before I got back. The cause of death was listed as pneumonia, plus a kidney infection, but I think she died because she couldn't live without my dad.

My siblings and I arranged for her funeral to be held a few days later and while waiting for that I threw myself into the completion of this book, hoping that the work would protect me from the sorrow, but the words wouldn't come.

So I went for a walk.

It was a shockingly clear, bright, and very cold day, atypical of Scotland in December. Everything seemed shiny and sharply in focus, but that may just have been my grief. I walked the streets of the West End of Glasgow, where I had roistered and caroused and caused a few broken hearts, including my own, so many years ago. I walked through Kelvingrove Park where, it seemed, the killer ducks had been replaced by a much friendlier variety. I walked past the magnificent architecture, the sandstone of the Victorian buildings basking warmly in the brightness of the sun. I walked and walked and walked and I couldn't feel anything, but I remembered that from my father's passing. Nothing at first, then a relentless build of emotion that rises unremittingly like a winter tide and threatens to engulf you.

Everywhere I looked was achingly beautiful and I couldn't understand it. People were blushing from the cold, their breath puffing little clouds of life into the ether. The trees were frosted with ice crystals and the cloudless sky crossed with the high vapor trails of distant jetliners.

I stopped on Great Western Road and looked in the window of a closed art gallery at a Peter Howson painting of a shouting man and a barking dog. A short chipper gentleman of advanced years, of which there are a few in Glasgow, came and stood next to me.

"It's Craig, in't it?" he said in an accent as thick as soup.

"It is," I said.

He told me he remembered me from the old days when I was causing trouble in the parish. We hadn't known each other, he just used to see me around.

"Yer American noo?" he asked.

"I am," I said.

"Must be nice. Although, you still seem Scottish to me. Nae offense."

"None taken," I said.

I felt a surge of affection for the old fella as I watched him walk

toward a nearby pub, his giant old-guy ears pink and shiny from the cold.

Suddenly I was struck by the first broadside of terrible sadness, it sprung up and wrung tears out of me unexpectedly. I rubbed my face pretending my eyes were watering from the cold, which was entirely possible, and walked in the other direction.

I realized that in my desire to be an American, I risked forgetting where I had come from, and that that would be an appalling act of self-robbery. I realized that I loved this place, that I always would, and that I would carry it with me wherever I went.

I am the child of two parents and two countries. My mother put the blue in my eyes and my father gave me grit. Scotland made me what I am and America let me be it.

America gave me everything I have today. It gave me a second chance at life. A life I had previously mishandled so catastrophically. Americans taught me failure was only something you went through on the way to success, not just in the sense of career or wealth but as a person. I learned that failure is only failure, and that it can be useful, spun into a story that will make people laugh, and maybe every once in a while give a message of hope to others who might need some.

For me, becoming an American was not a geographical or even political decision. It was a philosophical and emotional one, based on a belief in reason and fairness of opportunity.

I swore an oath not to be cowed by the authority of kings and churches. I won't allow any kids of mine to grow up as I did, witnessing casual hatred between children just because it had always been that way.

I didn't become any less Scottish when I became an American. The two are not mutually exclusive. I am proud of my heritage. I will always be Scottish in my heart, but my soul is American, which means: between safety and adventure, I choose adventure.

Scottish by birth, but American on purpose.

Acknowledgments

Thanks to everyone who helped me write this book, especially David Hirshey and Rebecca Tucker. Also thanks to Richard Abate and Nancy Josephson for making it happen. Thanks to my wife, Megan, for knowing everything in the book and marrying me anyway. Thanks to my son, Milo, for altering my perspective for the better. And to everyone that I left out—you're welcome.